How to Collect Art

How to Collect Art

Virginia Blackburn

WHITE OWL

AN IMPRINT OF PEN & SWORD BOOKS LTD.
YORKSHIRE – PHILADELPHIA

First published in Great Britain in 2023 by
White Owl
An imprint of
Pen & Sword Books Ltd.
Yorkshire - Philadelphia

ISBN 9781399096966

A CIP catalogue record for this book is available from the British Library.

Typeset in INDIA by IMPEC eSolutions
Printed and bound in England by CPI Group (UK) Ltd, Croydon CR0 4YY.

Pen & Sword Books Ltd incorporates the imprints of Pen & Sword Books
Archaeology, Atlas, Aviation, Battleground, Discovery, Family History, History,
Maritime, Military, Naval, Politics, Railways, Select, Transport, True Crime,
Fiction, Frontline Books, Leo Cooper, Praetorian Press, Seaforth Publishing,
Wharncliffe and White Owl.

For a complete list of Pen & Sword titles please contact

PEN & SWORD BOOKS LIMITED
47 Church Street, Barnsley, South Yorkshire, S70 2AS, England
E-mail: enquiries@pen-and-sword.co.uk
Website: www.pen-and-sword.co.uk

or

PEN AND SWORD BOOKS
1950 Lawrence Rd, Havertown, PA 19083, USA
E-mail: Uspen-and-sword@casematepublishers.com
Website: www.penandswordbooks.com

MIX
Paper | Supporting
responsible forestry
FSC® C013604

Contents

Foreword:
Why Art?

Why collect art? Creating art is one of the oldest of human impulses, as is the urge to collect it. And a collection, big or small, can be a source of enormous pleasure. On the one hand there is the decorative aspect of it and the sheer happiness you feel as you look at the treasure you tracked down through jumble sale or auction, through flea market or high-end gallery sale. Or alternatively, there is the interest in seeing history through the art and collectables of the time. Or the great sense of achievement in building up your knowledge of a particular area through your collecting over decades – and then switching your attention to something else.

There are as many reasons to enjoy collecting as there are days in the year. And there are no set rules. Perhaps your collection consists of vintage china from your parents' home, which brings you the happiness of recollecting them *in situ*; perhaps you have such an eclectic collection of just about everything that it spreads across your vast manor house and is the result of generations of enthusiasts. Or perhaps you haven't collected anything yet and would like to know where to start.

Whatever the category you fall into, this book is for you. In it we'll look at how to collect, what to collect, where to

collect it and all the other related areas such as displaying it, paying for it, looking after it – and selling it on when your tastes have changed and you want to make space for something new. Because that's another point about collecting: it doesn't ever stop. You might find that when you've achieved your own personal Holy Grail of collecting – say the five theatrical figures made in 1959 by Susan Parkinson for the Briglin Pottery, some of which are represented in the Victoria & Albert Museum and the Garrick Club – you then find a new interest that involves eighteenth century Dutch Delft china. What next?

Should you get rid of your Briglin pieces to make space? Should you get some more shelves built in your place to start displaying the Delft? Or should you just move house? Or perhaps furniture is your great love and having assembled a collection of classic Georgian pieces, you suddenly find your attention gripped by mid-century modern. As a matter of fact the two styles work quite well together, but you get the point.

We have always collected, even if the motivation for doing so has changed slightly over the years. The oldest piece of art known to man is the Venus of Hohle Fels, dating from 38,000–33,000BC, a small ivory carving discovered in southwestern Germany in 2008 and now at the University of Tübingen: like all art it tells us not just about the fashions and abilities of the time but also the society that created it. You could say it is now in a collection, although this one serves as academic a purpose as any of the more traditional collections that were built up when individuals began to amass great wealth.

Cave art dates back to at least 39,000BC, which is when the El Castillo cave paintings were made in Cantabria, Spain. And

while you wouldn't exactly call those paintings a collection either, and the reason for their creation (and who created them) remains disputed, the fact is that they provided a decorative surround that talks to us to this day. There is, in fact, a theory that they were painted in order to summon the animals they represented into the area for hunting, which gives them something in common with the votives found in ancient societies (and some modern ones) which were made to gain favour with the deities. Cave art of course is not collectable in the more traditional sense these days, but those votives most certainly are.

Collecting art started as a pastime for just the rich, although that is emphatically not the case any more, given that so much of us enjoy searching out treasures that 'to antique' has actually become a verb. But it was the very wealthy who began collecting as we understand it today and these collections became the basis for some of the world's greatest museums. And while I am certainly not suggesting that following the advice in these pages will lead you to establishing one of the world's great art collections, at the same time you never know!

Originally, members of royalty and the aristocracy would assemble artefacts and natural curiosities and show them off in Cabinets of Curiosities, of which more later in this book, or Wonder Rooms. These were the earliest forms of museums and the oldest example we know of is the Ennigaldi-Nanna museum, in the state of Ur, now Iraq, a Babylonian palace dating from 530BC and discovered in 1925. The palace belonged to Princess Ennigaldi, daughter of King Nabonidus, the last king of the Neo-Babylonian empire and himself a keen

collector of antiquities – in fact, he is sometimes called the first archaeologist. When latter day archaeologists found it, they discovered artefacts that were laid out in groupings according to the century they had been manufactured in, with labels made of clay cylinder drums declaring details about the pieces in three different languages. Many were already centuries old.

Closer to the modern day, perhaps unsurprisingly, the oldest public museums in the world opened during the Italian Renaissance, surely the greatest period of Western artistic production that the world has ever seen. Then, as now, patrons put together collections that were bequeathed to the public and in this case the patron was often the Catholic church. In 1471 Pope Sixtus IV donated a collection of ancient sculptures to the people of Rome: this became the Capitoline Museums, a group of museums on top of the Capitoline Hill in Rome, and the oldest public collection of art in the world. The second oldest is the Vatican Museum, started in 1506 by Pope Julius II, while Britain's oldest museum is the Royal Armouries in the Tower of London, dating from 1660.

Other early examples of collections housed in institutions open to the public include the Ashmolean museum in Oxford, which started life as a Cabinet of Curiosities collected by Elias Ashmole and opened in 1677, and the Amerbach Cabinet in Basel, also originating from a private collection and open to the public since 1671. The British Museum was founded on Sir Hans Sloane's collection of artefacts and opened in 1759 (Sir Hans has in more recent years been the subject of controversy, due to links to the slave trade, a subject totally outside this book's remit), and possibly the most famous

museum in the world, the Uffizi Gallery in Florence, was founded on the art collected by Cosimo de Medici, a collection which started in the fifteenth century.

Much more recently the same principles have applied as businessmen made huge amounts of money and then started to think about where to spend it. Many of the most famous and important museums in the United States were built upon private collections: the industrialists, bankers and robber barons around the turn of the last century first created vast fortunes and then began spending them on art – or in some cases, their wives did. The British art dealer Sir Joseph Duveen, often spoken of as the greatest art dealer of all time, correctly identified that American money was prepared to pass east across the Atlantic, in return for European art that travelled west. Or to put it another way, Europe had a lot of art and the United States had a lot of money. 'His entire astonishing career was the product of that simple observation,' S. N. Behrman wrote in *The New Yorker* in 1951.

The men Duveen dealt with read like a roll call of the powerful and mighty who were changing the face of the States at the time. His clients included John D. Rockefeller, Andrew Mellon, Henry Clay Frick (founder of The Frick Collection in New York), Samuel H. Kress, Frank P. Wood, William Randolph Hearst and many more. All these men and more made huge bequests to the US's most famous museums and it is as a direct result of their collections that the States possesses the world-famous museums it does today.

The Frick Collection is mentioned above, the Mellon and Kress collections are in the National Gallery of Art in

Washington, the Frank P. Wood collection is in the Art Gallery of Ontario and another client, Henry E. Huntingdon and his wife Arabella Huntington, established the Huntington Library, Art Museum and Botanical Gardens in San Marino, California. It opened in 1928.

All of these people assembled their collections for a complex number of reasons. As we mentioned above, the early cave paintings are thought by some to have represented some sort of shamanic way of summoning the animals the communities wanted to hunt. Renaissance art was used in part by the Catholic church to educate people in their faith: most churchgoers were illiterate and thus unable to read the Bible and so learned the Word of God through the painting of scriptural scenes instead. Portraiture and landscape painting developed through a desire to represent what the artist actually saw (this is not as straightforward as it sounds). Although a type of portraiture existed in, for example, ancient Egypt and Byzantium, it is totally different from what we would see as naturalistic portraiture today; ancient artefacts were collected in order to understand the past and some of the later great art collections were put together to signify the collector's fine aesthetic understanding (many didn't actually have any and needed Duveen-style guidance), selfless desire to give something to the nation and above all, to represent the enormous wealth that was needed to assemble such a collection.

The same holds true today: when an individual becomes enormously wealthy, first he (and it is usually, although not always, a he) buys the house and then he buys the art. Some of today's most successful artists have understood this and

turned themselves into not so much as an artist *per se* as a brand to signify enormous wealth on the part of the collector. You might know nothing about art but if you walk into a mansion and see a Damien Hirst shark in the hallway, you know that the owner has spent millions on it. And that is what the owner wants you to know.

That is also the reason that many people think an art collection is beyond them: they are put off by the stratospheric prices quoted in the press, without realising that you do not need vast sums to collect at all. Collecting was initially associated with Royalty and the aristocracy and more recently with industrialists, oligarchs and Middle Eastern and Chinese billionaires, so that many people would love to start an art collection, but believe it is not for them.

But that is not true. Anyone with even very modest means can start collecting: you do not need to spend millions, or even thousands, to have an attractive and pleasing piece of work. Many galleries will offer affordable payment plans, often charging no interest, while there are all sorts of opportunities, such as students' end of year shows, to nose out new talent before the market has yet latched on. Antiquing has for some time been a national pastime, with a plethora of television shows attesting to its popularity, and there have been many genuine cases when unwitting householders have found themselves sitting on a unique antiquity, such as a valuable pot that has been used as a vase for decades. You may already be a collector. You just don't know it yet.

So this book aims to act as a guide to get you going, or if you are already a collector, to give you a few new ideas. Collecting

is a vast area and we can't cover every aspect of it here but I will give you as much advice as possible and set you off in the right direction to learn more. But here's the best bit of advice of all. Do not buy anything on the assumption you will make money; only buy what you truly love and want to live with. Chances are you will not make money and even if you do the sums involved will probably be very small.

And don't be led astray by the headline-grabbing one-offs. There have been some very high-profile cases of people making a fortune through investment in art (not least when it comes to the artists themselves – Damien Hirst is worth an estimated £315 million), as when Hugh Grant bought an Andy Warhol screen silk of Elizabeth Taylor in 2001 for £2 million and sold it six years later for £13 million. He won a great deal of praise for his nous and timing, although Hugh later confessed that he'd been drunk when he made the original purchase, but the fact is that most people don't have anything like £2 million to invest in the first place and there is no guarantee at all they would see a return like that. Don't get caught up in the hype of astronomic prices washing around the contemporary art market, either. This is an area dominated by a small group of people who know exactly what they are doing and an innocent abroad in those waters risks going under in a flash. Personally, I would never borrow money to buy art: paying in instalments is one thing, taking out a loan to swim in murky waters is quite something else.

We also regularly hear about Chinese art (for some reason it is always Chinese, not least because there has been a huge growth in personal wealth in that country and with it a growing desire

to repatriate that country's art) going for a few pennies in a flea market and then bringing in a fortune. In November 2019, someone who had spent £1 on a Chinese vase in a charity shop in Hertfordshire sold it for £484,000 through Sworders Fine Art Auctioneers in Stansted Mountfitchet, Essex. It turned out that it was Chinese imperial and made for the Qianlong Emperor, who reigned from 1735 to 1796.

There are many more examples of this type, with some even more stratospheric sums at stake – in 2010 an eighteenth-century Chinese vase sold through Bainbridges for £43 million, after lying around for decades in a Middlesex home, although in this case the seller, Tony Johnson, is believed to have received 'only' £25 million for the item after the original buyer withdrew. Finding a neglected Chinese masterpiece languishing in a charity shop table might happen to you – but don't count on it. By all means rootle around in flea markets, charity shops, fairs and indeed anywhere else, and absolutely buy an attractive Chinese vase, or piece of eighteenth century Welsh porcelain or anything else that catches your eye. But buy it because you want it, not because you think it will make you money.

Once you have started collecting, don't be afraid to sell, either. Everyone's tastes change: when I first had a flat I wanted to furnish it in ethnic Indian furniture, but I didn't have the money. Then I developed a taste for beautiful seventeenth-century English furniture, but I didn't have the money for that either. I still love it, but these days I most favour mid–century design (as I mentioned above, the two can actually mix well). If I'd actually bought any of the earlier pieces I would have had to

sell them to make room for later items; do not be afraid to do this if your tastes move on. But one other piece of advice: if you are going for something that is known to have some value, namely that has sold in the secondary market and can thus be valued by comparisons with the past, it's much better to buy one good piece than five of poorer quality. But we'll get on to that.

Of course it makes sense to educate yourself before going out to forage and I'll tell you how to do that. But collecting should above all be about enjoyment. If you don't love that odd little piece of 1920s ceramic which later turned out to be by Clarice Cliff (lucky you!) there's no point in buying it at all. There's a clichéd image of astronomically rich collectors commissioning famous pieces to be stolen to order and then admiring them in a safe somewhere in Switzerland, for which there is almost no evidence whatsoever, but at least it contains one truism: the collector wants to possess the *Mona Lisa* (or whatever) because he loves it. A very high-profile piece of stolen art is usually all but worthless (unless it is used as collateral among criminals, which is a subject for a different book) because if it went on the open market it would be recognised. So the only reason to possess it would be for love. And that is far and away the best reason to collect.

That applies to the humblest little butterfly moulds from the 1920s (yes, kitchenalia is a collectable area) to the once in a lifetime purchase of a J. M. W. Turner (yes, they do still come up for sale, though you'd need pretty deep pockets.) And you can go about collecting in so many ways: choose a specific area such as porcelain and perhaps narrow it down to a particular manufacturer such a Meissen; pick an era, such as

the eighteenth century that you want to specialise in; choose a specific artist – some wealthy collectors group their Picasso paintings with their Picasso ceramics which, while expensive, are a fraction of the canvas's price – or just buy anything and everything that captures your eye. And with the internet and Google it has never been easier to track down and possess your beautiful objects. So here's how.

Chapter 1

How to Start

So you want to be a collector. The first and most obvious question is this: where to start? As we discussed earlier, there are no hard and fast rules about what to collect; in fact, just about everything is collectable these days. We'll go into a lot more detail about this in later chapters, and you certainly don't need to specialise when you're starting out, although until you decide what you're really interested in, I wouldn't spend a lot of money. But if you confine yourself to spending a few pounds in charity shops, you can afford to make a few mistakes when you're starting out. The very first picture I ever bought was a print that I got for £6 on Portobello Road market back in the 1980s: I still have it and I still like it. It was in very bad condition and glued to its mount (very bad); some years later I spent considerably more than £6 getting it unglued and re-framed. But it continues to give me pleasure and it always has.

Essentially, the best piece of advice when you start collecting is to do your homework, and this is easier than ever in the days of Google and the internet. But there are far more resources than that and we'll go into all of them in more detail later in the book. But here is an overview. First, if you are not yet sure what you want to collect, make the charity shop your second home. The same goes for car boot sales, flea markets,

one-off sales in your local town hall or similar institutions, fairs (these can range from local village fêtes to some of the grandest exhibitions you will ever see), neighbourhood sales and bargain hunts. Go to your local galleries: you do not need to buy anything but most owners will welcome interest in their stock and if you start to build up a relationship with them now, they may be very helpful when you actually start to buy. Most auctions are free to attend: if you have a local auction house, go.

Many artists will open their studios to the public, so check out the local ones in your area. It goes without saying that museums are also a valuable resource, although that said, for rather obvious reasons, the pieces on display there will be of museum quality and thus rather beyond the purse of most of us. But if you find a museum that specialises in your chosen area, it will give you a start. One of my favourite museums is The Museum of East Asian Art in Bath: it stems from the collection of art put together by the distinguished lawyer Brian McElney OBE from his decades working in Hong Kong. It is a beautiful introduction to art from that region and Brian himself has valuable tips on how to start out collecting art.

'I think I was a natural born collector,' he says. 'I collected stamps quite seriously in my teenage years, but I got bored of it and went on to something else. I moved to Hong Kong and what else do you collect there but Oriental art? If I'd lived in the UK, I'd have probably bought English watercolours. What got me started was when my aunt gave me a book called *The Ceramic Art of China* by William Honey, which was published

in 1945. Then, when I was in Hong Kong, I read everything I could find about it that was printed in the English language.

'And that's the first thing I'd recommend: read everything about the subject you're collecting. View as many pieces as you possibly can. Look at the bases. Sotheby's and Christie's both opened in Hong Kong in the 1970s and 80s. I would go and look at the pieces there, although most of the time I didn't bid as the prices were too high. Instead I went on a bargain hunt and talked to the actual dealers. Dealers like building up the expertise of collectors as that means they get dedicated collectors, and by the end of it I was so knowledgeable they began asking my opinions on things.'

Indeed, Brian became so knowledgeable that he was able to spot misattributions in auction catalogues and once bought a blue and white bowl that was down as being made in the nineteenth century, but actually came from the 1480s, at a fraction of its true worth. He also identified a tea pot that was one of 12 in the world made by a famous potter in conjunction with a mandarin. He found a bamboo carving of a frog that was dated 1623, highly unusual as dates tended to be within a 60-year cycle rather than so specific, and it was because of that piece that such carvings can now be dated back to the 1500s. 'Collecting goes in fashions,' he says. 'Although porcelain never goes out of fashion.'

His message: educate yourself sufficiently to know what you are looking at. Watch television or whatever you have on your tablet: it is full of shows that will give you an in. The oldest, most famous and most successful is the *Antiques' Roadshow*:

running since 1979, it is not only a way for householders to find out if their treasures are actually worth anything, but if you listen to the experts, it is also a valuable guide. They will tell you about finding marques on china, about condition, provenance and simple aesthetics: what makes one piece beautiful (and possible valuable) and what makes another not worthwhile. There are many more shows: *Bargain Hunt*, *Flog It!*, *Salvage Hunters*, *Dickinson's Real Deal*... Then there's *Sun, Sea and Bargain Hunting*, *Cash In The Attic*, *Going for a Song* and many, many more. (And for sheer entertainment value, you could always watch the 1980s television series *Lovejoy*, about a loveable rogue art dealer, although I certainly wouldn't advocate that as a learning exercise. It's just a bit of fun.)

If you are interested in buying contemporary artists – I am not talking about the mega-bucks brand names but far more affordable pieces, which is what most local galleries specialise in – follow the names you are interested in on Instagram and other social media. Again, this will begin to train your eye and enable you to start making comparisons without spending anything. We will look at galleries and fairs at greater length later in the book, but they are all on social media too. But do bear in mind that when you are starting out, it's far better simply to go with something you like rather than looking for a 'name'. There are no financial guarantees when collecting art; much better to find something you like and that you want to live with. But you may yet strike lucky.

One of the best examples of this in the twentieth century is the case of Herbert (16 August 1922 – 22 July 2012) and Dorothy (born 1935) Vogel, a couple of civil servants who

worked in New York City for 50 years, during which time they put together one of the most important post-1960s collections of art in the United States. They were somewhat snootily referred to as 'proletarian art collectors', for which read they were not part of the super-rich crowd who fly from one global art fair to the next on a private jet, but rather a normal couple who married in 1962, and after an early stint of painting lessons, they decided to focus their attention on collecting art. They lived in a small rent-controlled one-bedroom New York apartment, lived frugally on Dorothy's salary, and used Herbert's income, which never rose above $23,000, to collect art. When they ran out of room to display it, they stored it in cupboards and under the bed.

An early piece, bought to celebrate their engagement, was a Picasso ceramic (which would have been a sensational investment – these pieces sell for thousands now) and after their marriage, their first purchase was *Crushed Parts* by the US sculptor John Chamberlain. Over time they came to buy Cindy Sherman, Roy Lichtenstein, Robert Mangold and Richard Tuttle, all huge names in the latter part of the twentieth century. They only bought what they liked, never anything for investment purposes, purchased pieces that could be brought home on the subway or a taxi and often bought directly from the artists themselves, paying in instalments (we'll get on to that later.)

They held the first exhibition of their treasure trove in 1975 in the Clocktower Gallery in lower Manhattan, ultimately ending up with over 4,782 works and, after they donated the lot to the National Gallery of Art in 1992, the works are now

in 50 institutions across 50 states. In 2008 they launched *The Dorothy and Herbert Vogel Collection: Fifty Works for Fifty States* in conjunction with the National Gallery of Art, the National Endowment for the Arts and the Institute of Museum and Library Services, and you don't get a much better example of how to start an art collection than that.

If you are really serious about your chosen area, you might want to consider taking a course to learn more about it. There are innumerable choices out there, from taking a degree in history of art to one- or two-day sessions in learning about a specific area. Some of these resources are free, although most academic institutions will charge you. Most also offer online options. Places to look at are Sotheby's Institute of Art (https://www.sothebysinstitute.com), Christie's Education, which also runs a Young Collectors Club (https://www.christies.edu), the Royal Academy, which at the time of writing does not offer courses but has a great deal of information on its website (https://www.royalacademy.org.uk/articles/tag/collecting), the Royal College of Art (these tend to be more for people who work within the art world in some way, although it's worth a look, https://www.rca.ac.uk) and The Courtauld, one of the most famous places to study the history of art in the country (https:/courtauld.ac.uk). But this is just the tip of the iceberg. Check out what your local authority is laying on: there are numerous courses at all levels all across the country and there are very many more art schools than the handful listed here. There are also many more benefits alongside learning more about art.

'It is so good to do a course,' says Sophie Stewart, a wall art conservator at Paine & Stewart, who both studied and taught at the Courtauld Institute. 'It broadens one's knowledge, not just of art but of social history, aesthetic anthropology and so on. It is so broad in its range that the process of learning expands knowledge of a crucial time in history, teaching you about timelines, different cultures and tribes and the socio-economic aspects of the time.'

Once you have established what you want to collect, make a real attempt to develop your eye. Say you are interested in eighteenth century china. Start doing some background work into the different countries and manufacturers and you will almost immediately identify huge differences in style. Compare different examples of the different styles you like (this is all easily done online), note the types of patterns used, the colours, designs and so on. Learn to identify the manufacturers' marque on the back. Be very aware of the condition of the piece. Is it nicked and cracked? Has it been restored? Is the varnish chipped and, important this, does it somehow not feel quite right? Instinct plays a part in collecting: it doesn't take long before you start to get a real feel for what you're looking at and if you're dubious about a piece there's probably a reason for it. Trust yourself. You may well be more expert than you know.

All that said, there's no reason not to build a beautiful collection just because something takes your fancy. Sticking with porcelain, I have a friend who has an extensive collection of teacups and saucers, many chipped and not worth very

much, but all placed together making a beautiful aesthetic display. I knew someone else who bought a vast hoard of blue and white china, again most of it not remotely valuable and all mismatching, but she used it in lieu of a conventional matched dinner service and her dinner table was as attractive a sight as I have ever seen.

Exactly the same goes for paintings. I am a big fan of gallery walls, which as the name implies are taken from the way that some galleries display their art: it simply means filling every conceivable space on a wall with paintings, including around windows and on top of doors. It can be very attractive and striking but if you're going to do this it is very unlikely that every picture you hang will be a masterpiece (nor should it be – they do deserve a little space of their own). It just means that you will have chosen images that please you and as you build up your gallery wall, they will be shown to charming and pleasing effect.

Another way of starting to build an art collection is to start with prints and multiples, although please make sure to distinguish between limited editions, which are worth collecting, and reproductions of famous pictures, which are not. Limited editions come in the form of prints, lithographs, silk screens, etchings, photographs, sculpture and more and if you buy a limited edition print you can gain access to some very famous names indeed. For example, at the time of writing, it is possible to buy a Picasso limited edition print for a price in the low thousands. It won't go up in value in the way that a one-off Picasso painting may do (and nor will the insurance be so expensive) but it is a way to have the great Spanish master on your wall.

Some galleries specialise in producing limited editions and they are known as the publishers, and you can also find them through institutions such as the Royal Academy, the National Galleries of Scotland and the Royal College of Art. As the name implies, the works are produced in a limited edition: if you see 3/25, that means you are looking at the third print out of 25. A small run, such as 25, means a higher price, especially for a famous artist; a bigger run, such as 500, will not be worth as much. The size of the run will be decided by the artist, the gallery and where relevant, the publisher. There may also be artist's proofs (A.P.) workshop proofs (W.P.) and printer's proofs (P.P.). Usually, the artist will keep an A.P. for themselves and they will not be expected to comprise more than 10 per cent of the print run, so if you had an edition of 30, there would only be three A.P.s. The size of the edition will never change – often the original used to make the image is destroyed – but if demand is strong once the gallery has started releasing the images, prices may rise sharply and so an early buyer can find themselves sitting on a profit early on. (Bear in mind, however, that it may be difficult to resell.)

We'll talk more about money later on, but by this stage you should be ready to start collecting and it's time to work out a budget. If you are limiting yourself to buying at flea markets and charity shops that's not so important, as treasures can be found quite cheaply, but if you are prepared to spend more on your art, think ahead. Do you want to build up a big collection and what is your timescale? Of course, collecting is a lifelong pursuit – I'll never stop – but you might want to set out what you hope to achieve over the next year or so. Will you be buying

monthly or just as and when it takes your fancy? And what is your price range? Bear in mind that it is always better to buy one good piece than 10 mediocre ones, or to put it another way, prioritise quality over quantity. Think of the Vogels, although they seemed to manage both.

Finally, and this only applies to high-end collecting, you might want to consider hiring an art consultant or curator. This is really only for the collector with deep pockets, as you will have to pay for their services, to say nothing of paying commission (sometimes up to 20 per cent) on any work they buy for you, but essentially they will do all the leg work for you. They will establish what your tastes are, introduce you virtually to major galleries and art fairs, recommend up-and-coming artists (remember they may not always get it right), track down hard to find art works and much more. It is common for very rich collectors to have their own curators who will do all of this for them, but it is not practical for most of us as it adds hugely to the expense of putting together a collection and is the direct opposite of what couples like the Vogels did. And besides, it's not as much fun.

Chapter 2

Sketching it out: Drawings and Watercolours

You want to start your art collection proper and the chances are you might already have bought a few prints or multiples, as we discussed in the last chapter. But most collectors are almost bound to want to move on to collecting unique pieces and this is where drawing, painting and photography comes in. These can very loosely be put in the following ascending order in terms of price and desirability: drawings, watercolours and oils (and prepare for many variations on the theme along the way.) Photographs are also extremely collectable and we'll look at those at the end of this chapter.

> 'Beautiful colours can be bought in the shops on the Rialto, but good drawing can only be bought from the casket of the artist's talent with patient study and nights without sleep.'
>
> **Tintoretto**

Let's start with drawings. If there is a particular artist you are interested in, this can be the most accessible way into their work – although bear in mind that a Picasso drawing is not going to be cheap. A few artists confine themselves almost entirely to

drawings, and current examples include Stephen Wiltshire, known for his very detailed drawings of cityscapes; Adonna Khare, a contemporary US artist who specialises in animals; Paul Cadden, whose scenes made with graphite resemble old sepia photographs; Diego Fazio, an Italian artist known as DiegoKoi; and Cath Riley, from the north of England, who has won numerous awards and features in both private and public collections. Robert Longo is another one: he is a US artist who made his breakthrough in the 1980s with a series called *Men In The Cities*, a drawing and print series, while Kara Walker, best known for her black silhouette illustrations, is another whose drawing is central to her work. All of these are extremely collectable and examples of artists who have made drawing the central tenet of their careers.

But many more incorporate it into a fuller body of work. By its very nature a drawing can be far more spontaneous than almost any other artwork for the simple reason that all you need is paper and pencil; the cliché of an artist wandering around with a notebook and jotting down images as and when they occur and appeal is not that much of a cliché.

Start by doing some research, as we touched upon in the last chapter. UK-based museums with extensive collections of drawings include the British Museum, the Ashmolean in Oxford and the Fitzwilliam in Cambridge. On the continent, Florence has the Uffizi, Paris the Louvre and Amsterdam the Rijksmuseum. Over in the States, check out the Metropolitan Museum in New York, the Getty Museum, the Art Institute of Chicago and the National Gallery of Art Washington.

'Drawing includes three and a half quarters of the content of painting… Drawing contains everything, except the hue.'
Jean-Auguste-Dominique Ingres

Drawings can come in all shapes and sizes. They can be the preparation for a painting, an initial sketch for a bigger and more elaborate scene, and some collectors will go for both the initial drawing and then the completed work (not necessarily displayed together as the impact they make on the viewer will be very different.) They can be dashed off on a whim, a trial run for a bigger project or a very elaborate and well thought out artwork in their own right. Leonardo da Vinci executed a series of exceptionally elaborate drawings and his sketchbooks are some of the most precious artefacts we have from him. Michelangelo made more than 90 chalk and ink drawings in preparation for his work including the Sistine Chapel, while Albrecht Dürer executed 350 engravings and woodcuts based on a series of extraordinary drawings. Other great artists who incorporated drawing into their practice include Peter Paul Rubens, Rembrandt, Edgar Degas and Vincent van Gogh. None, it goes without saying, provide an entry level into an art collection.

Most of us are going to start at a rather lower level, however, so: how to establish if a drawing is any good or not? One tried and tested way is to seek out artists with an established reputation, whose work has sold at auction and in the secondary market and who are already established in major collections. There are institutions that specialise in drawings:

the Drawing Center and the Morgan Library and Museum in New York, and Drawing Room in London are all places to look for inspiration. However, going for artists with an established reputation would mean going in at a slightly higher level than many beginners would be happy with and so you might want to establish an eye first. There are no hard and fast rules when seeking out a drawing but here are a few tips you might want to bear in mind:

Drawings, for the above reasons, tend to be more spontaneous than paintings. That means you are not looking for the monumental impact of an oil on canvas but an illustration that is true to itself. Look at the lines that make up the work, the attention to detail (or lack of it), the fact that the artist might want to be giving a fleeting impression of their subject rather than too much detail.

'It is only by drawing often, drawing everything, drawing incessantly, that one fine day you discover, to your surprise, that you have rendered something in its true character.'

Camille Pissarro

Finally, if you have the wallet to do so, you might want to think about Old Master Drawings, although by their very nature these are never going to be cheap – in 2018 Christie's sold a figure study by the Dutch artist Lucas Van Leyden for £11,483,750, the third most expensive drawing ever seen at auction. That said, you can find very good works for the fraction of the cost of an oil painting, at the time of writing

around the £5,000 mark. Christie's recommends that if you go down this route, familiarise yourself with the history of the country that the artist came from as that will almost certainly have a bearing on the image, learn about the artist's techniques, be very wary of suspicious signatures (you are almost certainly not looking at a Michelangelo). And as always, only buy what you love.

There are a number of ways to go about collecting master drawings. The major auction houses have dedicated sales and there are also galleries that specialise in this type of work. In the past there have been Master Drawings Weeks in New York and London, with specialist galleries participating – keep an eye out as they will be advertised in the newspapers and art press.

The French, along with the Italians, are widely regarded as the most accomplished artists when it comes to drawing. Mark Fecher, of Didier Aaron, one of the galleries specialising in the field, says: 'From the fifteenth century, drawing was dominated by the Italians, who usually drew Biblical or mythological scenes as their patron was the Church. Then, from the eighteenth century, the dominance passed to the French, who produced more secular scenes. This was also the first time that drawing was seen as an art form in its own right.'

By the eighteenth century, French artists were undergoing rigorous training of up to six years, which contributed to their dominance in the field. Dealer Stephen Ongpin says: 'France has always been regarded as producing exceptional draughtsmen – Fragonard, Boucher and Watteau, for example,

and then the Impressionists. The students began by drawing Greek and Roman sculptures, followed by posed models, moving on to increasingly difficult subject matter. Students also competed for the Prix de Rome – the chance to work in Rome for five years, an indication of the importance of Italian art to the French. Initially drawings were done by the artist as a memo or as study for a composition and were never meant to be displayed. For example, Michelangelo in his old age burnt the drawings he had done in his twenties. He wanted people to focus on the end result and not the process that led to it. This idea persisted until the end of the eighteenth century: that the drawing was very much the artist's own.'

From then on, however, drawings began to be regarded as an art form in their own right. They are popular with collectors for two reasons: they have an immediacy not often found in the finished oil and they are cheaper.

Another very popular way of collecting drawings is through book illustrations, which are sold as original artwork (first editions of the books in which they appeared are also very desirable.) One of the most popular and collectable is E. H. Shephard, who brought to life the characters from *Winnie-the-Pooh* and *The Wind in the Willows*. These two collaborations alone are enough to guarantee his place in the history of book illustration, but they are only a fraction of his work.

Shephard also illustrated many less-famous books, worked as a political cartoonist for *Punch* magazine and produced numerous pen-and-ink drawings that stand in their own right. 'Shephard was simply one of the most brilliant draftsmen of his day,' says Gordon Cook, director of the Fine Art Society.

'When he came together with great authors, such as A. A. Milne and Kenneth Grahame, the result was greater than the sum of the two parts. Shephard had a genius for producing drawings that say everything they need to without overdoing it. They get exactly the right amount of information across.' Prices vary hugely: cartoons can be relatively cheap but in 2018 a drawing from *Winnie-the-Pooh* became the most expensive book illustration ever sold at auction at £430,000 via Sotheby's. It was a framed ink drawing of The Original Map of the Hundred Acre Wood.

'I suspect that there isn't a single child who wouldn't instantly recognise this wonderful depiction of the Hundred Acre Wood. This is the first drawing you encounter in the book and is the visual guide to the entire world of Winnie-the-Pooh,'

Philip W. Errington, Sotheby's director of printed books and manuscripts, said in a statement.

While these represent the Holy Grail for collectors in the area, Shephard's other work is considerably less expensive and well within reach of a more modest purse. Dealer Sally Hunter said: 'People forget that, apart from the famous ones, he worked for *Punch* and illustrated more than 80 other books.'

Ernest Howard Shephard was born in St John's Wood, London, in 1879 and studied at the Royal Academy Schools in 1897. Ten years later he placed his first cartoon in *Punch*, before being commissioned into the Royal Artillery in December 1915. He continued to draw throughout the war

and in 1921 joined *Punch*. Three years later he was asked to illustrate some verses written by A. A. Milne, which eventually appeared under the title *When We Were Very Young*.

A long-term collaboration with Milne followed and in 1931 his reputation received an even greater boost with the publication of *The Wind in the Willows*. But the originals of book illustrations were not collected then. They tended to gather dust in publishers' offices, although they were the property of the original artist. Although many were destroyed, a great deal of Shephard's work survived. Because he lived until he was 97, Shephard also saw his work attract great interest in its own right.

Next up are watercolours. Although we are going to talk a lot about money, prices, how to bargain and so on, it is important to understand that art should be collected for its own sake and not just because of what it costs. That said, there is a clear pecking order when it comes to prices: drawings are cheapest (we're not counting the Leonardos here), followed by watercolours, followed by oil paintings. There are a number of forces at play here: that pecking order also applies to the amount of time it takes to complete a work – that is, an oil painting also takes a lot longer to complete than a drawing – and the cost of materials used. Oil painting is also seen as the hardest of the three disciplines to master, although there are many incredibly accomplished drawings and dreadful oil paintings. It also has something to do with history: for at least 500 years it has been the practice of the rich to commission portraits in oil of their families. Where the rich lead, fashion follows. In art, as elsewhere, we are all like sheep.

But watercolours have a singular charm and represent a half-way house between the two extremes: they might require a little more preparation that a drawing (an easel as opposed to a notepad, some water for the colours instead of just a pencil), but they can have a spontaneity that can be much harder to achieve in oils. Essentially, a watercolour is made by taking a dry pigment, mixed with a binder, which is usually gum Arabic, and then water. The painter uses a brush to paint on paper, and less usually vellum, or other surfaces such as ivory. A gouache is very similar to a watercolour, but it is more opaque because white pigment or chalk has been added: when watercolour is painted on to a piece of paper, you can usually see the paper, but when gouache is applied you cannot. It has a more matte appearance.

Although they originated in northern Europe, watercolours have long been seen as a particularly British form of art. This is partly because of the Grand Tour, which privileged young men would take throughout Europe in the seventeenth and eighteenth century: watercolourists would accompany them and paint scenes of what they had seen, as a sort of early version of the smart phone. Not only were they easier to produce, but they were also easier to cart around, often stored in albums, where they either remained or ended up on the wall of a grand country home. As time went on some of Britain's greatest painters were watercolourists: J. M. W. Turner was one, along with Thomas Girtin. In more recent years perhaps the most famous artist working in watercolours has been David Hockney.

Watercolours remain extremely popular. They can also be extremely subject to fashion. In the 1980s, as everyone binged

on Laura Ashley and dreamed of country cottages with roses around the door, Victorian watercolours became extremely popular, with names such as Helen Allingham commanding very impressive prices. Victorian watercolours remain very popular in some circles and you can pick up some lovely examples for a few thousand pounds, of which more below.

'Watercolor is like life. Better get it right the first time – you don't get a second chance!'

Sergei Bongart

As always, do your homework. An excellent starting point is the Royal Watercolour Society. A gallery that holds selling exhibitions, it was founded in 1804 by the Society of Painters in Water Colours, who felt that their work was not being taken seriously enough by the Royal Academy. Their founders included Samuel Shelley, William Frederick Wells, William Sawrey Gilpin and John and Cornelius Varley. In the course of its history, Queen Victoria granted the Society a Royal Charter, and agreed to sign the certificate that each RWS Member receives on election to the Society. The tradition continues to this day.

Another valuable resource when doing your homework is the Victoria & Albert Museum, which not only has a comprehensive collection of watercolours, but also has a very useful introduction to the art form on its website (https://www.vam.ac.uk/articles/what-is-watercolour). The Royal Institute of Painters in Watercolours holds an annual selling exhibition at the Mall Galleries in London: check them out

at https://www.mallgalleries.org.uk/about-us/federation-british-artists-societies/royal-institute-painters-water-colours

As to which watercolours are the most collectable, as observed above, fashions change. For a start, collect what you want: if you browse your local galleries and establish which artists you favour, start to build up there. (I would not, however, follow in the tradition of the Grand Tour and buy local watercolours of famous places you visit: they tend to be pretty shoddy quality and it is highly unlikely you have picked up a future Turner.)

However, it remains the case that nineteenth century watercolours remain especially collectable. After Turner had done so much to popularise them, John Frederick Lewis and John Ruskin were both their champions, prompting an output that are very sought after. Look at the *Dictionary of Victorian Painters* by Christopher Wood for inspiration: there are some very famous names, including the Pre-Raphaelites Dante Gabriel Rossetti, Sir John Everett Millais and William Holman Hunt, who will cost a fortune.

But you can find much cheaper works for a few thousand further down the food chain. In a piece for *Homes & Antiques*, the *Antiques Roadshow* expert Grant Ford recommends Edward Radford, Charles Green, Elliot H. Marten, Wilmot Pilsburg, Frederick James Aldridge, Thomas Bush Hardy, Fred Dade, Claude Hayes, Thomas Nicholson Tyndale, Helen Allingham and the Stannard family. He also mentioned Robert Winchester Fraser, William Garden Fraser and Francis Gordon Fraser as well as Albert Goodwin.

Chapter 3

Oil in Oil – and Pop Art

And so we move to oil paintings. This is the 'big one' as far as many collectors are concerned: leaving aside some contemporary modern art, they are the most prestigious artwork to collect and traditionally, at least, they have been the best investment. I cannot emphasise enough that you should not buy art as an investment, but because you cannot live without it. However, I will mention the fact that in May 2020, the Knight Frank Luxury Investment Index reported that their Global Index of Artists, which tracks the value of their works sold at auction worldwide, had increased 134 per cent over the previous decade. Covid-19 marked a sharp slump in that, of course and the exact nature of the recovery will take some time to assess.

Emphasis has already been placed on doing your homework, but please do, in the usual way, through galleries, both public and private, tracking auction sales, befriending artists and so on. The same criteria apply: you can look for established artists, who will have higher prices, or seek out complete unknowns at end-of-year art school shows (we will talk more about these later in the book.) If you really want to educate yourself about art before you start to buy, I cannot recommend too highly *The Story of Art* by E. H. Gombrich. Do not be put off by its tome-like appearance: it is extremely readable, puts art in

context and helps train the eye. The only downside is that you will learn about some of the greatest art ever made, without ever having the slightest chance to collect it.

Oil paintings can roughly be split into categories: history, portraiture, genre (namely, everyday scenes), landscapes and still life, although in more recent times, much painting has become a good deal more abstract. Extremely briefly, Old Masters are the painters who were born before 1760 and reinvented painting during the Renaissance. The most sought after tend to be Italian and northern European but very little high quality work is left to come on the market and prices are stratospheric when they do.

Modernist and Impressionist work from the nineteenth century is also collectable although, also very expensive, and more recently, modern and contemporary art has held centre stage. However, these are at the highest end and like everything else in the art market, subject to fashion. Victorian oils were very popular for a while, but as with Victorian watercolours, have somewhat fallen out of fashion. Do your homework, seek out local and/or up-and-coming artists and you may strike lucky.

'Flesh was the reason why oil painting was invented.'
Willem de Kooning

Oil painting has a history. At some point in the past (slightly disputed) oil painting replaced tempera, which dated back to early Egyptian sarcophagi, and had been used in early medieval paintings, Indian temples, synagogues and much

else. Tempera was the main medium in Byzantine art. It lasted up to the Early Renaissance, with panel paintings attributed to Michelangelo employing egg tempera, but it gradually fell out of favour as oils began to catch on.

Oil painting is usually dated back to the twelfth century, becoming firmly established by Early Netherlandish painting in northern Europe in the fifteenth and sixteenth centuries, with the Bruges-born artist Jan van Eyck a particularly notable representative, before moving across Europe in the Renaissance. (There are, however, also oil paintings dating back to the seventh century created by Buddhist artists in Afghanistan, so clearly some other earlier, non-European artists had latched on to the technique.) This coincided with the use of canvas for oil painting, as opposed to wooden panels.

There are various different ways to go about building up your collection. You could focus on one artist, although if you do this and the artist falls out of favour, you will not have much of a chance of making a profit if you sell. Better to find an artist whose work you like and make it the centre of your collection, supplemented by other work. You could follow a school of artists, such as: St Ives and Newlyn, both based in Cornwall; Skagen and Bornholm in Denmark; the Glasgow School; the Epreskert Art Colony in Budapest; the New York School (abstract expressionism) – the list is endless, although it should be said the UK is home to many such schools.

You could collect by century, or a period within a century, by subject matter, such as maritime, animal, botanical (if you like botanical art, visit the collection at Kew Gardens), by country and so on. You could also buy whatever catches

your eye, which may be a less organised way of building up a collection, but can result in something extremely eclectic and individual. Personally, I think when buying a painting, exactly the same process applies as to a property or a piece of clothing: you just know, instinctively, that it is right for you.

> 'Painting is easy when you don't know how, but very difficult when you do.'
>
> **Edgar Degas**

Everything we have said above applies to collecting oil painting, from choosing local artists, to seeking out names that have already been established, to making contact with dealers, buying at auction and so on. But here are a few further hints you might want to bear in mind. Check for an artist's signature. It may well have been added on at some later date, however, so don't take it as proof of authenticity. Be aware that in most cases if you want to sell the work in the future you will probably not get what you paid for it. Some galleries will buy an artist's work back to resell, but if you are lucky you will only get 50 per cent of what you paid for it and it might be a lot less than that. The safest way is to buy at auction, where prices are public and established but do remember the market in an artist's work can plummet at any time and there is no guarantee at all you will get your money back then.

Catalogue raisonné

If the artist is an established one, he or she may have a catalogue raisonné. This is a comprehensive listing of all an

artist's work, although it may appear in different formats –
for example one volume may be devoted to just one type of
work by an artist who painted in both watercolours and oils,
while a second volume covers the rest. The catalogue may also
cover a whole school of artists. A good one will be extensively
illustrated. Older versions of these include a biography of
the artist; more modern version may include the author's
personal views and criticism. Some of these catalogues can be
enormous: Picasso's runs to 33 volumes and the early versions
have become collectors' items in their own right, selling for
up to $200,000. He, of course, worked in very many media,
including ceramics.

The catalogue raisonné is really important when it comes
to the value of an artist's work: inclusion can cause a work's
price to soar, whereas exclusion does the opposite. When it
comes to bigger names, auction houses will sometimes refuse
to deal with a work if it is not in the catalogue raisonné.
Unsurprisingly, given all this, these catalogues have quite
often been the subject of lawsuits, including some involving
the Warhol Foundation, the Pollock-Krasner Foundation,
and the De Chirico Authentication Board. Because of these
lawsuits, some people who were previously involved with the
production of the catalogues will no longer contribute to them.

There are different types of catalogue raisonné, so it is
impossible to state exactly what they have within them. However,
they may include some or all of the following: Title and title
variations, Dimension/Size, Date, Medium, Description
of the work, Current location/owner, Provenance, Critical
assessment, Exhibition history, Condition, Bibliography,

Essay(s) about the artist, Signatures, Inscriptions and Monograms of the artist, Reproduction of each work, List of works attributed, lost, destroyed, and fakes, Catalogue number.

The catalogue raisonné may also be known as Oeuvre, Catalogo Razonado, Catalogo Ragionato, Catalogo Generale, Opera Completa, Werkverzeichnis, Leben und Werk, Oeuvrekatalog, Complete Works, Critical Catalogue, Life and Work. To find out if the artist you are interested in has a catalogue raisonné, go to the International Foundation for Art Research (IFAR) Catalogue Raisonné Database.

Provenance

If you are buying higher-end work, provenance, or the history of a painting, is incredibly important, especially if at some future date it emerges the painting might have been stolen or misattributed to the wrong artist/century/school and so on. It can also provide a very enjoyable journey through a painting's life: who owned it, which galleries sold it, and its history. You can turn into a detective. One of the most famous examples of a painting with a full provenance is *Diana and Actaeon* by Titian: it was painted for Philip II of Spain in 1556–59 and its complete ownership history, through several owners and four countries, can be traced up to this day.

The provenance of a painting can be established in different ways, including checking it against the catalogue raisonné, as detailed above. But there are many ways to go about this. Check the back of the frame. If the painting is not a new one, this will tell you about its history: which dealers and galleries it has been through, whether it has been at auction and so

on. It may have a shipping label, something denoting what exhibition(s) it has been in, gallery stickers etc.

A signed statement of authenticity from a gallery or expert on the artist can also establish provenance and so can an original gallery sales receipt. However, a signature on the painting (see more below) is not so useful. Neither is an insurance valuation, as the person providing it will almost certainly be assuming the painting is original.

The painting might have been included in the inventory of a stately home, people who saw it *in situ* may have written about it, or it could have been mentioned in a will or a diary. It may have been in auction catalogues. The following may help when it comes to establishing provenance:

The Witt Library at the Courtauld Institute of Art has a collection of cuttings from auction catalogues. The Heinz Library at the National Portrait Gallery has the same, but it is restricted to portraits. There is a collection of UK sales catalogues at the National Art Library at the Victoria & Albert Museum. The University of York is establishing a web site with on-line resources, including diaries, sales catalogues, bills, correspondence and inventories, which involves art during the period 1660–1735.

In the United Sates, the Getty Research Institute in Los Angeles has a Project for the Study of Collecting and Provenance (PSCP) which includes an on-line database, which is a work in progress, of auction and other records. The Frick Art Reference Library in New York has an extensive collection of auction and exhibition catalogues and the Netherlands

Institute for Art History (RKD) has a number of databases related to artists from the Netherlands.

> 'I dream of painting and then I paint my dream.'
> **Vincent van Gogh**

Buyer beware

Be careful. Fraud is rife in the art market so it is very easy to fall for something that is not what it seems. Here are a few cautions:

- I mentioned above a signature on the painting. This might be proof that it really is an artist's work, but it might also be totally meaningless. People prefer to buy a work with a signature so an unscrupulous dealer might decide to provide one. Even the signature of someone totally unknown implies that this might have been an artist of some standing.
- There's no harm in buying a reproduction if you like what you see but it is highly unlikely to be worth anything.
- If the paint is very thick it might have been trowelled on to make it look like an original. An especially incompetent forger might have left brush bristles on the work.
- If the painting is suspiciously cheap, remember that if it looks too good to be true, that's because it is. (If you are an expert who has recognised something in a charity shop, that may not apply, but face it – you're not.)

- Sniff the painting. It should smell old. If you get a whiff of fresh paint and it's purporting to be an antique, make your excuses and leave.
- If you are really becoming an expert, you will be able to inform yourself about a painting depending on the oils used. There is much more available now than previously; the forger might have got their materials wrong. And if the painting is older, you should also be able to see cracks in the canvas.

'Genius is eternal patience.'

Michelangelo

South African paintings

This is another relatively new area of collecting that really took off after the ANC came to power in 1994 and Nelson Mandela became South Africa's first black president. In 2007, Bonhams held the first sale of South African art outside the country itself. Important artists, including Irma Stern, Gerard Sekoto, Maggie Laubser and Jacob Hendrik Pierneef, were represented. London is now the centre for the South African art market, with sales turning over a greater value than that sold in South Africa.

Giles Peppiatt, the director of South African art at Bonhams, who established that first sale, said: 'South African art of this type, as opposed to tribal art, did not exist until after the First World War. In the nineteenth century, English, Dutch and German artists visited South Africa to paint, but it was in the

European tradition. After the First World War, white people began to look at the country differently from the colonialists, thinking of it as their native land and imbuing native South Africans with a beauty and nobility that they had not had in paintings before. Black artists also became interested in the growing movement. Gerard Sekoto was the first black artist to paint, not tribal art, but in the European manner of oil on canvas. Others followed, including Gladys Mgudlandlu, who was a township artist from Soweto. She was totally uneducated and, having no money, painted on primitive materials. There is an honesty and a naivety about her work and its value will appreciate enormously.'

Names to look out for include Irma Stern (1894–1966). The Irma Stern Museum, run by the University of Cape Town, opened in 1971 and a painting by her sold for £500,000 in February 2007, a record for South African art. Jacob Hendrik Pierneef is another, as is Sekoto (1913–93), who became an artist after learning to paint while studying to become a school teacher. In 1940 one of his works was bought by the Johannesburg Art Gallery. For more than 20 years it was the only piece by a black artist to hang on the gallery's walls. Sekoto moved to Paris in 1947 and remained in France until his death, but his native country inspired much of his work.

'Wealthy black South Africans now collect work that reflects their black heritage,' Mr Peppiatt says. Other names to look out for include Gerard Bhengu, William Kentridge and Pieter Wenning, whose work is rare and much sought-after because his output was minimal and he died young.'

Small but perfectly formed

Miniatures is an area of collecting which has achieved stunning price rises in recent years, but is still accessible to collectors with modest means. Mark Griffith-Jones, the Sotheby's specialist in British watercolours and drawings, says: 'Miniatures emerged early in the sixteenth century, as the equivalent of today's portable photograph album. They came not out of the tradition of oil painting but of illuminated manuscripts. For example, if Henry VIII issued a royal writ, it would carry his signature and image. From that, it was a short step from document to work of art.'

To begin with, only monarchs and the aristocracy could afford costly miniatures: it was to be two centuries before the burgeoning middle class got in on the act. Miniatures were painted in watercolours, on vellum – calf skin shorn of hairs, shaved and polished to create a flat surface. By the seventeenth century, miniaturists began to be seen as artists in their own right. Often they had trained as goldsmiths or jewellers and, given the expense of their work, were attached mainly to the court. Isaac Oliver, John Hoskins and Samuel Cooper were some of the most important miniaturists of the day.

The identity of the sitter, as well as the artist, can be important, as illustrated by a 2.6 in portrait by Nicholas Dixon of Louise de Kerouaille, Duchess of Portsmouth. Louise was distinguished by her lively personal life: French by birth, she became one of Charles II's mistresses, and was rumoured to have been chosen for him by the French Court. Her nationality did not endear her to her chosen country: her great rival, Nell

Gwynne, called her Squintabella and, when once mistaken for Louise, Nell replied: 'Pray good people, be civil. I am the Protestant whore.'

Miniatures were sometimes worn as jewellery. But during the nineteenth century photography developed, of which more in the next chapter, which put paid to the miniaturists' trade. Rather than having to sit for hours for an artist, a person could have their image taken within minutes. Some artists continued with them, but their widespread appeal was lost. Many have survived, however, and the value of miniatures is soaring.

Pop art

Pop art does not exactly fit into a chapter on oil painting as usually it was anything but – mixed media, screen prints, found objects and so on – but as it slightly defies categorisation, a word about it here seems to fit. Everyone knows about pop art, with its heyday in the 1950s and 60s: practised mainly in the US and the UK, it took its inspiration from popular and commercial culture. One of its leading proponents, Richard Hamilton, wrote, 'Pop Art is: Popular (designed for a mass audience), Transient (short-term solution), Expendable (easily forgotten), Low cost, Mass produced, Young (aimed at youth), Witty, Sexy, Gimmicky, Glamorous, Big business.' Andy Warhol's *Campbell's Soup Cans* are a perfect illustration of this: the logo and packaging of a commercial product turned into an art form.

Its leading artists – Andy Warhol, who started as a commercial illustrator, Jasper Johns, James Rosenquist, Robert

Rauschenberg and Roy Lichtenstein – enjoy the status of household names. Their prices match. But not all pop artists are in that category of fame and as such do not merit such high prices and it is worth looking around for them. Gerald Laing, born in Britain but resident in the United States in the 1960s, and who died in 2011, is often thought of as an American artist and, since the heyday of pop art, has been shamefully overlooked, although that has changed in recent years.

Even the most cursory inspection of his work reveals artistry that was absolutely of its time. Laing, born in Newcastle-upon-Tyne, went to St Martin's School of Art, London, in 1963–64 before moving to New York for the remainder of the decade.

'I grew up in the grimness of the 1950s,' said Laing in an interview a few years before his death, and who lived in the Scottish Highlands for nearly 40 years. 'I can remember the war – gas masks, Anderson shelters and bombs falling, which gave way to the grimness of the next decade. By the 1960s a small number of the population might have been wearing miniskirts, but the majority were still depressed. Against that background, advertising and photography seemed to be the future. I wanted to paint dreams of perfection – one of the major ideas of the 1960s.'

Moving to America opened up a new world to Laing. The brashness of the US appealed to him. 'Unlike us, they'd had a good war,' he says. He became fascinated by the preoccupations of American life, specifically bikini girls, astronauts and drag racing. 'It was extravagantly perfect,' he says. 'It was part of the American dream.'

This subject matter reappeared constantly, making such an impact that although few might recognise Laing's name, many would know his work. His screen print of Brigitte Bardot is one of the iconic images of the time.

Laing was unique: a British pop artist working with his American contemporaries. But falling between two stools has contributed to the neglect of his work. Dealer James Holland-Hibbert says: 'He was in the wrong country at the wrong time.'

Because Laing was working abroad during the sixties, British pop artists tended not to know him. And at the height of his success in the US he disappeared back to Britain, finding the market too cynical for his tastes. His works are well represented in American museums, but this, too, has worked against him because he did not leave behind a great deal on the open market so that people might remember his name.

Other pop artists worth a look are Patrick Caulfield, Jim Dine, Keith Haring, David Hockney, Alex Katz, Julian Opie, Eduardo Paolozzi, George Segal, Rosalyn Drexler, Elaine Sturtevant and more. Prices vary enormously depending on the name and reputation of the artist, so research is as essential as always. Tate Modern is a good place to start.

Chapter 4

Through a Lens Darkly: Photography

Compared to the other visual arts, photography is relatively new, although it has come on a long way since Nicéphore Niépce took the first ever photo in 1827. It is also one of the cheapest ways to start collecting: a photo by an unknown should cost no more than a couple of hundred pounds. (Mind you, at the top end they can run into millions.) As with painting, genres have developed: these include pictorial, surrealist, street and landscape. Collectors might want to focus on just one of those areas or more, or perhaps concentrate on building up work using particular techniques, such as ambrotypes or daguerreotypes.

In the last few decades, modern and contemporary photography has become extremely collectable. Sir Elton John has one of the biggest collections of photography in the world: 'They are like reading a book,' he says. 'Your imagination comes alive and you imagine what was going on when the photograph was taken.'

People really started collecting photographs in the 1970s and it was in the following decade that it became a serious pursuit. As always, this was reflected in the movement of prices: in the 15 years from 2000, photography's price index rose by 48 per cent and by the end of 2017 art photography sales were up 54 per cent. Some people think it's a good way

to start collecting as it's more accessible than an oil painting but I personally think it's a matter of taste. In any case, whatever you buy, your taste is going to develop and change over time.

Start with getting to know the area: there are now specific fairs dedicated to photography, such as Paris Photo, Photo London and Photofairs, and festivals including Unseen, FIX Photo and Format. Then there is the V&A Photography Centre, the large auction houses hold sales devoted to photographs and there are galleries that specify in the area, including in London Huxley-Parlour, The Photographers' Gallery, Hamiltons, Michael Hoppen Gallery, Iconic Images Gallery and Atlas Gallery.

'All photographs are accurate. None of them is the truth.'

Richard Avedon

There are very many collectable names but the following are particularly popular (and expensive.) Look out for Julia Margaret Cameron, Cindy Sherman, Alfred Stieglitz, Walker Evans, Cecil Beaton, Henri Cartier-Bresson, Man Ray, Don McCullin, Irving Penn, Nobuyoshi Araki, Annie Leibovitz, Eve Arnold, William Klein, Norman Parkinson, Terrence Donovan, John Swannell, Terry O'Neill, Danny Lyon, Arthur Elgort, Jimmy Nelson, Elliott Erwitt, Bruce Davidson, Joel Meyerowitz, Alec Soth, Steve McCurry and Vivian Maier.

This is by no means a comprehensive list: when you start your research you will find many more. Richard Heeps, for example, created a very striking work called *Indian Coca Cola*,

with fading colours that somehow mirror the decline of the American Golden Age; Michael Schachtner has created iconic images of the Converse All Star shoe. And as with all artists, the younger you find them, the better value is their work. Check out their social media, their Instagrams and the locals near you. Collectors might focus on certain photographers, certain eras, certain countries, certain styles and so on.

The work on offer is hugely diverse. Be aware that not all photographs are printed when the image is taken. This especially applies to famous historic shots. If the picture is printed at the time it is usually described as 'vintage'; these tend to be the most sought after photographs and the best way to understand it is to compare it to a bottle of wine. If a bottle of wine is vintage 1930, that is when it was made. Ditto a photograph. Otherwise, it may be described as 'printed later' or, for example, 'printed 1987.'

Most modern prints will come in editions (similar to those described previously), so you will know exactly how many images exist, in what size and so on. As with other edition works, 1/4 means one out of a run of four; some dealers caution not to go above runs of 20 and of course, the smaller the run, the higher the price. Some photographers may also sell the artist's proof, namely the first perfect print of a negative, and as with other editions, prices may start to rise as the edition begins to sell. Technically, a photographer could create more images from the negative after the edition has finished its run but doing so would destroy their reputation. So any photographer who values their career would never do that.

The condition of the work may affect its value, but not always: very old photographs, by their nature, may not be in a very good condition, but their rarity value and general matter of interest may increase the price. There are also factors that will affect the condition depending on what the original photo was used for: if it was taken for a news story and reproduced in newspapers, chances are it's going to be very creased. There may be blemishes, fingerprints or even changes in colour, but this should not apply in any way to modern and contemporary photographs which, to be truly collectable, should always be in perfect condition.

> 'In photography there is a reality so subtle that it becomes more real than reality.'
>
> **Alfred Stieglitz**

As with paintings, there are many different types of photographs. At the most obvious level, they can be glossy or matte, colour or monochrome. Usually they are printed on paper, but not always: some are on metal or canvas. The materials employed can also be vastly different and include: silver gelatin print, the commonest way to make black and white photographs; C-print, made from a coloured negative; carbon print; albumen print, which was invented in 1850 and was common over the next 40 years; autochrome, the first colour photograph; and many more. An exhaustive list of the different types of photography can be found on the V&A website at https://www.vam.ac.uk/articles/photographic-processes.

There is now also the difference between analog and digital photography which require different techniques and skills and there will be artists who are skilled in each. To preserve them for the future, frame your photographs as carefully as you would a painting. Certain glass glazes can filter out UV light; this will preserve their colour but it is advisable not to hang them in direct sunlight. Try to keep them somewhere cool and dry.

Chapter 5

Furnishing your Collection

I'm going to start this one on a personal note. As I mentioned at the beginning of this book, when I was in my early thirties I bought my first flat and got very excited by the idea of filling it with Indian furniture. But I didn't have the money, so I lived among hand-me-downs. Time went on and my tastes changed, at which point I got very excited about filling the place with seventeenth-century furniture, especially anything involving secret compartments and oyster wood. But I still didn't have the money, so I didn't.

By the time I could start buying a few pieces, my tastes had changed yet again, by this time centring on mid-century items (the century in question is the twentieth), which it must be said is an extremely fashionable area in collecting at the moment. But the point is this: there are numerous different areas to centre on when collecting furniture and your tastes may change greatly when you do. But don't worry: you can sell the earlier pieces to make room for the new.

Antique and more modern furniture, like all aspects of the art market, is subject to fashion and if you are a traditionalist, at the time of writing, this is a very good time to buy. From the 1960s to the start of this century, furniture from the eighteenth and nineteenth centuries was extremely popular and soared in value, but then 'brown furniture' as it is known, fell massively

out of favour and according to *The Antique Furniture Index* (now discontinued) fell 45 per cent from its peak in 2002. It is now possible to buy some of these pieces for three figures – davenports and Pembroke tables are two once popular areas that are now languishing – and in this case your best bet is probably auction houses, especially in the provinces. But do bear in mind that some of the exceptional items, such as Chippendale, are never going to be cheap.

Collecting antique furniture is a little different from collecting visual art for the simple reason that it is probably going to be put to practical use. As always, do your research (the Victoria & Albert is an excellent place to start), buy one good piece rather than five mediocre and bear in mind that you can probably mix styles. Also, one really excellent piece can set the tone of a room; you can dot others around it. I'm going to concentrate initially on furniture made in the British Isles, but in many cases what I write also applies to furniture made in the United States (which was a colony throughout much of the high period of British furniture making) and clearly, there were many influences from across the Continent.

> 'I also have intense relationships with furniture... probably because we practically had none when I was growing up.'
>
> **Barbra Streisand**

We could go back a long way when it comes to English/British furniture but we will start with Jacobean and Carolean as these remain popular with some collectors, and older pieces are

much more rare and difficult to find. The somewhat unlovely term 'brown furniture' derives from English country house style and usually refers to the furniture made in the UK from the late seventeenth to the early twentieth century, widely seen as the Golden Age for British furniture. Conveniently, for the beginner, furniture made during this period is usually referred to by the name of the monarch on the throne at the time, hence William & Mary, Queen Anne, Georgian (1714 to 1801) and Victorian (1837 to 1901). Some furniture, especially from the eighteenth century, which was really the golden age of furniture, was also categorised by the name of the designer, specifically Chippendale, Hepplewhite, Sheraton and Adam.

There was also a change in the materials used during this time: oak and walnut, both British trees, were the main woods used until 1740, at which point due to increased trading with the West Indies, mahogany arrived on the scene. By the Victorian period, smaller items tended to be walnut, while larger ones were made out of mahogany. The characteristics of these different styles of furniture can be characterised as follows.

Jacobean

This refers to James I (James VI of Scotland), who ruled Scotland from 1567 and England from 1603. Jacobean furniture was made from 1603 to 1649, and was mainly made of oak, although lime and cherry also appeared and cypress was used for chests. It was physically huge, with simple carving, sometimes gilded or painted, and was geometric and symmetrical, with straight and rectilinear lines. The designs,

of classical or geometric motifs, incorporated spirals, semi-circles containing petals, patterns of eights, contiguous circles, lozenge panelling, rounded scrolls and double archs. Chests and cupboards were richly carved. This is the era in which upholstered furniture began to emerge.

Carolean

Carolean style, also known as Restoration style, was produced under the reign of Charles II, from 1660 to 1685. Charles had spent his years in exile in France and Holland and brought back French and Dutch Baroque tastes to Britain: the furniture of this period was now more in line with continental European styles. It also meant that Dutch expertise in veneering, marquetry, lacquer and gilding was employed, and marquetry, the technique of applying mixed veneers onto wood, became a hallmark of Carolean style. Puritanism was rejected and opulence began to appear in design: furniture makers used walnut instead of oak, employed floral marquetry, twisted supports and legs, exotic veneers and cane seats and backs. There were ornate carved and gilded scrolling bases for cabinets and velvet upholstery.

New types of furniture began to appear: they included cabinets on stands, chests of drawers, arm chairs, wing chairs and day beds. Freestanding bookcases and dressing tables also made an appearance. Design motifs included flowers, birds, cupids and acanthus leaves.

William & Mary

This was the moment when there was a decisive shift in English furniture-making from the medieval to lighter, more versatile

and comfortable styles, and which covers the period 1695–1730. William of Orange, who reigned over five provinces of the Dutch republic, and his wife Mary, deposed her father James II in 1688 and brought to the throne – and the country – a taste for Dutch design and Dutch furniture makers. It was also heavily influenced by the Baroque, which was extremely decorative in style, and is sometimes referred to as early Baroque.

Oak was the primary wood and it is distinguished by high relief carving, strong curves and intricate woodturning, while the furniture is lighter and slimmer than its predecessors, often physically lifted on slim legs from the ground. One commonly used technique was dovetailing: dovetail joints are tapered triangles and look like a bird's tail, which create interlocking joints. Paint, stains and different types of wood create different types of colour, and Japanning, a type of varnishing, also featured. Chairs had woven cane seats and heavily scrolled backs. This style was also prevalent in the United States.

Queen Anne

Fittingly, given that the name comes from a female monarch, this furniture is somewhat lighter and smaller than its predecessors, although it does not correlate exactly to her reign, which was from 1702 to 1714. The new style first appeared in 1689, but really only gained in popularity from the 1720s to about 1750. This style was also very popular in the American colonies, particularly among the growing wealthy class, not least as skilled British workmen began to emigrate there. Boston, in particular, became a major producer and

this style of furniture was made there until about 1800. This period is also known as 'late Baroque.'

The Queen Anne style was elegant. It is characterised by curved lines (unlike William & Mary, which was known for straight lines), crest rails, pediments and ornamentation, often in the form of a shell, scallop, scroll-shaped motifs, acanthus leaves, Oriental figures, animals and plants. The scrolls were C-scrolls, S-scrolls and ogee (S-curve), sometimes in relief form. Marquetry, inlay, veneering and lacquerwork all featured. The fashion switched from oak to walnut (this period is sometimes called 'the age of walnut'), while poplar, cherry and maple also appeared. Probably the most famous and recognisable feature of Queen Anne furniture is the cabriole leg: it is shaped as a double curve, the upper part convex and the lower concave, with a claw and ball or paw foot.

Social habits were changing and that influenced the style of furniture. Drinking tea had become popular which meant that small moveable chairs were needed, along with small side tables. The chairs had splat backs, curved to fit the hollow of the spine. China cabinets, bookcases, wing-backed chairs and secretaries all featured and in 1774 the first tilt-top tea table appeared.

Georgian

Georgian furniture was produced between 1714 to 1837, covering four King Georges and William IV and ending when Queen Victoria ascended the throne. It can roughly be split into three periods: Early Georgian, under the reign of George I (1714–1727), Transition and Chippendale under George II

(1727–1760) and Classic Georgian under George III (1760–1820). George IV died in 1830, which is when the period came to an end. If you want to see how the furniture looked *in situ*, Hogarth included it in his paintings. These various styles of furniture were also very popular in the United States, as they were shortly to become, and were also influenced by ancient Rome and contemporary design on the Continent. This was the age of the Grand Tour, in which wealthy young men spent a few years travelling across Europe and their experiences and tastes had a direct influence on the development of design back at home.

The Georgian style marked a move from walnut to mahogany. Chair backs grew shorter, narrower and were sometimes oval, and the ball and claw foot was overtaken by the Dutch round foot. William Kent was one of the most important designers in the early period and developed a very ornamental style: he was heavily influenced by Italian Baroque and Palladian. The Transition period was marked by Rococo, which originated in France but crossed the Channel. Later Georgian, also known as Regency, became heavier. It was influenced by the Napoleonic Egyptian campaign and began to feature snakes, sphynx, beetles and other Egyptian designs; black and gold became a very popular combination. A later name to look out for was Thomas Hope, a Dutch-born designer who settled in London after the Grand Tour. His book *Household Furniture and Interior Decoration*, published in 1807, introduced the term 'interior design' to the English language.

Given the time scale involved, the whole period contained a series of different types of design: Rococo, Chippendale,

neoclassicism, Regency and more. When viewing the furniture, look for dovetailing, square headed nails and mixed materials. The following are the particularly famous and influential designers of the period:

Chippendale

Thomas Chippendale (1718 to 1779) was dominant during the 1750s and 1760s, under George III, and it was during this time that Georgian furniture really began to come in to its own. During his time as a cabinet maker in London, he utilised mid-Georgian, English Rococo, Chinese, Gothic and Neoclassical styles. His designs are highly sought after and in 1754, *The Gentleman and Cabinet Maker's Director*, a pattern book, was published. He was the first cabinet maker to publish a book of his designs and its success brought him enduring fame.

He utilised much that was popular in the Queen Anne period: cabriole legs, ball and claw feet and S-scrolls. He also made straight and square legs, called Marlborough legs, and created very elaborate Rococo designs that are heavily carved and gilded. These included console tables. His Chinese-style pieces used a lot of fretwork glazing bars (in which the wood tracery held the glass) and pagoda-style pediments; some also featured japanning. His Gothic furniture used medieval, ecclesiastical motifs.

Chippendale set up his workshop in St Martin's Lane, creating furniture for the new luxury market and many of Britain's grandest houses. His *Director* contained 160 engravings of different styles, including Gothic, Chinese and Modern Taste, for which read French Rococo. Later

editions included the new Neoclassical style; three editions were published in total. However, he did not adhere solely to his *Director*: he also made simpler pieces for bedrooms and private spaces and worked as much as an interior designer as a furniture maker. His work can still be seen in stately homes all over the country, including Nostell Priory, Blair Castle, Wilton House, Normanton Hall, Harewood House, Petworth House and Dumfries House.

Robert and James Adam

Robert (1728–1792) and James (1732–1794) Adam were the sons of the famous Scottish architect William Adam and were extremely influential on the designers that came after them. The brothers were both furniture makers and architects, as well as interior designers. Robert and later James took the Grand Tour between 1754 and 1758, collecting antiquities and drawings that were a heavy influence on their work when they settled in London. Robert, in particular, introduced Neoclassical style to the UK.

They began replacing cabriole legs with straight ones and as they progressed they began to create inlays in tulip wood, satinwood and ebony; details included urns, laurel wreaths, oval sunbursts, acanthus leaves, arabesques, ribbon bands, festoons and garlands. Not much survives, but their style was reflected in other work for decades to come. They are probably most famous for their architecture, though, including Royal Exchange and Charlotte Square in Edinburgh, Pulteney Bridge in Bath, Osterley Park, Syon House and Kenwood House around London.

George Hepplewhite

The designer (1727–1786) made light, airy furniture in satinwood and walnut. None of it survives, but pieces of it made in his style were made for years. One very distinctive feature in his work is the shield-shaped chair back; he also used shorter and curved chair arms and square, straight legs, often ending in a spade foot. He was also noted for the design of sideboards and four-poster beds. After his death, his widow Alice published a book of his designs: *The Cabinet Maker and Upholsterer's Guide*, which came out in 1788: this established his reputation and other cabinet makers continued to use the designs for years to come.

Thomas Sheraton

The last of the great Georgian furniture designers (1751–1806) worked into the nineteenth century, and the furniture that bears his name was produced from 1790–1820. He too produced written guides, with his first, *The Cabinet-Maker and Upholsterer's Drawing Book*, published 1791–1794, being especially influential. His furniture was designed in the neoclassic style, a simpler look than its predecessors, using satinwood, mahogany and beech and incorporating contrasting veneers and inlays. Legs were very slim, straight and sometimes tapered, feet were in the shape of a rectangular spadefoot, cylindrical foot or tapered arrow foot. Chair and sofa backs were rectangular. Very little still exists that was made by Sheraton himself, but you can find pieces in the Sheraton style.

French furniture

We've already touched on French furniture, but it's a very popular area in its own right, so it's worth a few words more. Some people buy museum quality furniture for their collections; others use it as inspiration for the style of their house. 'The golden age of French furniture was from 1715 to 1830, but nineteenth-century furniture is also popular,' says Gabrielle de Giles, a specialist in French furniture. 'People like the French country château look: it is easy to live with. Much of it is painted, so it doesn't require high polishing. You can put down a glass of wine without worrying whether it is going to ruin your furniture.'

French design in this period was dominated by two women. The first, Madame de Pompadour, Louis XV's mistress, encouraged the king to adopt the Rococo fashions of the time, 1715 to 1774 – a style known as Louis Quinze. But it was the next period, 1774 to 1793, that produced the most desirable furniture, which is still popular, albeit stratospherically expensive, today.

Marie Antoinette, the consort to Louis XVI, is credited with promoting the Neoclassical style known as Louis Seize. The look is straight classical lines, combined with luxurious wall hangings and slenderly proportioned furniture painted in light colours. Adopted by the court, the style caught on among the aristocracy. 'It is the most popular and the most expensive area of French furniture, but it does hold its value,' says George Perez-Martin, of Brownrigg, the Petworth dealer.

After the French Revolution, two more styles emerged: the Directoire, after the government of the day, followed by the

Empire style, from 1804 to 1830. As the name suggests, this came about at the time of Napoleon. After that purists can become finicky, as French furniture entered a long revivalist period, reproducing everything from the Gothic to the Rococo to the Neoclassical. Paradoxically, it is this period that produced many of the pieces that we see and buy today, much of which has the appearance, but not the price, of Louis Seize originals. Condition is important and a lot of furniture has been restored, so watch out for modern screws. Some picces have been repainted, but this is acceptable if the original piece was painted.

Victorian

Victorian furniture was made during the reign of Queen Victoria from 1837 to 1901. It coincided with the Industrial Revolution, which meant that for the first time furniture was manufactured, and it was heavily influenced by Gothic, Rococo and Louis XV furniture. It was much more curvy than the clean lines of the Regency era. The wood tended to be dark and was often gilded; it was mahogany, rosewood or walnut. The pieces were decorated with carvings of flowers, leaves, curling vines, ribbons and bows, on the tops of sofas, chairs, beds and chests of drawers. Upholstery became far more lavish and luxurious, using velvets, damasks, brocades and needlepoint. Gothic revival was popular, as was the manufacture of furniture based on much earlier designs. But not all the innovations were positive: for example, chests of drawers often had wooden knobs, because they were cheaper to make and use than more traditional brass.

The Industrial Revolution totally transformed furniture making in Britain for a number of reasons. For a start, it increased people's wealth, which meant that a growing wealthy middle class was able to afford pieces on a scale they wouldn't have done before. People were moving *en masse* to the cities and wanted to furnish their houses. But it also marked a change in the relationship between manufacturer and consumer. No longer was there a personal relationship between designer and client because multiple copies of one piece could be made in factories – the start of mass manufacturing. Teams of craftsman, rather than just the one, would work on a piece. The Chesterfield sofa was supposed to have been commissioned by Lord Philip Stanhope, the fourth Earl of Chesterfield (1694–1773), but it was only in the Victorian era that it really became popular with a much wider clientele. Buttoned upholstery became popular across the board.

Changing fashions also changed the way furniture was made. Victorian women wore huge, voluminous skirts, which meant that chairs were built with low arms or none at all to accommodate them. Balloon backs and deep seats were popular. The coiled spring was patented in this era, which meant chair legs became shorter and seats deeper, in order to house the spring. Sometimes marble was used to top items such as tables and sideboards. Items to look out for that were typical of this period include ottomans, work tables, both for games such as chess and for sewing, davenports (writing desks), chiffoniers, Gothic revival sideboards, Sutherland tables, sideboards decorated with mirrors (these were mass produced in 1840) and brass bedsteads. Pieces became bigger

and more solid and in many ways, design standards slipped, not least as the furniture was designed for what would suit the factories, rather than for its intrinsic design. Most of it, for obvious reasons, was not signed.

Arts and Crafts

The decline in standards in some furniture manufacture prompted a backlash at the time and resulted in the establishment of the Arts and Crafts movement (1880–1920), which started in Britain and spread across the world. It was based on the ideas of the architect Augustus Pugin, the writer and critic John Ruskin and the designer William Morris. In Scotland, Charles Rennie Mackintosh was an important figure. It spread across every area of life, although we are only going to look at furniture here.

William Morris said, 'Have nothing in your house that you do not know to be useful, or believe to be beautiful', an excellent piece of advice that we should all adhere to. The movement aspired to a far simpler appearance and functionality than that utilised by the Victorian furniture designers, while furniture makers returned to workshops rather than factories. William Morris is one of the most famous designers of the era, but also important were Leonard Wyburd, who was head of Liberty's Furnishing and Decoration Studio, E. G. Punnett for William Birch, Robert Lorimer in Scotland and George Jack. Ambrose Heal, of the Heal family firm, Ernest Gimson, Peter Waals, Ernest and Sidney Barnsley, Edward Barnsley and Gordon Russell are all names to look out for. Also look for CFA Voysey, a firm that designed wallpaper, textiles and silverware.

The furniture from this period should be handmade and the most commonly used wood is oak. Design is simple, but with motifs including upside down hearts and tulip leaves. Chairs have rush or leather seats and leather and copper straps are deployed. I am not listing prices here or elsewhere as they so quickly go out of date but if you like this style, be prepared to spend at five figures for good pieces. When it began, the movement had a socialist vision and wanted to create furniture for the underprivileged and harked back to the medieval system of trades and guilds to sell their wares. Needless to say the opposite happened and only the wealthy could afford to buy.

'No animal should ever jump up on the dining-room furniture unless absolutely certain that he can hold his own in the conversation.'

Fran Lebowitz

Art Nouveau

Art Nouveau furniture was produced between the 1890s and 1914 and most of it was also produced by hand, although towards the end of the period it began to appear on production lines. It was a movement that spanned the whole of Europe and the United States and was named after Maison de l'Art Nouveau in Paris. There was a big overlap between architects and designers, in that the former, including Charles Rennie Mackintosh, designed furniture to match the interior of their houses. In Spain, Antoni Gaudi was another.

Styles of Art Nouveau differed around Europe, but in Britain there was a big overlap with Arts and Crafts and the

Glasgow School, exemplified by Charles Rennie Mackintosh and his wife and fellow designer Margaret Macdonald Mackintosh, both of whom had studied at the Glasgow School of Art. Mackintosh designed furniture with straight lines and right angles, which was decorated with painted wood, enamel, stained glass and painted silk. They remade the Glasgow School of Art, which was known as the Mackintosh building, which included architecture, decoration and furniture, and the Willow Tea Room was so famous for its furniture and décor that it influenced succeeding generations of artists. Sadly, after two fires in 2014 and 2018, only a burnt out shell remains. Furniture made in Glasgow in this period was known as the Glasgow Style.

In general terms, Art Nouveau furniture took inspiration from nature, including vines, flowers and waterlilies. Its lines were curved and undulating, using the whiplash line, an asymmetrical, often in an S curve. It, too, used nature as a muse, using cyclamen, iris, orchid, thistle, mistletoe and holly, along with swan, peacock, dragonfly and butterfly. Different coloured woods produced an effect of asymmetry and polychromy. There was often marquetry using enamel and the woods were walnut, oak and teak. This furniture was very labour intensive, with its extensive carving, and was thus very expensive, which was one of the reasons it began to fall out of fashion. But it is a very distinct style and highly collectable.

Art Deco

In 1925 the International Exhibition of Modern Decorative and Industrial Arts was held in Paris and as a direct result

of this, Art Deco, a powerfully influential movement, was born. It manifested itself in almost every area of human achievement (think of the Chrysler Building in New York) across Europe and the United States but here we will confine ourselves to its furniture. But as shorthand to recognising the style, think of Hollywood movies from the 1930s, which will often be a perfect showcase for the style. It was influenced by leaps ahead in technology, such as the use of the telephone, a desire for glamour that characterised the Roaring Twenties and growing international travel, which meant that pyramid shapes and animals indigenous to sub-Saharan Africa, such as zebras, appeared.

Art Deco lasted up until the 1940s. It was a very striking style of design: the proportions were large, and woods included ebony, burl walnut, ash and maple. The style employed veneers of sycamore, amboyna, mahogany and violet wood, while ivory, brass and mother of pearl were used for inlays. This is when shagreen (a type of sharkskin) became popular. Lines were geometric, symmetrical or angular, with sweeping curves (think of actors making an entrance down those Hollywood staircases) and there were bold colours and striking patterns and prints. Marble often topped cabinets and tables, and new materials, such as Bakelite and Lucite began to appear. Metal was also used.

Typical Art Deco interiors would use silver, black and chrome. Wood was very highly polished or lacquered. Motifs included sunburst shapes, jagged edges mirroring those found on skyscrapers such as the Chrysler Building, zigzag patterns, animals, trapezoidal shapes, triangles and sometimes nudes.

Designers to look out for include Jacques Emile Ruhlmann, Paul Follot, André Mare, Eileen Gray and the Sue et Mare partnership in France and Gordon Russell and Betty Joel in Britain. All this opulence was, however, extremely expensive and petered out at the start of the Second World War. Original Art Deco furniture is very expensive, but if you like the style, modern manufacturers are still producing it. But that would not be deemed collectable and is unlikely to rise much in price.

Modernist

Modern, or modernist design, existed from the late nineteenth century up to the present and represents the complete opposite of everything that came before it. Rather than creating a unique and ornate piece that was an artwork in itself, modernist design reflected that it came from the industrial age: it was functional, practical and affordable. (The original pieces we are going to mention are now anything but affordable, although they are highly sought after and collectable.) This practicality came to be known as functionalism. The aesthetic was cutting edge, excess stripped away, with minimalist principles of design; the pieces were made by machines, saving time and energy. But unlike the Victorian period, when machine-made furniture led to a collapse in standards, modernist furniture was beautifully made and has withstood the test of time. They represented newness and innovation when they were first made and the shock of the new is still there.

Modernist furniture evolved in different forms across Europe and the rest of the globe and while until now we have largely concentrated on the UK, it is necessary to venture

further afield. Various movements contributed to its growth, concentrating on clear lines and modernity: these included the De Stijl movement, founded in 1917 by Theo Van Doesburg in The Netherlands, which included Mies van der Rohe. In Germany there was the Deutscher Werkbund, founded in 1907 in Munich, which also included van der Rohe, and the Bauhaus School, founded in 1919 by Walther Gropius. Materials used changed. There was plastic, of course, glass and moulded plywood, this last used to particular effect by Charles and Ray Eames.

Some of the pieces produced have become so famous that the shapes would be familiar even to people who know nothing about furniture, and in many cases they are considered to be pieces of art in themselves. In many cases the originals will be very expensive, but you can buy much cheaper versions that are made today. Here, in no particular order, are some of the greatest designs of their time: Gerrit Rietveld's Red-Blue Armchair (1917), Marcel Breuer's Wassily Chair (1925–6), Le Corbusier's LC4 Chaise Longue (1928), Le Corbusier's LC2 Sofa, Eileen Gray's side table (1927), Mies van der Rohe's Barcelona chair, Isamu Noguchi's coffee table (Japan was opening up to the outside world and becoming increasingly influential) and Robin Day's Polypro chair. This was designed in 1963 for the British furniture design house Hille and anyone who has ever been in an office will be familiar with it: made with moulded polypropylene, with no arms and steel legs, it became so famous it even made it on to a postage stamp.

Over in the States Charles Eames and his wife Ray became two of the most influential designers of the century: their

lounge and Ottoman (1956), the Aluminum Group furniture, the Eames Chaise, numerous chairs, especially the Eames Fiberglass Armchair, are all absolutely central to twentieth century design. While we're on this side of the Atlantic, it is also worth mentioning Paul R. Evans II, a designer associated with the American Craft Movement of the 1970s, who worked with Directional Furniture, where he created some famous lines including the heavily industrial Cityscape series. Florence Knoll was said to have revolutionised office design; she and her husband Hans turned Knoll Associates into a global force in furniture. And finally, be aware of the following names: Alessi, American Furniture Warehouse, Art Van, BoConcept, Duravit, Habitat, Kartell, Ligne Roset and Vitra.

'Everything is designed. Few things are designed well.'

Brian Reed

Mid-century modern

This is the style referred to in the opening paragraphs of this chapter and it is my personal favourite. It can be sub-divided into several different categories and there are also many cross-overs – you may see references to mid-century modern, which we looked at above. There is also a cross over with Hollywood Regency, which is very flamboyant and glamorous. As you develop your eye, you will easily be able to distinguish different styles.

The mid-century style I am referring to here thrived in Italy, France and Belgium, with a scattering of other designers across Europe. It used glass, lucite, brass and gold and crystal.

Mirrored side tables, traditional furniture such as butler's trays made of brass and glass, chests of drawers in unusual materials such as chrome all feature. You might find coffee tables cleverly shaped into an S, lucite side tables with brass. It dates from about the 1950s or 60s, although Hollywood Regency, which is essentially a more flamboyant version of it, goes back to the 1930s. For many years these pieces could be picked up for a song, often in the south of France, but it has grown very popular in recent years and prices have risen accordingly.

There are a number of designers from that period which are very sought after. Piero Fornasetti was one and this encompasses other areas than just furniture. Working in mid-century Milan with the great designer Gio Ponti, he created eye-wateringly original designs, with extraordinarily strong graphics. Piero's son Barnaba runs the Milan-based business now and still produces furniture and many related items, including a series of plates called Tema e Variazioni (Themes and Variations) featuring the face of the opera singer Lina Cavalieri. Much of the modern work is in the same style and design as the older: the difference is the price. The older work is much more expensive: for example, Fornasetti's famous Architettura trumeau will cost upwards of £20,000 new (at current prices, these may change), whereas a 1950s version will run into six figures. But any Fornasetti, old or new, is produced to the highest production values and will become an heirloom item in itself.

The Italian designer, who died in 1988, combined surrealism with trompe l'oeil in a way that is utterly unique. Fornasetti was born in Milan in 1913. At the age of 17, he enrolled at the

Brera Academy in the city to study drawing but two years later he was expelled for insubordination, a trait responsible for a mischievous quality throughout his work. Undaunted, he took part in a student exhibition at Milan University the following year and in the Milan Triennale for the first time with a series of painted silk scarves.

By the 1940s he was already becoming established as a designer of some note, but it was in the following decade that his extraordinary and unusual designs, by this time in furniture as well as other media, made him an internationally known name. And his reputation has grown in recent years. There is a 1950s desk by Fornasetti in the V&A, which 35 years ago would have cost about £10,000 – if you had managed to get hold of one, for there was little on the market. That same desk would cost between at least £70,000 and £100,000 today.

Interest in Fornasetti was given a huge boost among US buyers in 1998 when Christie's held an auction dedicated to the designer in Los Angeles. Themes and Variations, a gallery in London, is Fornasetti's British agent. It opened with an exhibition of his work in 1984 and takes its name from a series of 365 Fornasetti plates.

'Fornasetti designed mainly furniture in an extraordinary way,' says Liliane Fawcett, of the gallery. 'For example, he would design a chair and make it look like a column or decorate a chest with butterflies. His importance as a designer stems from his originality, the way he used different materials, strong colours and lacquer. There are so many facets to his creativity. A minimalist would like his black and white pieces; someone who is more flamboyant would choose something Baroque.'

Prices of the original pieces made 40 or 50 years ago are now extremely high. Everything was made in the Milan workshop and nothing was mass-produced, which means that the work has a rarity value. But not everything is as expensive as that desk. Some of the large items of furniture can be bought for considerably less. The cheaper way to collect Fornasetti is to buy what the workshop is producing now, re-editions of a 1950s original. This was of a design that would be approaching six figures were it one of the older pieces, but the entry point is much lower than that.

A striking umbrella stand featuring a series of Roman heads, for example, is priced at £650 at the time of writing. If you investigate relevant auctions, you may well find pieces that are much cheaper than that. As ever, the advice is to buy the best that you can afford, but even the collector who wishes to spend as little as possible has the option to adorn his or her residence with a touch of Fornasetti, and that is by buying the series of plates in the Themes and Variations range. 'The designs of the plates were finished by Fornasetti in the 1970s and are now made in the Milan workshop by his son,' Ms Fawcett says. 'The model who features on them was chosen because she had a kind of banal beauty: striking, but at the same time able to fit into any situation. These include her features within the shape of a light bulb or as a series of baubles. They are beautiful, original and cost much.'

Other designers to look out for from the era include Aldo Tura, Franco Albini, Afra & Tobia Scarpa, Paolo Buffa, Mario Ceroli and Marco Zanuso. The German/Belgium Hans Kögl makes beautiful floral designs. In France look out for Maison

Jansen, which was founded in 1880 and lasted until 1989, and which was one of the most important furniture makers of the twentieth century (the furniture is not always signed, so you may be buying something 'in the style of'.)

Danish Modern

Danish twentieth century furniture is a very different kettle of fish from that described above. Far more austere and almost exclusively made in wood, the furniture stems from a long tradition in cabinet making that was influenced by Bauhaus and consolidated when Kaare Klint established the School of Arts and Crafts at the Royal Danish Academy of Art in 1924. After the Second World War, Denmark became an established place of excellence for furniture making. The pieces are designed to be functional, using wood, leather and metal and are designed to add colour and interest to white painted rooms. Designers to look out for include Kaare Klint, who is known as the father of modern Danish furniture, Arne Jacobsen, Hans J. Wegner, Finn Juhl, Børge Mogensen and Fritz Hansen.

Chinese furniture

Chinese furniture evolved totally separately from its western counterparts, from the end of the fourteenth century to the beginning of the twentieth, with the Ming period (1368–1644) considered its golden age. Most of the rest dates from the Qing dynasty (1644–1912). As with western antiques, provenance, age, condition and material are crucial factors to take in to account. Wood is very important when buying Chinese furniture. The pieces are made in hard and soft woods and the

two most important and collectable of the former are zitan and huanghuali – prices will reflect this. Other hardwoods include padauk and rosewood. The furniture is created using joints, not glue or nails.

Ming furniture used mainly rosewood and comprises tables, chairs and cabinets, with little inlays, carving and chasing, while Qing is mainly padauk. During the Qing period, Guangzhou-style furniture emerged, which is more decorative and influenced by western styles, such as Baroque and Rococo. It used timbers that were native to the Lingnan region, along with sculptural decoration and inlays using materials including jade, marble, ceramics and shells. Beijing-style furniture refers to that used by the Royal court and was very grand in scale. You might find pieces featuring dragons, phoenixes and tigers. Modern pieces in the same style are produced today.

Chapter 6

Collecting China

We are now in the area where everyone has a few pieces of what can be highly desirable and collectable items. After all, many people do not possess an original painting, but just about everyone will have at least a few plates. Collecting china is an extension of that and as with everything in the art world, it is a hugely diverse area and one which you might want to investigate before you decide where to concentrate. Are you interested in ancient Chinese porcelain? Early European examples? Mid-century vintage? And do you want to broaden your perspective beyond just porcelain to contain pottery and stoneware? There's a lot of choice out there, so take your pick.

China, or to be more specific in this instance, porcelain, originated in China between 2,000 to 1,200 years ago before beginning to move across Asia, and there it stayed until the eighteenth century, when Meissen in Germany became the first European porcelain manufacturer. Porcelain is divided into three categories: hard-paste, which originated in China, soft-paste, which comes from early European attempts to emulate the Chinese, and bone china, which was originally English, but is now made all over the world, including in China.

Hard paste porcelain, which is sometimes called 'true porcelain', was originally made from a compound of petuntse (rock) and kaolin (clay) and fired at a high temperature,

around 1400°c. It is now usually made from kaolin, feldspar and quartz. Soft-paste porcelain is made of a combination of materials, including clay, and, among others, ground-up glass and soapstone and while it is not as strong as hard-paste porcelain, it can be highly decorative and collectable. It is fired at 1200°c. Bone china, 'ware with a translucent body', is made of a combination of materials, including bone ash and kaolin. Originally made in England in the mid-eighteenth century, it was developed by Josiah Spode. It is the strongest of the porcelains and is now manufactured all over the world.

'The very "marks" on the bottom of a piece of rare crockery are able to throw me into a gibbering ecstasy.'

Mark Twain

Chinese porcelain

Chinese porcelain is the oldest type of porcelain and is extremely beautiful – there have been some very high-profile cases referred to earlier in this book about junk shop finds that have turned out to be priceless treasures. It is one of the most significant areas of Chinese art and also a very ancient one: Chinese pottery is even older than its porcelain and dates back to the Palaeolithic era. Do your homework and start by learning about different palettes and glazes. The Museum of East Asian Art in Bath, which I mentioned earlier in this book, is an excellent place to start and its founder, Brian McElney has written about it extensively. As with everything you buy, condition is important, so get used to handling Chinese ceramics when you are able. (The same is true of all the other

categories below.) And always remember to buy something because you love it, not as an investment.

Very loosely speaking, Chinese porcelain can be divided into three areas: that made for the Imperial court, that made for the very sophisticated Chinese market and that made for export. Start with the colour of pieces, or palette. In a guide to buying Chinese ceramics, Christie's points out that the wucai ('five colour') palette characterised the Wanli period (1573–1619), which then gave way to the famille verte palette in the seventeenth century, the Kangxi period (1662–1722), comprised of green, with lesser amounts of blue, red, yellow and black. In the 1720s, the famille rose palette was added. The eighteenth century saw the introduction of technical advances, including the glazes copper-red and flambé.

Different types of porcelain were made across the country from the kilns in the north and the south, using quite different wares and glazes. Longquan is located in the Zhejiang province in the southwest and Yaozhou is in Shaanxi province in the north. During the Song dynasty (960–1279), their kilns produced quite different pieces: the former's celadon glaze produced a bluish-green tone while the latter's appeared more olive. Laohudong and Jiaotanxia in Hanzhou, Zhejiang province housed the Guan ware kilns: they produced objects with greyish blue glazes decorated with marks that looked like fissures in jade. Blue and white ceramics, arguably the most famous and recognisable of Chinese porcelain, come from kilns in Jingdezhen in the south during the Ming dynasty (1368–1644). The Ming dynasty was also the period during which the Dehua kilns initially produced pieces with white

and cream glazes with a creamy tone, which over the next few hundred years evolved into a series of ivories and whites.

You should also be aware of underglaze. This changed within the period from the Ming to the Qing dynasty (1644–1912), with different designs being used and a different tone of cobalt blue when fired. In fifteenth century pieces, according to Christie's, there is a 'heaped and piled' effect in blue and white porcelain. This meant that the underglaze cobalt blue was concentrated in certain areas, and bubbled through the surface of the glaze to turn blue black. By the eighteenth century the texture was more even and became the norm. Blues were not always the same: in the Wanli period (1573–1619) blue and white pieces seemed to be a greyish-blue tone; in the Jiajing period (1522–1566) blue and white pieces were almost purple.

As with most china types, and more on this below, be aware of the marque, or in this case, reign mark. This will state the dynasty and name of the emperor; however, this is easy to forge. You can spend a lifetime becoming expert in the field of Chinese porcelain – but it is a lifetime well spent.

Meissen porcelain and the importance of marks

The manufacture of porcelain spread across the Far East and of course it was exported to Europe, where the increasingly competitive manufacturers struggled to unlock the secret to how to produce it themselves. This finally happened in the German city of Meissen in 1708, when Johann Friedrich Böttger, who claimed to be an alchemist, was imprisoned by Augustus the Strong (a massive porcelain fan) and told to prove it. In a way he did, because although he didn't produce the stuff you find

in the ground, he did manage to create hard-paste stoneware, the first ever properly produced in Europe, although there had been other experiments in Holland, England and Italy. (Credit must also go to Ehrenfried Walther von Tschirnhaus, a mathematician, who had been experimenting with glass and then turned to porcelain. He struck white gold, as his ingredients included kaolin, which was vital, and when he died suddenly, his recipe was handed to Böttger.)

The Meissen factory was established three years later and a decade or so later Johann Gregorius Höroldt came in from Vienna and helped to establish painting workshops, introducing beautiful overglaze colours and a brilliant palette, ushering in the classic phase of Meissen porcelain. The underglaze 'Meissen blue' followed, introduced by Friedrich August Köttig. The factory is still producing stunning china to this day. If you are in the area, nearby Dresden has a collection of it in the Zwinger museum and you can also visit the factory to learn about its history and see the early designs. Many early shapes and patterns looked Chinese, and to a lesser extent Japanese, in design, showing their Oriental influence.

Augustus was himself a massive collector and commissioned many dinner services and pieces of china, as well as selling it across Europe. Although the methods were at first a closely guarded secret, gradually and inevitably porcelain manufacture began to spread across Europe, although most of it was soft-paste porcelain. It was also around this time that Meissen began to develop its famous mark, which is featured on the back of the items, in order to protect its identity. Early experiments included AR (Augustus Rex) and

K.P.M. (Königliche Porzellan-Fabrik, literally Royal Porcelain Factory), until Meissen settled on crossed swords, the arms of the Elector of Saxony as the Arch-Marshal of the Holy Roman Empire, although there were also early variations of it.

That pattern is used to this day and the same applies to all the great porcelain manufacturers: they all have a mark on the back that is unique to them. This can be used not just to identify the date the porcelain was made, but also its quality. If a piece made in a factory is not deemed to be top quality, it can be sold anyway, but the manufacturer will often make a scratch across the mark, to signify that it is not top quality.

Meissen china remains one of the most famous names in the world of porcelain, although it was soon to be subjected to stiff competition from Sèvres, amongst others, of which more below, creating everything from tableware to massed groups of figures to figures that recurred regularly, such as the Harlequin. Names to follow include Johann Jakob Kirchner and Johann Joachim Kändler, two early modellers, although if you are lucky enough to find them, they are hugely expensive, well into six figures. Several early designs are still in production today: the Swan Service, 1737–1743, was originally made for Meissen's director Count Heinrich von Brühl, amounting to more than a thousand pieces: the originals are now in museums, but the pieces are still being made. Another famous one was Blue Onion pattern, dating from 1739 and inspired by Chinese design from the Kangxi period and still in production, alongside various dragon designs, also inspired by China, the Purple Rose pattern and the Vine-leaf pattern.

Meissen was the first top quality European porcelain manufacturer, but it certainly wasn't the last. Confusingly, some of the early pieces are known as Dresden china, as the city of Dresden is nearby, but there is a quite separate area of collecting porcelain which actually is Dresden china. It is made in a factory in Freital, which was founded in 1872. It, like everything else, has a mark, in this case SP Dresden, in blue. There are many, many other famous German porcelain manufacturers, including Nymphenburg, Villeroy & Boch, Fürstenburg, Frankenthal, Ludwigsburg, Rosenthal and many, many more, but by this time porcelain manufacture had spread across Europe and many more companies and countries were manufacturing their own white gold.

Sèvres porcelain and other French names

As Meissen porcelain began to appear throughout Europe, other countries fought hard to catch up, none more so than France. A soft paste porcelain appeared at Chantilly, St Cloud and Vincennes from 1738, the last being supported by Louis XV and Madame de Pompadour, but it was at the factory built in 1756 in Sèvres where manufacture really took off. Just as early Meissen porcelain resembled that of the Chinese, so early French porcelain resembled that of Meissen, but now there began to develop a distinct French identity. The company produced stunning wares made with bleu lapis and bleu celeste and like Meissen and all the other porcelain designers, developed its own mark. This was two interlinked Ls with a letter in between them, signifying the year the piece was made, with variations throughout the nineteenth century.

By the middle of the eighteenth century, its porcelain was considered to be the finest in Europe.

Painters and gilders were also allowed to add their own mark, which means their pieces can be identified, and also as with Meissen, there are names to look out for. They include François–Joseph Aloncle (1734–81), who painted birds, Jean-Louis Morin (active at the factory 1754–87), who painted military and marine scenes, and Étienne-Henry Le Guay (active 1748–97), a famous gilder. It is the quality of the painting, and the fact that the pieces were gilded, that made them seem so opulent and desirable. In Germany, the monarch supported the Meissen factory; in France Louis XV went on to support Sèvres and in fact ended up owning the factory. He was not the only monarch who appreciated it: over in the UK George IV also developed a taste for it and in so doing helped spread its popularity throughout Britain. Catherine the Great was another Royal fan.

The French revolution meant that a lot of the Sèvres that had belonged to the Royal family went on to the market but the factory still produces work to this day. And of course, many other porcelain manufacturers sprung up across France: they include, in no particular order, Chantilly, Villeroy-Mennecy, Rouen, Saint-Cloud, Vincennes, Limoges, Revol, Cligancourt and Nast. Some of them are also still producing pieces and there are many more modern manufacturers as well.

There is another very attractive type of French china, which is called faïence. It is actually a type of pottery using a fine tin glaze, and we'll look at pottery in more detail below, but this is worth mentioning here. Faïence actually dates back to ancient

Egypt, but it appeared in Europe in the mid-sixteenth century, first in Italy, near the town of Faenza (hence the name), then Delft and finally France. The first well-known faïence designer was Masseot Abaquesne, who worked in Rouen in the 1530s, followed by a number of centres of excellence, including Nevers, Lyon, Moustiers, Marseille, Strasbourg and Lunéville.

The south of France became known for its faïence, where it is manufactured to this day: the character of the clay, the palette of the glaze, and the style of decoration all mark it out. It is chunkier than porcelain and satisfying to hold. Some people prefer it to porcelain because of the warmth of its appearance and the richness of the colour, using gold, blue, green and white. During the eighteenth century (and now) it was also cheaper than porcelain and so more accessible to those who did not have the wealth of Louis XV.

The Chelsea and Bow porcelain factories and the development of British china

British china is now world famous, with names like Wedgwood, Royal Doulton and Royal Crown Derby known everywhere, but its origins lie in two small eighteenth century factories in London. Neither lasted long as independent operators, but both produced the earliest English porcelain. The first of these was the Chelsea Porcelain Manufactory, which was established around 1743–45 and stayed independent until 1770, when it merged with Derby Porcelain. Unsurprisingly, early pieces relied on Meissen prototypes, in the form of salt cellars in the shape of shells, for example, although the company went on to become known for its figurines.

The pieces were made of soft paste and marked, initially, with the word Chelsea. There then followed four marks, which represent the phases the company went through: the triangle period (1743–1749), when it created mainly white pieces, most notably the Goat and Bee jugs and the raised anchor period (1749–1752), its most successful period. Artists painted on a clear white surface, including Italian ruins and harbour scenes; copies were made of two Meissen services and flowers and landscapes were copied from Vincennes, which was shortly to move to Sèvres.

After this came the red anchor period (1752–1756), which reflected the influence of Japanese export porcelain, while a strong preponderance of botanical design might have stemmed from the factory's proximity to the Chelsea Physic Garden. In later years these designs were reflected in Portmeirion Pottery's Botanic Garden range. And finally there was the gold anchor period (1756–1769), in which the influence of Sèvres is very strongly felt. The pieces are very Rococo, using dark colours and lots of gilt.

On the other side of London, another factory was plying its trade. This was the Bow factory in the East End (it later relocated to New Canton in Essex) which opened in about 1747 and closed in 1776. It, too, made soft paste porcelain, and it, too, took inspiration – a polite way of putting it – from what was going on elsewhere. It based figures on Japanese Kakiemon-style and Chinese-style blue and white porcelains, it also was influenced by its rival across the city in London and it also began to copy Meissen figures. Its methods were slightly different from Chelsea's, which used slipcasting; in Bow the

artisans pressed paste into moulds. The body of the work was warm and creamy; the glaze was somewhat ivory. Most of the production was aimed at the luxury end of the market, but some was cheaper, as with its white sprigged tableware. There were large botanical styles for flat pieces and smaller European flowers on smaller pieces. Distinctive colours included green and crimson-purple.

There was never a consistent mark on Bow china, but there are names to look out for. These include George Michael Moser, who was an important figure in the English Rococo style and a founder of the Royal Academy. It is possible the sculptor John Bacon modelled for the factory. It is thought that a pair of figures made by the factory of Kitty Clive and Henry Woodward as the Fine Lady and Fine Gentleman in David Garrick's production of Lethe were the first full length portrait figures in English porcelain, dating from 1750–52.

Some figures were enamelled by William Duesbury of Derby Porcelain and the factory also adopted the new technique of transfer printing from Battersea enamels. Some figures were painted, rather than enamelled, and have not worn so well. At its height, Bow was probably the largest factory of the time, employing about 300 people, of whom 90 were painters, but as other factories began to open across the country, its fortunes began to fail and ultimately its moulds and implements were transferred to Derby. England's largest porcelain factory was no more.

But there were plenty to take its place. Royal Crown Derby (initially Derby Porcelain) started around 1750 and Royal Worcester a year later (it is not entirely clear which is the older

of the two.) Both are still producing porcelain. Worcester is one of the most popular of the eighteenth-century English porcelain: it was founded in 1751 and from then until 1783, was known as the first period or Dr Wall period, after Dr John Wall, one of its founders. That first period is the most highly prized among collectors, with tableware being a speciality. It too was influenced by Chinese and Japanese (kakiemon) ware, with coloured enamels and underglaze blue. A period followed, during which the company changed its name and marks several times, known as the Regency period, and the company ultimately became the Royal Worcester Porcelain Company.

Welsh porcelain

The brightest stars are often those that shine only briefly, and this is as true in collecting as anywhere else. Take Welsh porcelain, an exceptionally beautiful china that was produced, at its finest, for a mere seven years. Its worth was not realised at the time, but just ten years after production stopped, it was already being collected – and still is, at a price.

The story of Welsh porcelain is a simple one. 'In 1813, William Billingsley arrived in Nantgarw, South Wales, and set up a factory with his son-in-law, Samuel Walker, with £250,' said David Phillips, of Phillips Antiques, a specialist in Welsh porcelain in Pontypridd, Glamorgan. 'By January 1814 the money ran out. William Weston Young, the painter and decorator, provided a further £600 to keep the factory going, but it lasted only until September 1814.'

Intent on producing world-class porcelain, the men found a way to continue. Lewis Weston Dillwyn owned a factory in

Swansea and offered to help. So production moved to Swansea, a new kiln was created and trials started by the end of the year. Many different forms were created and were decorated either at the factory itself or in London. Artists who worked at the factory included Henry Morris, George Beddoe, Thomas Baxter, William Pollard, David Evans and Billingsley himself. In London, the china was decorated at two shops: Bradley & Co and Mortlocks. The latter, a well-known china retailer, was so impressed by the porcelain coming out of Swansea that it contracted to take every perfect piece that was produced.

The word perfect is the key here because the problem at both Swansea and Nantgarw was kiln loss – up to 90 per cent of the china manufactured collapsed in the kiln, making the factories uneconomical to run. But still the men persisted. In 1817 they moved back to Nantgarw and resumed manufacturing with £2,100 that Weston Young managed to raise from local gentry. The china was, if anything, even more exquisite than before and was bought by aristocracy and royalty.

Although made by the same people, the porcelain produced at the two factories was very different. 'In Nantgarw, it had a brilliant white sheen, which was highly translucent,' Mr Phillips says. 'In Swansea, there were 11 experiments over the years, which resulted in three main types of Swansea porcelain: glassy, duck egg (which has a green tint) and trident body, which was poor in quality and rejected by the London dealers. This contributed to the firm's collapse.'

The pieces are highly decorative. Because this was the Regency period, there were a great many floral designs. A lot of the chinaware was moulded and the moulding was decorated

in relief. While Billingsley succeeded in his quest to make some of the best porcelain ever produced, he was unable to do so at a profit. Kiln loss continued to be very high. And so, in 1820, production ceased and the brief glory days of Welsh porcelain were over.

Welsh porcelain has never been cheap. In the 1930s, when the average wage was about £5 a week, pieces of Nantgarw china were put up for auction with estimates of £80 to £100. You can find out more about William Billingsley and his creations in the National Museum in Cardiff, or its website. Some dealers specialise in these wares.

There are many more famous British porcelain manufacturers, not least Josiah Wedgewood, who also started in the eighteenth century, as did Josiah Spode.

Vintage porcelain

There are famous name manufacturers across the globe; we have only touched on the best known here. It is a matter of finding out what your tastes are, reading up on the subject and getting going. But there are other ways to collect porcelain, which costs significantly less (albeit not with the potential for capital growth), and that is by developing an eye for particular styles you like, such as blue and white china, and buying at fairs, charity shops and antique markets. This could be vintage porcelain, namely that which is 20 to 100 years old – after that it is classed as an antique. If you have done your homework, you will start to recognise particular marks (and they are by no means all expensive) and you may find a bargain. Equally, you may find something with no mark, which you like, and

although it may not be worth a fortune, it could be an attractive and decorative piece in your home. To return to blue and white china, if you collect a great deal of it, not necessarily of the same design and manufacturer, it could look extremely striking grouped together on the shelf. There are also quirky pieces, for example, jugs in the shape of faces and so on. Just try to make sure that it is in the best condition it could be.

When you are buying, trace your finger around the edge of the piece to see if there are any chips or cracks. Condition is vital. Always examine the underside. You might want to use a magnifying light to check for chips or cracks and if you're really going to go hard core, a black light or UV-A light will reveal flaws. If you are interested in a figurine check for missing toes and fingers and ask as much as you can about where the piece comes from, who made it, how old it is and any provenance, if known. (Very possibly the seller won't know themselves.) Sets tend to be better than individual pieces and rarity value will usually push up how much the piece is worth. As always, big names sell better than unknowns, and another factor when it comes to cost is who owned the piece before you. Was it a celebrity? Or a famous ceramics collector? In that case the stardust may rub off on you.

Pottery, Earthenware and Stoneware

O f course, other types of ceramics are also highly attractive and collectable and we touched on one above, in the form of faïence. Pottery is the term that covers it all (including, technically, porcelain): it is an extremely old form of art, with origins dating back to the Neolithic period. It is made by forming a ceramic (often clay) into a shape and firing it at temperatures between 600–1600°C in a pit or kiln. The pottery most of us collect today is relatively modern, but there are very ancient pieces indeed. The Gravettian culture Venus of Dolní Věstonice figurine was discovered in the Czech Republic and dates back to 29,000–25,000BC; pottery vessels were discovered in Jiangxi, China, which date back to 18,000BC; and early Neolithic and pre-Neolithic pottery artifacts have been found, in Jōmon Japan (10,500BC), the Russian Far East (14,000BC), sub-Saharan Africa (9,400BC), South America (9,000s–7,000s BC), and the Middle East (7,000s–6,000s BC). These are more for collectors of antiquities, rather than the ceramics we are looking at here.

Earthenware is a type of glazed or unglazed pottery, fired below 1,200°C, sometimes as low as 600°C, and basic types, such as terracotta, absorb liquids such as water. This is the earliest type of pottery and when early potters began to add ceramic glazes, impermeable pottery came into existence.

Stoneware is fired at around 1,100–1,200°C; it is stronger and non-porous. It first appeared in China and did not appear in Europe until the late Middle Ages. Germany was one of the best manufacturers in its early European days. It is a very tough form of pottery and made more usually for practical use than decorative, although some fine work was produced in China and Japan and even the most utilitarian pieces are now considered attractive in their own right.

There are many ways to collect pottery, from buying something on a whim seen in a junk shop to spending well into the five figures (or more) on museum-worthy pieces, but there are a few different categories that are considered to be particularly beautiful and collectable. Here are some of the some of them, some of which are made to this day.

Italian majolica

When you go to Italy today, you will see very attractive brightly coloured pottery everywhere. This is well worth a purchase for its decorative value alone and who knows? One day it might be worth a fortune (but don't count on it.) However, for something really collectable you will have to look a little further back and prepare to spend rather more (unless you have an exceptionally lucky junk shop find), in some cases into the six figures. Italian majolica actually started life as maiolica in the 1400s, named after the Spanish island of Majorca. This was exported to Italy, where it became immensely popular, and then on to France (faïence), the Netherlands and England, where it was known as delftware, and Spain as talavera. If you want to do your homework and

have the chance to travel there, the Cleveland Museum of Art has an excellent collection. Another resource is auction back catalogues: many famous collections of majolica have been sold at auction and you will be able to see the breadth of what is on offer through their websites.

Majolica is made by shaping and firing a piece of earthenware clay. A tin glaze is added, creating a white, opaque surface on to which the artist paints a design or scene. The nature of the glaze, which absorbs pigment like frescoes, makes errors impossible to fix, but it also preserves the colours beautifully and if you see pieces from this period, you will see the colours that the masters of the High Renaissance used in their painting, which have faded on the paintings, but which remain intact on the beautiful pottery.

The manufacturers used five signature colours: cobalt blue, antimony yellow, iron red, copper green and manganese purple. The works often featured historical and mythical scenes, called istoriato, literally 'painted with stories.' Other designs featured plants, animals and heraldry. Centres of excellence developed through Italy: first Florence, followed by Faenza, Montelupo, Arezzo, Siena, Bologna, Orvieto and Deruta. Arezzo has the State Museum of Medieval and Modern Art, which has a huge collection of istoriato wares. In the sixteenth century there was further production at Castel Durante, Urbino, Gubbio and Pesaro. This was, of course, a time of quite astonishing creativity in the arts in Italy and it is reflected in the work that was produced from clay.

As with porcelain, the monarchy, aristocracy and wealthy took an interest and began to collect. Eleonora Gonzaga

ordered a set for her mother, Isabella d'Este, in 1524. The King of Spain, the Grand Maître of France, and the Duke of Bavaria all built up collections and the work became so highly thought of that the artists began to sign their names on their wares. The Della Rovere Dukes of Urbino bought the work, the Medicis bought from the Fontana family, with some of their purchases now on display at the Bargello Museum in Florence.

This was the golden age of majolica, with prices to match, but it remained popular, featuring in the Great Exhibition in London's Crystal Palace in 1851 and the Philadelphia Centennial Exhibition in 1876. It suffered a brief loss of popularity in the early part of the twentieth century, but from the 1970s onwards, became very popular again, with some people believing that the bright colours and interesting forms were a welcome reaction to minimalism. There are items for every purse and a junk shop find can brighten a room quite as gladly as any museum piece.

Delft china

Delftware is made to this day, but it is the older pieces that are particularly popular for collectors. It originated in Antwerp when the Italian Guido da Savino set up a workshop in the first half of the sixteenth century, but it was in the seventeenth century that it really began to take off, when Belgian potters moved to the Netherlands to escape a Spanish invasion during the Eighty Years War.

As with Italian majolica, it was earthenware made with a tin glaze, which provided a brilliant white surface to work on. In the case of Dutch Delft china, this provided the perfect

backdrop to sumptuous blue designs, originally used to compete with similarly coloured Asian wares, although other colours were also occasionally used. The early designs were also based on Chinese ones, as with so much else in the history of china.

Across the Channel, potters also began making English Delft, or London Delft, also in the same distinctive blue. In the Netherlands, manufacture centred on the city of Delft, once the capital of Holland, where the china is still made. If you visit the Royal Dutch factory, not only can you watch the artisans working on the china, but you can have a go at painting your own piece.

Early designs were painted on tea sets (yet another Chinese influence was the fact that tea drinking was becoming popular in Europe and needed the utensils to accommodate it, just as it also had an influence on the style of furniture, as we have already seen), vases and decorative tiles, figurines and candlesticks, among others, and in the early days were not marked. Gradually more traditional Dutch scenes, for example involving windmills, or boats in full sail, came to be made, while flowers, portraits and Biblical scenes also featured. And, as with other types of china, various monarchs became connoisseurs. Queen Mary II of England arrived in The Hague in 1677 after marrying the Dutch William of Orange, the future William III, and loved Delftware so much she ordered pieces for Honselaarsdijk and Het Loo, her Dutch palaces, and Hampton Court back in England. A great lover of flowers, she did much to popularise vases among the English and Dutch aristocracy.

There are names to look out for. Harman Pietersz from Haarlem was the earliest known potter working in the field and founded a craft guild in Delft in 1611. Others were Lambertus van Eenhorn, Louwijs Fictoor, Ghisbrecht Lambrechtsz, Adriaen Pijnacker, Frederick van Frijtom, and Rochus Hoppesteyn. In the 1660s, the Dutchman John Ariens van Hamme created delftware near Lambeth, England, and other potters, including Michael Edkins, Joseph Flower and John Bowen, came to work there. Dutch potters often used initials and symbols to mark their products, though English factories typically did not.

In the heyday of Delft pottery, there were 32 factories in Delft and 12 in Rotterdam; some used marks on the bottom of their china but many did not. Of those that did, the marks would consist of letters or figurative symbols and might reveal where the object was manufactured and the name of the pottery. The golden period lasted from the late seventeenth to the early nineteenth century; the best and most sought after pieces are from then, but beautifully decorative items are made up to this day.

There are so many different and collectable types of pottery that it is impossible to list them all here, but here are a few particularly popular types.

Picasso ceramics

Yes, the great man turned his hand to earthenware, too. This pottery is massively collectable, but that is reflected in the prices: they have soared in recent years, not least through famous collectors such as Lord and Lady Attenborough. The Attenboroughs had a holiday home in France near Picasso's

studio and collected from 1954 onwards. When the collection was put up for auction at Sotheby's in November 2016, it sold (in individual lots) for more than £3 million. Wealthy collectors sometimes display their Picasso ceramics with their Picasso paintings, or at the very least, their Picasso prints. However, you can still buy pieces for the low thousands, not least as Picasso showed himself to be as prolific in this area as everywhere else.

Pablo Picasso started creating earthenware after a visit to the Vallauris annual pottery festival in 1946. He visited the Madoura ceramics workshop, where he met the owners Suzanne and Georges Ramié and started work on his own creations the following year. The collaboration with the Ramiés was to last for 25 years. Between 1947 and 1971, he designed 633 different ceramic editions and 3,500 ceramic designs, starting with simple plates and bowls, before moving on to more fantastical designs involving pictures and vases. Often the handles, or the mouth of the jug, would be designed to look like a face or part of an animal; he also began to create mythical creatures including fauns, horses and goats. Bullfighting scenes are common and he also used his second wife, Jacqueline Roque, as inspiration for the work.

When Picasso created the works, they were meant to be affordable – by this stage he was already a superstar and most people could not possibly afford an original Picasso painting – so he created editions of 500 or more to keep prices down. This, combined with the fact that he produced ceramics for over 25 years, means that there is a lot of work out there and the major auction houses often have a lot of this in their prints and multiples sales.

Ultimately, after some years of experimentation, Picasso's ceramics boiled down to two types of production: the first involved the replication of an original work by hand and the second used dry clay moulds to create original images. These pieces display the mark Empreinte originale de Picasso. Other marks include Madoura Plein Feu and Edition Picasso and they might carry an edition number, such as 45/80, or a date. The edition number can make a big difference in price, especially if it's a large edition: essentially, the earlier, the better.

Other famous artists of the day also made ceramics: Marc Chagall was one of them but as his works were made in editions, they are much more rare. Fernand Leger was another, as was Jean Cocteau, who had a studio in nearby Villefranche-sur-Mer, and created more than 300 pieces. Incidentally, do be careful not to confuse these works with ceramics created by other artists with designs on them that look vaguely similar to that of the artist. Here's a hint: if it's up for sale at £30 it's almost certainly not a Picasso!

Poole pottery

Poole pottery is a popular choice for collectors. The factory opened in Poole, Dorset in 1873, when it was called Carter's Industrial Tile Manufactory, and stayed there until 1999, when it moved to Sopers Lane. The factory closed there in 2006. Its earliest work involved architectural ceramics, including tiles and ornamental ceramics (its ceramic tiling was used in London Underground stations in the 1930s), before moving towards decorative and ornamental pottery.

In the 1920s, when the company was known as Carter, Stabler and Adams, the chief designer was Truda Carter,

with 'paintresses' interpreting the designs and adding their own touches to the handmade pieces. Other designers of note were Phoebe Stabler and Ruth Pavely. There were a number of ranges made by the pottery: Twintone, which is two-coloured tableware and was produced until 1981 and Traditional. That is the range most popular with collectors and comprises floral and animal motifs, influenced by Mediterranean styles. They also produced art deco designs.

In the 1950s, Lucien Myres became director of Poole and hired Alfred Read as chief designer. He worked with Guy Sydenham and work by the two of them is highly sought after. Others ranges produced by the company were Delphis, launched in 1963 and comprised individual pieces, Aegean, launched in the 1970s and using spray on glazes in 1970s patterns and Living Glaze, which is what the company is currently producing. The main factory is now in Middleport Pottery in Burslem, Stoke-on-Trent. The most common mark to look out for is the Dolphin mark; you should also look out for the Carter Stabler Adams mark.

Moorcroft

William Moorcroft (1872–1945), the son of a Burslem china painter and a graduate of what is now the Royal College of Art, joined the pottery company James Macintyre and Co in 1897 at the age of 24. He was astonishingly successful, so much so that he was put in charge of the company's pottery studio and soon created his first famous range, Florian Ware, inspired by Art Nouveau and decorated by hand employing a technique known as tubelining, a technique that continued to be used in all Moorcroft Pottery. He signed his work, whether fully or

with his initials, which makes it a lot easier to identify, and it is this early work that remains the most sought after. Patterns include Poppy, Hazeldene landscapes, Claremont, which has a toadstool motif, and Tudor Rose.

In 1912 Moorcroft set up his own pottery on Sandbach Road, Cobridge. Liberty & Co was his backer. Queen Mary was a fan and granted him the royal warrant in 1928. In 1935 his son Walter (1917–2002) began to work for the company, adding his own designs and taking over running the company in 1945, receiving his own royal warrant in 1946. The patterns used have always been extremely striking and colourful, even if the emphasis on different patterns changed.

There is much to choose from. In the early years, Moorcroft created plain-glazed tableware for Liberty, as with his Powder Blue range, along with patterns influenced by Art Nouveau or Arts & Crafts. while work created by father and son is extremely popular. After the Second World War, Walter introduced exotic flowers into the designs, and there was another shift in 1986, when Sally Tuffin took over the design. She introduced animals, birds and geometric patterns into the pieces. Rachel Bishop made the designs from 1993 to 1997, which was the year that saw the creation of the Moorcroft Design Studio. It produces work to this day.

Clarice Cliff

Clarice Cliff (1899–1972) produced very striking pottery, which remains hugely popular with collectors, while not being priced out of the stratosphere (although some important pieces can go well into six figures). One of seven children, Clarice was

born in Tunstall, Stoke-on-Trent, and aged 13, went to work in the potteries. Unusually for the time she moved to another factory, A. J. Wilkinson in Newportt, Burslem, because it offered her better opportunities. She learned how to model figures and vases and handpainting skills: outlining, enamelling and banding. She worked with the factory designers John Butler and Fred Ridgway and eventually her work became so outstanding that she was given her own studio in Newport Pottery in 1927.

Her success was almost immediate and these days she has some very high profile fans, including *Vogue* editor Anna Wintour and Whoopi Goldberg. Although she continued working up until the 1960s, she is most associated with Art Deco design, simple, sometimes geometric shapes, and brilliantly coloured abstract, geometric and figural shapes. Her most famous and sought after work is the Bizarre range, designed between 1928–1936 (her team of workers were known as 'the Bizarre Girls') and other patterns include Deecia, Patina, Caprice, Fantastique, and Somerhouse. Enormously striking in appearance, and instantly recognisable, her work uses colours including deep orange, yellow, blue and black. Her *The Age of Jazz* figures are also enormously popular. Her facsimile signature is on the back of the work.

Grayson Perry

Up until now I have concentrated on work that has stood the test of time: this could not yet be said of that of the potter, tapestry-maker and general eccentric Grayson Perry, who is still very much with us, but my guess is it will. Perry's very

individual work has engaged the interest of people who would not normally dream of collecting ceramics: his vases have a classical outline, but the images they display do not.

Perry was born in 1960 and is best summed up as a contemporary artist; he is also known as a cross-dresser with an alter ego known as Claire. He has had numerous solo exhibitions, with work in museums including Stedelijk Museum, Amsterdam, Tate and V&A in London and in 2003, he won the Turner prize, the first time it went to a ceramic artist.

Perry's work is clearly influenced by Greek pottery and folk art but his subject matter can be unnerving. It reflects his unhappy childhood, lack of male guidance and uses sexually explicit images. The work is highly skilled: the surfaces are complex, using techniques including, 'glazing, incision, embossing, and the use of photographic transfers,' which needs several different firings. Perry also makes large tapestries, again employing modern methods to an old art form: sketches translated using Adobe Photoshop and the tapestries woven on a computer-controlled loom. Some Grayson Perry works such as commercially produced plates start in price in the hundreds of pounds, but expect to pay thousands (many of them) for the major pieces.

Chapter 8

Set in Stone – Statuary

P ablo Picasso called sculpture 'the art of intelligence.' And who can resist a fine piece of marble, beckoning to you, or scenes carved out in limestone, or the graceful sight of a water nymph at the side of your outdoor pond? Statues have always been sought after, whether they be ancient gods or modern abstracts and as ever, it's best to find an area that suits you. It's all a matter of taste. But just to alert you: if you google 'collecting statues' a lot of comic book figures – which are indeed highly collectable – come up.

But this chapter is about what we traditionally think of as statues: internal and external figures with a tradition heading back many thousands of years. And it is surprisingly affordable: even very old works dating from antiquity can be had for just a few thousand pounds. Important statuary from the seventeenth, eighteenth and nineteenth centuries is still far cheaper than contemporary works.

Names like Henry Moore, Amedeo Modigliani and Alberto Giacometti are out of reach to all but those with the very deepest pockets – Giacometti's *L'homme au doigt* sold in 2015 for $141.3 million. Antiquities aren't always that cheap either – the *Guennol Lioness*, a 5,000-year-old Mesopotamian statue discovered near Iraq, sold for $57.2 million in 2007. And while people who collect paintings wouldn't always think of

collecting sculpture, some of the most famous art in existence is in sculpture form, starting with the *Venus of Willendorf* mentioned earlier in this book, the Terracotta Army and Michelangelo's *David*.

But there are bargains to be had. As always, start by doing your homework. Obviously many museums have extensive collections of antique statuary and that is a good start, but if you can visit artists' workshops that will start to develop your eye. Barbara Hepworth's studio in St Ives, in Cornwall, is an excellent example. Be aware that there are different issues when it comes to collecting sculpture, as opposed to flat objects, not least that they are likely to take up a lot more space than a painting, although much smaller figurines can be displayed on tables and desks and these are a good place to start, as you develop your eye. You might also want to display the statues outside, in which case bronze and stone are the best options. Statues can be very heavy, which also dictates where they should be placed.

Be aware of the different shapes available to you: classical busts and torsos, abstracts, figures and natural shapes. There are essentially four basic models of sculpture: moulded, cast, carved or assembled. Moulded sculptures are created by using clay, wax, papier mâché and plaster. Look for artists' marks on the base or the side, which may reveal the artist's name and edition size (although this is not always possible or relevant, as with antiquities) and view the work from several angles as, unlike (most) paintings, it is three-dimensional. The work might be unique or part of an edition, which also obviously has an effect on the price: during the nineteenth century it

was not uncommon for editions to run to 100, but now there are much shorter runs, usually around 12. As with paintings, provenance is important. Like paintings, statues might have been restored, although in this case you should look out for extremities that might have been broken off, such as noses, fingers and toes.

It is all down to personal taste, but here are a few popular areas and hints what to look for.

Antiquities

Collecting statues thousands of years old actually has something in common with collecting watercolours: both were popular from the seventeenth century onwards with men making the Grand Tour. As with most artworks you should start by trying to establish provenance and if you discover the statue had previously belonged to a famous Grand Tourist, that will have an effect on the price. You may also discover where and when the work came to light. The oldest of these types of works are the Cycladic idols at 5,000 years old.

Famous past collections relating to the Grand Tour were William Petty's and that of Thomas Herbert, the eighth Earl of Pembroke. Greek statues are older than Roman ones, but there are also Roman copies of Greek statues. There are a range of colours: the statues would have been carved from marble, but these could have been white, black or grey. Cypriot sculpture was carved from limestone.

When buying antiquities, you will often encounter figures displaying one of the gods, muscular heroes, sides of sarcophagi, busts of important people including emperors

and so on, but if you find a more unique and unusual image, that will carry a higher price. If you find a bust that can be identified as a specific individual, that will also push up the price. Antiquities should have signs of age: 'Spiderweb-like calcified root marks and encrustations are the most common and reliable,' according to Christie's and you should be very careful before doing any restoration work. It might actually detract from the piece.

Ancient Egypt

Tutankhamun alerted collectors to the mysteries of Ancient Egypt and while some of the items here described do not strictly belong in the chapter on statues, they slightly defy categorisation in the terms of this book. So here they are. Skip quickly to the next section if you're not interested. 'People have been fascinated by Ancient Egypt since the Battle of the Nile between Nelson and Napoleon in 1798,' said Madeleine Perridge, of the Bonhams antiquities department.

'That was when the Rosetta stone was found. French and English scholars raced to translate the hieroglyphs on the stone. Although the French won that race, the British won the battle, which is why the Rosetta stone is here, in the British Museum. However, Napoleon had a fascination for Egypt, and in France the Empire style began utilising aspects of Egyptian design, heralding the first Egyptian Revival. From there it came to the UK, and the interior designer Thomas Hope fell in love with Egypt, creating interiors using sphinxes and Pharaohs' heads. By the late 1890s the passion for all things Egyptian was stronger than ever, and when Nefertiti's head was found,

it came to define female beauty. In fact, Ancient Egypt fitted in well with Victorian sensibilities, with its ghoulishness and seances – they used to hold meetings in which they would unwrap mummies in front of the public.'

There was a further frenzy when Howard Carter discovered Tutankhamun's tomb in November 1922, and the Art Deco movement, especially jewellery, utilised Egyptian design. After decades in which all things Egyptian created a furore – further fuelled by the original Tutankhamun exhibition in the 1970s – Egyptian Revival became unfashionable around the turn of the twenty-first century, but is now on the up once more.

The Egyptians placed vast numbers of artefacts in their tombs – from everyday objects, which they believed would be needed in the afterlife, to pieces that were created especially for the tombs – with the result that an enormous amount has been preserved to the present day. The most famous of these, obviously, is Tutankhamun, and works of that quality and fame will either end up in museums or prove utterly unaffordable to most people. But there is a great deal that a more modest purse might buy.

'Egyptian antiquities really became popular among collectors in 1972, when the British Museum staged the Tutankhamun exhibition,' says James Ede, the owner of the gallery Charles Ede. 'Since then, prices for good Egyptian antiquities have appreciated by 20 to 50 times.' However, he is quick to emphasise that no one should buy these pieces as an investment, but rather as an object to be greatly loved.

Egyptian antiquities are classed from the pre-dynastic era of 3500BC until about 500BC. 'The afterlife was of paramount

importance,' Mr Ede explains. 'They would place ushabti –
meaning "answerer" - figures in their tombs to serve them in
the afterlife. Initially they would have only two, but in time
this grew until they would have had at least one for each day
of the year and then they even introduced figures of overseer
ushabti.'

Other figures might be bronzes of the deities, such as the
cat-headed goddess Bastet.

There are limestone canopic jars designed to hold the
viscera of the deceased. During mummification the heart was
left intact, while the brain was removed and destroyed. The
liver, lungs, stomach and intestines, however, were taken out
and put into the four pots. These represented the four sons of
Horus, the four points of the compass and the four protective
goddesses. Look also for faïences and amulets.

Medieval carvings

Medieval art covers a vast period, but focus on the eleventh to
the sixteenth centuries. Much of the art is religious, while its
creators are largely anonymous, considered then to be artisans
rather than artists. Not much still exists because a great deal
was destroyed by Cromwell and the Reformation, and what
was left was largely ripped out by the Victorians and replaced.
But what has survived gives a very different idea of the Middle
Ages from that commonly held today.

'Medieval art is full of compassion and, often, humour,'
says Richard Philp, a dealer in the field. 'There is a sense of
humanity in the most dreadful conditions – the fourteenth
century saw the plague and there was the 100 Years' War. But

the art does not reflect the horror. For example, the French produced gentle, feminine figures.'

Look for oak figures of saints and kings: Mr Philp once had an oak figure of Louis XII, King of France from 1468 to 1515. Carved in about 1500, it is the only surviving medieval royal portrait carved in wood. Particularly sought-after items are misericords, small carved shelves for churchgoers to lean against when standing. Stephen Foster, of A&E Foster, the dealer, says: 'The carved scenes record everyday life. There was a lot of humour involved and some scenes are very rude – you see characters pulling faces or with bums hanging out, and they also poke fun at serious figures, such as doctors who were often depicted as quacks, sometimes in the shape of monkeys holding up urine bottles.'

Renaissance bronzes

These smaller figures, meant for private contemplation and not churches and cathedrals, began to appear in Italy in the early fifteenth century, before moving northwards across Europe. Harking back to antiquity, like so much else in the Renaissance, these signified the revival of bronze statuette production and are much sought after by collectors. Many are models of the gods of antiquity despite appearing in the age of Christianity.

The statuettes were made by employing an ancient tradition involving making a model, covering it in wax and then covering that in plaster. It is fired, melting the wax, and then molten bronze is poured into the mould, which was left to cool. The artist would break off the plaster and work on the figure with

a chisel, although over time techniques were developed that allowed the artist to produce multiple figures.

Early bronzes tend to be heavier than newer ones. The patina is important: it is created by treating the bronze with oils, which create a tarnish through oxidisation. This can change over time as the bronze is handled by human hands, and red–gold Florentine bronzes from the sixteenth to eighteenth centuries are particularly desirable. Be careful not to over-polish them.

Buddhist statues

In recent years, Buddhist statues have become immensely popular as collectable ornaments, even if the collector has a somewhat tenuous grasp of what Buddhism actually stands for. The actual Buddha came from what is now the border of Nepal and India, but a lot of Buddhist statues come from China, Japan, Tibet and South East Asia. Buddhism spread along the old Silk Road and into Central Asia. All of these regions produced Buddhist statues.

There are an awful lot of fakes or cheap reproductions out there, so the best strategy is to find a reputable dealer, but there are a few tips to bear in mind. These include:

- The materials used. Bronze, stone, stucco, terracotta and lacquer were all used, although the first two are the hardiest.
- Check for inscriptions which may date them, thus adding to their worth.
- Familiarise yourself with the Buddha himself. He has been depicted in over 100 traditional poses and this

can also affect the price. These poses ('mudras') gives the statue its meaning and allows identification of the Buddhist deity.

- Handle the piece and try to note suspicious details, such as an oddly hanging piece of jewellery or a strangely folded robe. If it looks coarse and unfinished it is probably not an original.
- Provenance and condition are as important here as anywhere else.

While it is not in the remit of this book to tell you how to treat religious statuary, if you wish to treat Buddhist statues with respect, it is not the done thing to have them in the kitchen, bedroom or bathroom. Try to keep the figure at least two and a half feet off the floor and if you want to experience its positive energy, you should place it opposite your front door.

Garden statuary and other objects

Visitors to the annual Chelsea Flower Show and other keen gardeners may be interested in this area. Chelsea itself sometimes sells garden ornaments and architectural elements, and there are also specialist galleries such as the Worcestershire dealer Holloways, an online business at www.agos.co.uk You can also find specialist sales at local auction houses. Edward Holloway, owner of Holloways, says: 'The vogue for garden antiques took off in the 1980s, when Sotheby's began to hold specialist auctions.' Many people also buy through private sales.

Toby Woolley, director of furniture and works of art at Christie's, says that collectible garden antiques first appeared at

the end of the seventeenth century, when ornamental gardens were very much in vogue. The most sought-after pieces today are made of Coade stone – an artificial stone that looks like terracotta and was used in architectural moulds from 1770 to 1830. It was made by Eleanor Coade on a site that now houses the Royal Festival Hall in London.

Terracotta is a popular material. The Great Exhibition, at the Crystal Palace, London, in 1851 and an end to the tax on bricks led to a revival of interest in this medium. Look for terracotta figures, sun dials, pottery sundials, marble statues, decorative urns, and wrought iron swing seats.

Contemporary sculpture

Contemporary sculpture has been influenced by trends in the twentieth century, among them pop art, which introduced minimalism into the genre, pluralism and postmodern ideas and more recently digital technology. Materials vary, as they do in older works, but these days may include recycled material. And although there is still plenty of figurative work, there are also now many abstract designs to choose from. Henry Moore, Barbara Hepworth and Lynn Chadwick are some of the most famous sculptors of the period. Here are a few big-name contemporary artists. They are on the expensive end of the scale (very, in some cases), but are highly collectable:

Philip Jackson

A Scottish, figurative sculptor, Royal Sculptor to the Queen and an artist whose work appears in many museum collections. His work on the RAF Bomber Command Memorial won him

the 2013 Marsh Award for Excellence in Public Sculpture and he has also sculpted a number of footballers, including a six-metre tall (massively more than life size) bronze statue of Bobby Moore outside Wembley Stadium. He accepts commissions.

Jeff Koons

Very controversial and extremely expensive US artist famous for dealing with popular culture. He is famous for, among others, balloon animals produced in stainless steel with mirror-finish surfaces. Other subjects include Michael Jackson and his pet chimpanzee Bubbles. Only for collectors with very deep pockets: in 2013 *Balloon Dog (Orange)* sold for $58.4 million and in 2019 *Rabbit* went for $91.1 million, both record auction prices for a work by a living artist.

Robert Gober

An American sculptor whose work relates to the domestic and the outdoors. Initially a painter, he turned to sculpting in the 1980s and his work is to be found in a variety of museums, including The Museum of Modern Art in New York and Tate Modern in London.

Antony Gormley

A British sculptor most famous for *Angel of the North* in Gateshead in the north of England. His career kicked off in 1981 with a solo exhibition at the Whitechapel Art Gallery and almost all his work is based on the human body. Much of it is based on moulds taken from his own body.

Thomas Schütte

A German artist who had his first US solo show at the Marian Goodman Gallery in New York in 1989 and has since exhibited across the world. He has also been seen on the Fourth Plinth at Trafalgar Square. The recipient of numerous awards, including the Golden Lion at the Venice Biennale, his *Großer Geist No. 16* (2002), an eight-foot-tall sculpture of a ghostly figure, sold for $4.1 million at Phillips de Pury & Company in 2010. *Großer Geist Nr. 6* (1996), a bronze figure with green patina, fetched $5.3 million at Christie's New York in 2014.

Louise Bourgeois

The French-American sculptor, who died in 2010 at the age of 98, was well-known for her large scale sculpture and installation art (as well as painting and print making). Themes include home, family, sexuality and mortality and she is particularly well known for her portrayal of spiders, which started as two ink and charcoal drawings in 1947 and eventually grew to a series of enormous bronze and steel spiders in the 1990s.

Paul McCarthy

Based in Los Angeles, the American artist started as a painter before turning to video and sculpture. He is preoccupied with typical Americana, including Disneyland, B movies, soap operas and comics, creating comic book-like figures to represent them, and in 2014 thoroughly upset some Parisians by constructing a piece called *Tree* in the Place Vendôme which some said looked like a sex toy. It was subsequently exhibited

at Paramount Ranch 3 in the Santa Monica mountains, where it got a rather warmer reception.

Damián Ortega

This Mexican artist uses objects from everyday life, such as Volkswagens, film posters and tortillas, to make huge and spectacular sculptures and installations. He started out as a political cartoonist and it shows.

Lynda Benglis

This American sculptor is best known for her wax paintings, foam works and poured latex sculptures. She first came to prominence in the 1960s, although it was not until the 1980s that her work was properly appreciated, and she now features in collections including The Guggenheim, The Museum of Modern Art, the Whitney Museum of American Art and many more.

Tara Donovan

A Brooklyn-based American sculptor famous for large-scale installations, sculptures, drawings and prints. She achieved recognition shortly after receiving an MFA from Virginia Commonwealth University in 1999; her works identify and exploit the physical properties of mass-produced goods.

Marc Quinn

The British sculptor Marc Quinn is perhaps best known for *Self*, a self-portrait in which the artist took a silicone cast of his own head and filled it with 10 pints of his own blood. It needs to be kept frozen and a further iteration is made every five

years, representing the aging process. He also created *Alison Lapper Pregnant* for The Fourth Plinth in Trafalgar Square and his work is to be found in Tate Modern, the National Portrait Gallery and the Metropolitan Museum of Art, among others.

Rachel Whiteread

British artist Dame Rachel Whiteread was a Young British Artist and the first woman to win the Turner Prize in 1993. She is most famous for *House*, a large concrete cast of the inside of a Victorian house, the Judenplatz Holocaust Memorial in Vienna and a resin sculpture for the Fourth Plinth. Many of her works are casts of ordinary domestic objects.

Kiki Smith

The West German-born American artist was moved by her father's death in 1980 and the death of her sister from Aids to create works exploring sex, birth and regeneration. Her work includes sculptures of hearts, lungs, stomach, liver and spleen. Sculptures include *Mary Magdalene*, *Standing* and *Lilith*, in the Metropolitan Museum of Art.

Richard Serra

The American artist Richard Serra was involved in the Process Art movement. Born in 1938 in San Francisco and now based in New York, he is one of the most significant artists of his generation. His large-scale, site-specific installations can be found all over the world. He has featured in numerous major international exhibitions and has been awarded honours internationally.

Chapter 9

Collecting Collectables: Part One

Just about everything is collectable now. Be it the statues of comic book figures referred to earlier, kitchenalia from the 1950s or earlier, basketry from sub-Saharan Africa (this can be very expensive these days as not much of quality survives the harsh conditions), door mats, matchboxes – you name it and someone is going to be collecting it. The list is so long that this book cannot provide a comprehensive guide to everything, not least as it changes all the time. However, here, at least, is a guide to some particularly collectable areas. But there will always be more.

Robots

They are associated with the future, but their roots lie in the past – the eighteenth century. In about 1760 watchmakers and horologists began making the first imitation singing birds, a new style of design that led, in the Victorian era, to figures of people that could actually move. These types of automata are now the subject of interest to serious collectors, especially from Russia, with the most sought-after usually being late nineteenth-century French. 'They were made for the rich and famous,' said Arthur Lewis, a Gloucestershire-based dealer who specialised in automata. 'It was their equivalent of radio or television, an evening entertainment.

Gentlemen would collect them and invite their friends to view them after dinner.'

The greatest of the early automata manufacturers was Pierre Jaquet-Droz, who lived from 1721 to 1790. He created three figures, *the Lady Musician*, *the Draughtsman* and *the Writer*, which caused a global sensation. They toured the world, including Europe, Russia and China. He also made songbirds, fountains and musical watches, all of which now command astronomical sums.

Although clockmakers were the earliest automata manufacturers, dollmakers soon got in on the act, as they were needed to produce the shells for the amazing new machinery. 'The golden age of moving figures was from 1840 to 1910, mainly in French workshops,' says Laurence Fisher, automata expert at Bonhams, the auction house. 'They reached their peak between 1880 and 1890, and the best of them were Blaise Bontems, Gustav Vichy, Jean Marie Phalibois and Louis Renou, all French.'

The figures varied widely, but the most successful, Mr Fisher says, were those based on fantasy, such as the wonderful Pierrot serenading the Moon. Mr Fisher says: 'It was made by Vichy, and when Pierrot has finished singing, the Moon opens her eyes and smiles at him. Fantasy worked because there were no constraints. The early watchmakers tried to bring a bird to life, but while it was charming, it wasn't realistic. This didn't need to be realistic, so it could work on its own terms.'

The subject matter was varied: the figures could be snake charmers, magicians, dancers or any number of animals that inspired the creators of automata to ever greater heights.

Vichy, the son of a clockmaker, was the master of them all and his work is highly sought after now. Of course, automata were also made in Britain, although the figures tended to be more restrained. It was not unheard of for a manufacturer to come up with a singing-bird music box that was marketed in France, Britain and the US with the same tune and movement, but with differences in the box itself. The most obvious difference was that boxes designed for the US were wound up on the right-hand side, not the left, as they were in Europe.

Prices in automata vary hugely, and although they have been rising, they are not excessive. Another factor to consider is that the materials that make up the automata often have a value in themselves – many of these items were produced in gold.

Leopold Lambert is another of the great French automata makers. He started in Vichy's workshop and later married the seamstress Eugenie Maria Bourgeois, who in turn made many of the clothes for the figures.

Sporting memorabilia

Sporting memorabilia has become big business, although there is no guarantee of astonishing rises in price and anyone thinking of betting the farm on such items would be well advised to think again. But if you started collecting football programmes as a child, or any one of the numerous sport-related items on offer, you may now possess a valuable collection.

'Schoolboys have collected sports-related items, especially football, since the 1930s,' says Chris Williams, a dealer who runs Sportingold, a specialist auctioneer. 'But the World Cup in 1966 really sparked off people's interest. There were two

match programmes: one for the group games and one for the final, England v West Germany. There was also a character called World Cup Willie, whose name was on tea towels, postcards, bottles and so on, which are now highly collectible.'

Another milestone was Euro 96. 'This is when autographs began to be valuable,' Mr Davies says. 'Key items, such as anything belonging to England's 1966 World Cup football team, shot up in price. They appeal to collectors – mainly men – because these people were their childhood heroes and when they buy something relating to them, they are bringing home a little piece of their heroes.'

Of course, the field is huge and anyone thinking of investing in sporting memorabilia should proceed with caution. 'Sporting memorabilia can make an excellent investment, provided that it is selected carefully,' says Dan Davis, sporting expert at Bonhams, the auction house, which holds three sales of general sporting goods and three sales of golf-related items every year. 'You should never buy an item that was manufactured to cash in on an event, such as replica shirts which have then been signed. Instead, look for a shirt worn during a cup final or a memorable match. These are part of sporting history. For example, the ball with which Jonny Wilkinson scored the winning drop goal in the 2003 rugby World Cup would be a good item to own.'

Football is the most popular sport when it comes to memorabilia, but there are many other areas of interest. Golf has a huge following and cricket memorabilia are also highly collectible. A full set of the *Wisden Cricketers' Almanack*, the annually published bible of cricket which first appeared in 1864, would now cost £80,000 upwards, up from £10,000 a

decade ago. However, the prices of individual volumes vary hugely. For instance, the almanacks published during the First World War and the Second World War would now be worth in the high hundreds of pounds, whereas a volume dating from the late 1940s would fetch much less.

Street art

This could also come under the category of painting. Street art, which is graffiti to some and the work of genius to others, is just that: art made in public places on the street. It has two particularly famous practitioners, Banksy and Shephard Fairey, but there are many more if you search around. There are also galleries which specialise in street art and sometimes even hold workshops, such as Graffik Gallery in London.

Shepard Fairey, born in 1970 in South Carolina, and now based in Los Angeles, was one of the first street artists and shot to international fame on the back of the Obey Giant campaign and his poster for Barack Obama in 2008. Beth Gregory, of StolenSpace, which has exhibited him, says: 'Fairey is not quite a graffiti artist, as his work is not letter-based artwork, but he has taken the ethic of graffiti to create visual iconic images that are then propagated over and over again, in the way graffitists do. He uses posters, stencils and any number of different media to get the image across to more people. He understands the way our consumer society works: what he is doing is using the power of advertising, except that his is a brand without a product.'

Fairey does this with his posters adorning advertising billboards without actually advertising anything, or as he puts it,

'market nothingness'. Appropriately enough, Fairey's interest in art originated in the street. In the mid-1980s he became a devotee of skateboarding, which led him to develop a desire to create the paraphernalia that went with it. 'Skateboarding in the Eighties was do-it-yourself,' he says. 'That was what got me into making T-shirts and screenprinting. At first I cut stencils and spray-painted shirts. Then I realised my art teacher had a primitive screenprint rig in the back room. I started screenprinting shirts for myself and a couple extra for friends. You could see that in a short time in 1984–85 my whole career was beginning to form, based on that stuff.'

Fairey first made his name in 1989, when he was still at the Rhode Island School of Design, from which he graduated in 1992 with a BA in Illustration. He created a sticker campaign called 'Andre the Giant Has a Posse', which in turn evolved into a campaign called 'Obey Giant'. The images that he created were replicated across the globe and a selection can be seen on his website (www.obeygiant.com – 'Manufacturing quality dissent since 1989'), becoming, in Fairey's own words, an 'experiment in phenomenology'.

Fairey is very much an artist of his time, not confining himself to traditional canvases, but also working as a graphic designer and illustrator. In 2003 he founded the Studio Number One design agency, which produced the cover for the albums *Elephunk* and *Monkey Business*, by the Black Eyed Peas, as well as the poster for the film *Walk the Line*. He also published a book, the title of which could be said to sum up what his work is about: *Supply and Demand: The Art of Shepard Fairey*.

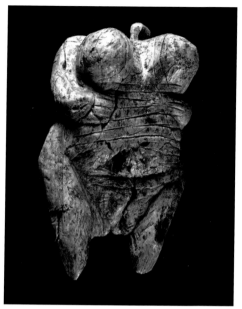

Above left: Venus Hohle Fels. *(Photo: Hilde Jensen, Copyright: University of Tübingen)*

Above right: Frank Auerbach Jake, 1990. Etching on Somerset white paper, edition of 50. Printed by Mark Balakjian and Dorothea Wight at Studio Prints, London. Published by Marlborough Graphics. *(© The Artist. Marlborough Gallery, London)*

Below: Gallery Space, Museum of East Asian Art, Bath, UK. *(© Gavin Elkins)*

Above: *London Bridge in the Rain* by Stephen Wiltshire. *(Courtesy of The Wiltshire Pad)*

Below: Jean-Baptiste Oudry, (Paris 1686–1755 Beauvais), White Greyhound. *(Image courtesy of the Didier Aaron gallery, Paris, New York, London)*

Above: Terry Frost, *The Boat*. The painting is owned and printed by Cornish Masters.com

Right: John Smart *Portraiture miniature of Mrs Russell, nee Cox,* in a bright green dress. Watercolour on ivory. *(© Philip Mould & Company)*

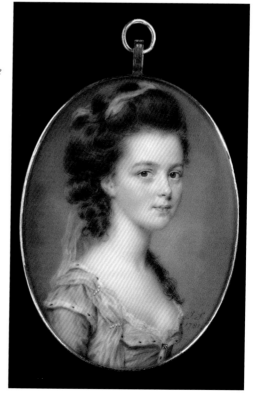

Above: Installation views of *Helmut Newton: High Gloss* at Hamiltons Gallery. *(Courtesy of the gallery)*

Below: Arts and crafts Windsor arm chairs. *(Photo courtesy of Peacock's Finest, peacocksfinest.com)*

Georgian Mahogany Linen Press eighteenth century George III period, circa 1770. *(Courtesy of S & S Timms Antiques)*

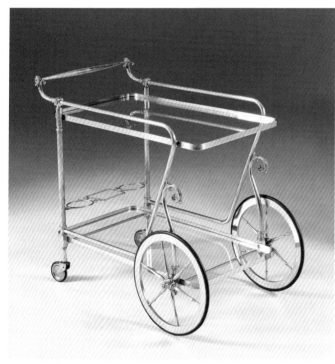

Italian 1950s brass drinks trolley. *(Courtesy of Valerie Wade)*

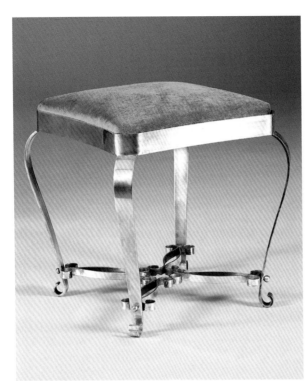

Left: 1950s Italian brass stool. *(Courtesy of Valerie Wade)*

Below: US vintage mid-century portable whiskey bar set. *(Courtesy of Valerie Wade)*

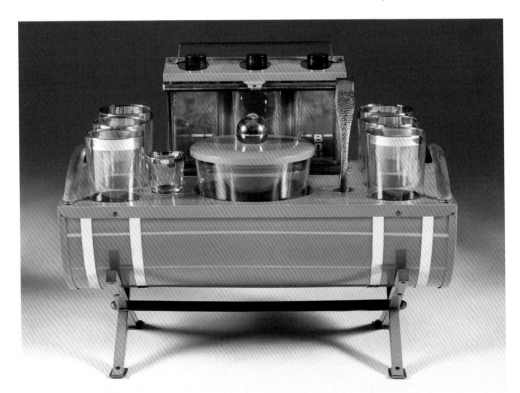

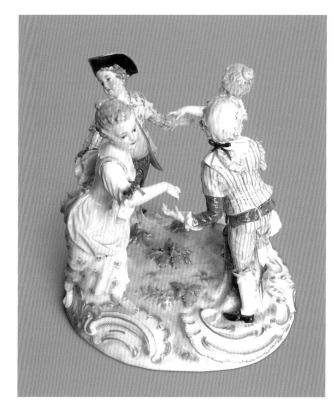

Right: A Meissen group of dancing children c. 1880 (Model by J. J. Kaendler, model year 1760). *(Courtesy of and photographed by Alexandra Alfandary Antiques)*

Below: Two painted earthenware caparisoned horses, Northern Qi period, 550–577. *(Image Copyright: Eskenazi Ltd)*

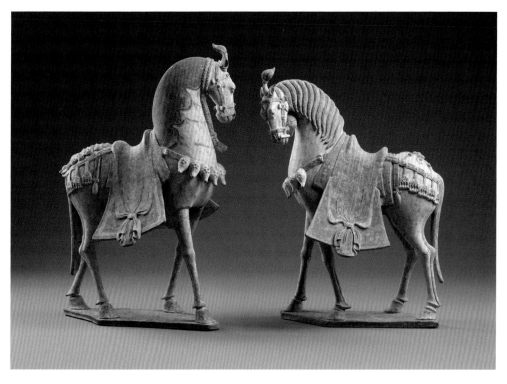

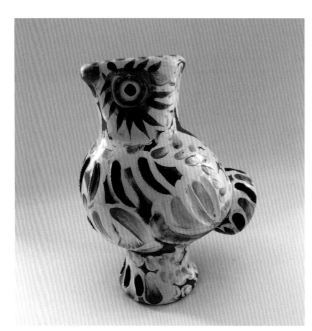

Left: Picasso ceramics, *Wood Owl* – AR 602. *(Images supplied by Ceramiques du Chateau)*

Below: An Urbino Maiolica Istoriato Tondino, c.1540–1550, probably workshop of Guido Durantino. *(Courtesy of Guest and Grey)*

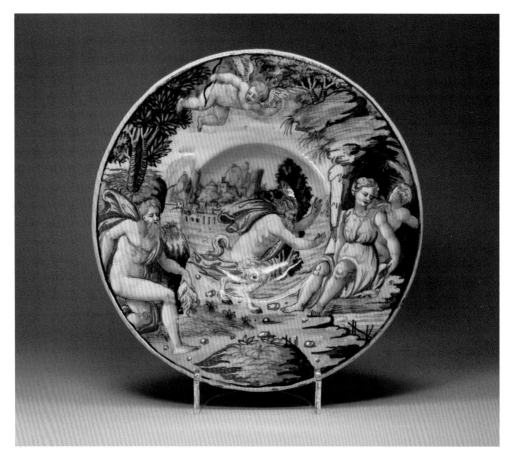

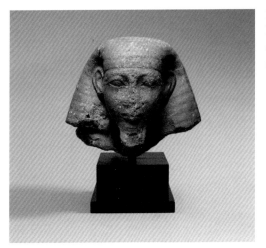

Egyptian head of Senenmut, New Kingdom, Eighteenth Dynasty, Reign of Hatshepsut, c.1500–1450bc. *(Courtesy of Charles Ede)*

The Glass Slipper by Philip Jackson. *(Courtesy of Philip Jackson)*

Interior of the Graffick Gallery. *(Courtesy of the gallery)*

Above left: A tau-shaped figurative porcelain handle, Meissen, modelled at one end as a bearded gentleman wearing a ruff and felt cap. *(Courtesy Michael German Antiques)*

Above right: A decorative silver-handled dress cane, the handle modelled as a donkey's head, with inset brown glass eyes, date c.1910. *(Courtesy Michael German Antiques)*

Above left and above right:
A one piece hazel wood Folk
Art cane, the handle carved as
a bloodhound's head, with inset
brown glass eyes, English, date
c.1880. *(Courtesy Michael German
Antiques)*

Right: A decorative enamel
handled cane, of cream & green
'candy stripes', with two bands
of applied gilt metal decoration to
the top and bottom of the handle,
English, date c.1900. *(Courtesy
Michael German Antiques)*

Left: Late Victorian astronomical refracting telescope on stand by William Wray, London. *(Courtesy of Jason Clarke Antiques)*

Below: George III cased altazimuth double telescope theodolite by Miller & Adie of Edinburgh. *(Courtesy of Jason Clarke Antiques)*

Above: Three draw telescope by Matthew Berge (Late Ramsden) owned by Horatio Stewart, 95th Rifles. *(Courtesy of Jason Clarke Antiques)*

Below: Antique silver George III snuff box made in 1810 by John Shaw of Birmingham. *(Courtesy of William Walter Antiques Ltd, The London Silver Vaults, Chancery House)*

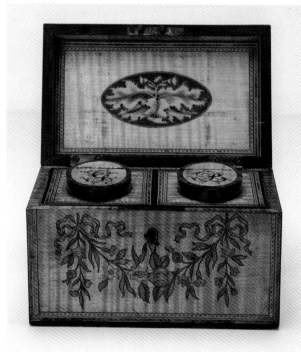

Above: George III marquetry tea caddy, kingwood banded with oval panels delineated by barber's pole stringing and inlaid with marquetry designs of flowers, cut and tied as bouquets or growing from a pot or basket. English c.1790. *(Courtesy of Walpole Antiques)*

Left: Green & Black tea caddy, sycamore inlaid to the outside with swagged and ribbon-tied roses, blackthorn ovals and a basket of flowers to the lid. English c.1790. *(Courtesy of Walpole Antiques)*

Above and below: Sailors' Valentines. *(Courtesy of Mackinnon Fine Furniture)*

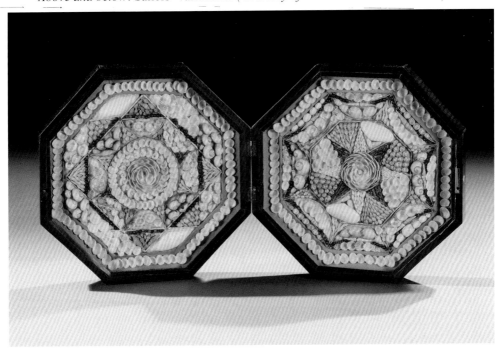

Left and below:
Sotheby's Auction.
*(Courtesy of
Sotheby's)*

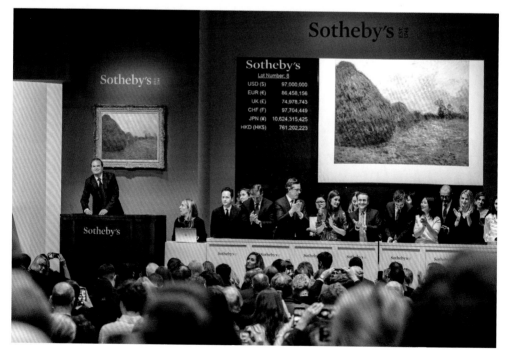

Back in Blighty, of course, we have the inestimable Banksy. Banksy was responsible for the riotously dramatic finale of a Sotheby's sale in October 2018 when *Girl with Balloon* sold for just over £1 million, only for the work to partially disappear through a shredder built into the frame. Its value promptly went up.

Banksy's identity has never been confirmed, although he is widely believed to be Robin Gunningham, from Bristol, which is where his work first came to light. He says he was inspired by the work of 3D, another street artist, and his work now adorns streets, walls, bridges and houses. He has gone far beyond his original remit, through numerous projects, including the documentary *Exit Through The Gift Shop* and his parody of Disneyland, Dismaland. If you are fortunate enough to have a Banksy on your wall, the value of your house will be boosted and it has not been unknown for people to remove the relevant brickwork and carry it off for safekeeping. Some of his work is quietly sold through an agency Banksy himself set up, called Pest Control.

Banksy's work is now too expensive for all but the wealthiest collectors, but it is an excellent way to start appreciating street art. Other well-known street artists to look out for include Cornbread, Daze, Dondi White, Tracy 168, Lady Pink and Os Gemeos.

Arms and armaments

Britain is a military nation and as such it should be no surprise that arms and armaments are a popular, if specialist, area of collecting. It is also a surprisingly accessible field. Victorian

military swords are still to be found for as little as £40 in junk shops and even ornate examples with superb workmanship sell for only a few thousand pounds. Only the rarest objects, or those associated with a particular person, command very high prices. For example, when Sotheby's held a sale to commemorate the 200th anniversary of the Battle of Trafalgar, a scimitar presented to Lord Nelson by Sultan Selim III of Turkey, as a mark of respect for his victory at the Nile, fetched £336,650, against an estimate of £60,000 to £80,000.

'There is a great deal of interest in the area, as we are all very familiar with the shapes and sights of arms and armour,' says Dominic Strickland, of Michael German Antiques, a London dealer specialising in arms and armoury. 'We all know what knights in armour used to look like and there is a level of fascination with arms. Collectors are often fascinated not only by the history, but also by the mechanics of a piece, in a similar way that a watch collector takes great interest in how a timepiece works. But what people do not realise is that it is not difficult to collect.'

David Hansord, who runs the eponymous dealership in Lincoln, agrees. 'The most sought-after pieces are those that had some historic importance,' he says. 'If a weapon was presented to a famous name, it will be extremely expensive. But the beautifully made weapons of the seventeenth and eighteenth centuries are also highly sought-after.'

One of the most popular and accessible areas in this field is Victorian military swords. The other main area of arms collectibles is guns, especially those dating from 1750 to 1850. The most desirable guns, because they were the best made and

the most efficient, are British, but European weaponry can also be extremely beautiful. Several names stand out: Joseph Manton (1760–1835) was probably the best British gunsmith, while Nicolas-Noël Boutet (1761–1833), who was gunsmith to Napoleon, held the side up for the French.

There are two types of guns that interest most collectors: flintlock guns, dating from about 1650 to 1820, and those with the later percussion mechanism, which were made from about 1818 to 1860. 'The former used a piece of flint to create a spark that ignited the powder,' says Mr Strickland. 'The latter used a little cap that already contained the charge. These were deemed to be more reliable and easier to use.'

Again, it is not an expensive field.

It is only when you start to look for rare early pieces that prices begin to escalate. For instance, the vast majority of suits of armour are likely to be Victorian copies. Good originals come to light only about once a decade, and even then they are likely to be composites – which means that although all the pieces of armour date from the same period, they did not necessarily originate from the same suit. Of these rare pieces, most date from the mid-sixteenth century and cost well into six figures.

Primal art, or tribal art

Primal art has been hugely influential on some of the greatest artists of the twentieth century, including Picasso and Matisse. The French call primal art 'les arts premiers', the first art, because it represents the earliest type of artistic endeavour and one that still exists throughout Africa and Australia. Speaking

in 2007, Clive Loveless, a London-based expert and dealer in the field, says: 'Picasso's *Les Demoiselles d'Avignon*, which has two figures inspired by African masks, is probably the best-known example of the influence of primal art and the painting marked a turning point in how the West looked at this early art form. While the French retained their fascination with it, interest tailed off in the UK about 30 years ago, when rising property prices encouraged many dealers to cash in and sell their galleries. Interest revived when interior designers began to decorate minimalist homes with primal art, and now the serious collectors are returning, too.'

The term primal art covers myriad objects, from the Australian boomerang to African spears, shields, masks and even baskets. The Tutsi in Rwanda are renowned basket-makers, weaving them into sculptured shapes, which are presented as gifts or displayed as a sign of prestige. One of the great charms of collecting primal art is that it also serves as a reminder of what the west has lost. For example, many societies have initiation ceremonies, of a type we no longer have, to mark the passing from boyhood to manhood. These ceremonies often take place in special initiation houses and require pieces, such as masks, that are of interest to collectors.

But it is African masks that are the most striking and popular.

It's a serious area for collectors: a good entry-level mask starts at about £2,000, while special pieces exceed seven figures and prices at the top end have doubled over the past decade. In December 2014 at a Sotheby's auction in Paris a Muminia mask by the Lega people of the Democratic Republic of Congo fetched €3.6million – an auction record only topped

by the 2006 sale of the Ngil mask of the Fang culture of Gabon said to have inspired Picasso, which went for $7.5million. 'The market has changed a great deal,' says Bryan Reeves, owner of gallery Tribal Gathering London and one of the founding members of Tribal Art London, the UK's only non-western art fair. 'People are increasingly picking pieces that relate visually to their interior environment and a lot more specialist dealers now sell at contemporary art shows.'

Reeves had a Chokwe mask (£5,500) from 1920s Angola, decorated with yellow pigment and unusual face markings, and a stunning 'house mask' (£12,000) from the same period in the Luba Kifwebe style, from the Democratic Republic of Congo. Used as part of ceremonial costumes for events such as weddings, funerals and initiation rites, these masks would often represent the spiritual world. 'Sometimes they depict spirits that are a cross between a human and an animal,' explains Reeves, 'and might have been worn by a chief coming to power.'

Both the rituals and the masks can be traced back to well past Paleolithic times, but most available today date from the beginning of the twentieth century onwards. The best examples come from west Africa: Mali, the Ivory Coast, Cameroon and Gabon. And since most of the countries they originate from were once French or Belgian colonies, today the market is centred around Paris and Brussels.

The most important elements to look for in a mask are provenance – forgery is rife in the market – age and expression. The unifying theme is that they are nearly always striking to look at. 'People buy them because they are dramatic and

powerful; they make very strong artistic statements,' says Alex Arthur, founder and publisher of Brussels-based *Tribal Art* magazine. 'Most are carved out of wood, although sometimes they incorporate metal, clay and stone as well as raffia, and some also feature animal or human teeth.'

Bundu helmet masks are worn by the Sande women. When the vast majority of masks were made and worn by men, these are very rare examples of ceremonial dress worn by women. (This section first published in the *Financial Times How To Spend It* magazine in 2016.)

Art Deco

Every era produces an art form that captures its essence, and the 1920s and 1930s were no exception. Art Deco was a streamlined reaction to its flowery predecessor, Art Nouveau, as well as a reflection of innovations of the time – skyscrapers, jazz-loving bob-haired flappers, and new media, such as Bakelite. This era has already been mentioned in the context of furniture but it produced much else that was collectable too.

'The two most important sculptors of the Art Deco period are the Romanian Demeter Chiparus and the German Ferdinand Preiss,' says Jeremy Morrison, head of twentieth-century design at Sotheby's. Chiparus's designs were made in three sizes and figures include dancers based on Nijinsky and Ida Rubinstein in their roles in *Scheherazade*. One of the features of the Art Deco age was the increasing numbers of women participating in sports, such as tennis and javelin throwing, and this was the inspiration for many figures by Preiss. 'They are iconic and eye-catching,' says Mr Morrison.

However, these two artists are by no means the only ones to look out for. Claire J. R. Colinet is another, alongside Bruno Zach, Paul Philippe, Marcel Bouraine, Pierre Le Faguays, Josef Lorenzl, and Professor Otto Poertzel.

Railwayana and more

The great age of the railways may be long past, but mementos live on in the shape of railwayana – objects used on the railways, such as hand lamps and level-crossing signs. Peter Rixon, head of the collectors' department at Dreweatt Neate, says: 'Railwayana is separated into three periods. In the period until 1923 lots of little railways crossed the country, some merely a single line joining two places. Between 1923 and 1947 the four great railway companies existed: the Great Western Railway (GWR), the Southern Railway (SR), the London, Midland and Scottish Railway (LMSR) and the London and North Eastern Railway (LNER). The third period is from 1947, when the railways were nationalised, to the present.'

There is a market for modern railwayana, but the most sought-after items are those from before 1923. Just about everything that was connected with trains is collectible, and not just by railway enthusiasts. For example, railway posters, which were often designed by famous artists, are popular with train buffs and poster collectors. Even door handles garner interest because the big four companies would stamp them with their initials. Collecting railwayana need not be an expensive hobby, with much starting at less than £100.

However, serious money is involved when it comes to brass locomotive nameplates. 'These are rare,' Mr Rixon

says. 'All locomotives operated by a particular company had numbers, but only the more prestigious had names. There would be two nameplates, on either side of the carriage, as well as a plate with a cab door number and a plate with a number that went on the smoke box at the front. It is rare to find a complete set of nameplates and cab door and smoke box number plates – and they are very expensive.'

Indeed, they were expensive from the start. Nameplates became collectible in the early 1960s, as the era of steam ended and the trains were scrapped. British Rail, which by then ran the railways, realised that it had a commercial opportunity on its hands and began selling off the plates for about £15, sometimes to railway workers, who kept them and then sold them off at quite a profit. If they include the cab door number, the value goes up.

There is also a market for items connected with the London Underground (slightly to the bemusement of anyone who regularly takes the tube). Decommissioned trains have yielded up seat fabric, while station tiles and phone handsets are popular. The London Transport Museum has sold off items in the past, including Metropolitan Line luggage racks dating back to the 1960s. Of all the strange things, lift buttons are particularly popular: apparently the museum has sold 1,053 lift buttons at the time of writing to the tune of £26,325. That's not all: overground train drivers' seats were to be had for £375 each and over 3,500 luggage racks have fetched £355,500. However, wait until the relevant items are decommissioned: you could find yourself in hot water by trading in matters currently in use.

Airline memorabilia is also popular: some years ago British Airways sold off some surplus stock including William Edwards plates, bread baskets and towels. Go on eBay or Etsy and you will see a roaring trade in china, cutlery, glassware, uniforms and much more relating to your airline of choice. There is also a market in vintage BOAC items and, in a sign of the times, airline masks.

Kitchenalia

Britain is obsessed by all things culinary, if our devotion to celebrity chefs is anything to go by. A knock-on effect, perhaps, has been the growth in popularity of kitchen antiques, or kitchenalia. Items such as a Dover whisk (hand whisk) can be exceedingly popular.

Skip Smithson, of Smithson Antiques, says: 'Kitchen implements as we know them today started in the Georgian period, but it was the Victorian era that really kicked them off. Victorian houses had huge kitchens with vast numbers of staff and they needed implements to cook with.' And so came the era of copper stewpots, cast-iron tea kettles, peelers, graters, knives, flummery (blancmange) moulds, sugar nips (tongs), pastry cutters, spice columns, coffee mills, pepper mills, water pitchers, potato mashers, meat tenderisers, ice scoops, porridge spurtles (stirrers), oak thibles (spatulas), brass weights, egg cutters, cucumber slicers, colanders, butter markers, ham stands, mixing bowls and jelly moulds.

Mr Smithson adds: 'Kitchenalia became collectible in the 1970s, as kitchens became more streamlined. Until then many kitchen implements were used daily and it was only

when they were no longer needed in new kitchens that it occurred to people to collect them. People also realised that an old set of scales or kitchen jars could be used as attractive decorative items.' Items include sweet-making machines from sweet shops, corkscrews, bread-makers, butter moulds, sometimes with illustrations that are imprinted in the butter, and breadboards. And not only are these pieces collectable, but they are still sometimes functional, too.

Pocket watches

Boys' toys are nothing new and the pocket watch is a case in point, although there is a crossover here with collecting jewellery, an area this book is not going to tackle as it is another area of collecting altogether. And pocket watches are a distinct category from more mainstream wrist watches. As soon as they appeared in the late sixteenth century manufacturers sought to add more functions and make them increasingly ornate. As a result these timepieces are now highly collectible.

At the top of the range, the most expensive pocket watch sold was a Patek Philippe Henry Graves Supercomplication, fetching US$23.98 million (23,237,000 CHF) in Geneva on 11 November 2014, but far more affordable models frequently come on the market. 'The earliest pocket watches appeared in 1570, but they were treasured and few people had them,' says Paul Maudsley, director of watches at Bonhams. 'By the 1640s and 1650s more people owned them and 1690 to 1700 brought the production of some of the finest ever made. The first watches were made in Germany, but by 1650 production had moved to England and France. From the 1690s to about

1870 Britain made the best pocket watches, after which mass production began in the United States.'

Pocket watches continued to be manufactured until the 1950s – although wrist watches had become popular during the First World War – and are now collected for a variety of reasons, appealing to collectors of, say, nautical items or relating to particular eras. Inscriptions and pictures can also boost their appeal. Mr Maudsley says: 'You see many depictions of farewell or welcome, as well as scenes of men in front of pubs waiting for their ships to come in. Other motifs are farming and railway viaducts.'

There are also masonic watches, musical watches, watches with star charts – almost every conceivable design has found its way on to a pocket watch. And their great charm is that they are a direct link with the past, not just visually, but audibly. 'What makes them so individual, is that you will hear the same ticking sound the watch made when it was first produced all those years ago,' Mr Maudsley says.

Chess

Has there ever been a more fascinating game than chess? Classed variously as an art, a science and an entertainment, the game is thousands of years old and chess sets are now highly collectible. And television series such as *The Queen's Gambit* has enhanced interest in the era still more.

'Chess is thought to have originated up to 5,000 years ago in India,' says Gerry Berwyn-Jones, Bonhams' chess specialist. 'This early form was called chaturanga, but it was played by four people, each of whom had a king, a rook, a knight, a

bishop and four pawns. It wasn't until the second period (the sixth to sixteenth centuries) that the game was played by two players, each using sixteen pieces.'

Chess spread initially from India to Persia and then throughout the world. It began as a war strategy game, and by medieval times – when it was being played throughout Europe – wagers would be placed on the outcome, causing the Church to view it with a disapproving eye. King Canute was said to have played chess, and there have been rare finds relating to chess throughout the years: the British Museum, for example, owns the famous Lewis chessmen, a set probably made in Norway in about 1150–1200. Fashioned out of walrus ivory and teeth, the pieces were found near Uig, on the Isle of Lewis, off the coast of Scotland, but no one knows exactly where they came from or why they were hidden.

Chess was initially the game of kings throughout Europe, but later spread to café society, where the middle classes began to play the game. One particular aficionado was Samuel Pepys. When he arrived in Cambridge in 1650, he discovered the university had banned cards and dice, and discouraged football, but was enthusiastic about chess, which the university authorities felt to be well suited to academic life. Pepys become well known for his love of chess, so much so that James II presented him with a set made of viridian and natural ivory pieces. It is now in the Museum of London, but copies were made, which are now rare and highly collectible – one sold at Bonhams for £3,643.

These days, sets made before the nineteenth century are rare and, although not necessarily in the best condition, can

be highly sought after, with prices to match. Most collectors, however, will be looking to acquire pieces from that period onward.

Perhaps the most famous chess manufacturer in Britain was John Jaques who, in 1847, produced the Staunton design, named after Howard Staunton, then the world's leading player. It was popular and is the template for sets to this day. Other names to look out for include George Merrifield, John Calvert and William Lund.

Chess sets have been made in almost every imaginable material – one-off English silver sets exist, for example, but are rare and expensive – with myriad designs for the pieces. They are also within the reach of most collectors, as some can be a couple of hundred pounds or less – although equally, when it comes to rare sets, the sky is the limit.

Mapula embroidery

Mapula (meaning mother of rain) embroideries from the northwest of South Africa, were originally the products of crafts workshops set up to help disadvantaged women in 1991. Since then they have become world-famous. The Queen has one, which was presented to her in 1999, South African Airways has a collection and Oprah Winfrey was fortunate enough to be able to buy them as decorative pieces for her girls' school in South Africa.

Initially they only produced small pieces to sell at craft fairs, but the work soon began to attract international attention. Their breakthrough came in 1996 at the Embroidered Impressions event on the Greek island of Naxos. It was for this that they

first started making the large cloths that are now so sought-after. Most striking are the huge tapestries, usually brightly coloured figures against a black background, illustrating everything from scenes of local life to international events.

'A lot of the work appears primitive in style, but that, and the subject matter, is what makes them truly African,' says dealer Julian Machin. 'The women mainly tackle autobiographical subjects with honesty and a lack of irony that almost gives them a childlike quality.'

They are certainly joyous, with a celebratory quality. But given the quality of the work, they are still not overly expensive – and how often does an opportunity come up to invest in internationally recognised art and help the disadvantaged at the same time?

Wine accessories

In Britain such is our appreciation of wine that accessories to enhance the ritual of drinking it have proliferated. Claret jugs, corkscrews and wine labels are just a few of the many types of silver and glassware that are now highly collectable, too.

'England has always been the centre of the production of wine accessories and the UK is still the largest importer of wine in the world,' says Robin Butler, a dealer in wine-related antiques and author of *The Book of Wine Antiques*. 'As we did not actually produce very much of it, instead we created wonderful accessories with which to enjoy it.'

Petworth dealer Nicholas Shaw, says: 'While wine itself has been around for at least 5,000 years, it is about 300 years ago that the now highly collectible wine-related ephemera

began to appear. The first wine labels are hugely popular with collectors.'

These labels are the predecessors of the modern paper label. The earliest were made in parchment, bone, wood or ivory and hung by a chain about the neck of the bottle. Later, from about 1740, wine labels tended to be silver. They would differentiate between the bottles of wine typically found in well-stocked households – namely, claret, port, madeira and sherry.

'There is a huge variety of shapes, sizes, names and decorations – at least 2,000 to 3,000 different examples,' Mr Shaw says. 'For example, a label in the Georgian style will be relatively simple, whereas a Regency one will be much more ornately decorated with motifs, such as shells.'

Another highly collectible wine-related antique is the corkscrew. Originally, they were known as bottlescrews and the first patent for one was issued to the Rev. Samuel Henshall in 1795. In 1802 Sir Edward Thomason patented a new variety, the double-action corkscrew. He was not alone; by the turn of the last century, more than 300 patents for corkscrews existed in England alone. 'There is a vast array of corkscrews and collectors want to buy something no one else has,' Mr Shaw says.

Silver wine labels were used for claret, port, madeira and sherry and many wine-related antiques are still usable today, glassware particularly so. 'In the early eighteenth century the first wine bottles that could be stored on their side appeared, giving rise to the whole new area of glass,' Mr Butler says. 'Probably the best-known example is the claret jug. These were initially solid silver, but from the 1830s they were made of glass and silver, usually cut glass and often green or burgundy.'

Mr Shaw adds: 'The best period for claret jugs is 1836 to 1850. Even today these are a must-have accessory for many a dining room.' For the serious wine collector, these are only a few of the areas to explore. Wine coasters, which held decanters, also attract attention. Originating from about 1760, most come in pairs, made of wood and silver. Others items include decanters, funnels, punch bowls and wine coolers, but the variety is vast. Mr Butler, for example, sold a 'gentleman's social table', or wine table, made in 1795 to the 1793 design of George Hepplewhite. He also had a magnum Hodgett's decanter in its original stand from 1805.

Embroidery

The world of antiques turns up many anomalies and one of the most surprising is that what was once the handiwork of the leisured classes is now highly collectible in its own right. Well-bred young women were, for centuries, expected to be accomplished embroiderers and so channelled their energies into samplers, stumpwork – raised embroidery – and embroidered pictures that were used to show off their talents to prospective husbands. Popular with collectors for some time, these items now fetch hundreds, if not thousands, of pounds, especially work from the seventeenth century, considered to be the golden age of the sampler.

'Samplers first appeared in the late sixteenth century and were made all over Europe,' says Marilyn Garrow, a dealer who runs Fine Textile Art in Suffolk. 'The Spanish took the art to Mexico and later it appeared in the US, where samplers now command phenomenal prices. They were made by non-

professional affluent women, using costly linens and silks.'
An exception to that rule is samplers made in orphanages or
almshouses, in which the children would be taught how to sew.
This is an area of interest in its own right, with some collectors
looking for work from different institutions.

Samplers are, literally, samples of different stitches,
sometimes in beautiful and ornate patterns. Artists would
travel from one grand house to the next, drawing a design
on the cloth that the young women would then embroider.
Another source of patterns was the relatively new phenomenon
of publishing, particularly botanical drawings, which the
women would lift straight from the books to use as designs.
Other preoccupations include travel, especially China, with
incidences of Oriental gentlemen (or the women's idea of
Oriental gentlemen) appearing in the work.

In the seventeenth century various types of samplers
emerged. A ribbon sampler was a long strip of material in
which each row would feature a different style of embroidery.
Then there were darning samplers, featuring different darning
techniques. Stumpwork from this period is also highly
collectible and usually features scenes taken from the Bible.
A sampler would usually feature its maker's name, the date
and the age she was when she made it.

When collecting embroidery, condition is of paramount
importance. A sampler in poor condition might be worth a
couple of hundred pounds, but one in excellent condition,
especially an early piece, could fetch tens of thousands of
pounds.

Collecting Collectables: Part Two

Toy trains

The first toy trains appeared in the 1850s, but they have never lost their appeal and the market is still going strong today. 'The toy train market was among the first areas that collectors became enthusiastic about when toys generally became collectible in the 1960s and they have established a consistently strong performance since then,' says Hugo Marsh, of Christie's.

Hornby and Bassett-Lowke are the two best-known manufacturers, with Hornby producing a great deal more than its rival. However, other companies, such as Märklin, of Germany, are also popular. When collectors first turned their attention to toy trains it was possible to get in at pocket-money level. That is no longer the case and any model worth having will start in the hundreds of pounds. While prices in the mid-market have remained stable for about five years, the very rare pieces continue to rise in price and can go for tens of thousands of pounds.

Sometimes the toys reveal something about the social history of the time. In the mid-1930s there was intense rivalry between the LMS and LNER companies for travellers on the London to Scotland route. Both sought to create the most

streamlined locomotive possible and a handmade model of one made by LMS sold at Christie's some years back.

Mystery clocks

With hands apparently magically suspended in space, Cartier 'mystery clocks' are mesmerising and the very best ones extremely rare. 'The first mystery clock was made in 1913 by one of Cartier's suppliers, Maurice Couet,' says James Stratton, clocks expert at Bonhams. 'Inspired by the clocks of the French magician and clockmaker Jean Eugene Robert-Houdin – in which the hands appeared to be suspended in mid-air – Couet made his clocks from blocks of rock crystal with the movement hidden in the base.'

This first series of mystery clocks was called Model A – an amusing comparison to the mass-produced Model T Ford introduced a few years earlier. Only 60 are known to exist today. Unusually, given that they cost a fortune at the time of manufacture, just as they do now, they were not special commissions but were made for stock. Nevertheless, they sold almost immediately they were put on the shelves. The first was bought by J. P. Morgan Jr, the American financier.

The First World War brought a temporary cessation to their manufacture, but in 1922 the clocks started to reappear. And in a reflection of the *Zeitgeist* – the rise of Art Deco, exoticism and general fascination with the East – these clocks utilised the likes of scarab brooches and Egyptian faïence as the centrepieces of their designs.

Louis Cartier, the head of the Paris boutique, had a huge collection of Eastern pieces and it is possible that some of

them may have been utilised in the making of the clocks. For instance, one Cartier mystery clock from that period has a jade mandarin duck as its centre, while others incorporated elephants and chimeras.

The final series of the clocks is known as the portico series, in which the clock is suspended from the frame. Only six are known to exist today.

Whitefriars glass

How fashions change. Sixty-five years ago Whitefriars was one of the best-known names in English glassmaking. But it is only since two exhibitions in 1995, along with two books about the manufacturer, that interest has been rekindled in the work produced at its London factories. Work from the 1930s to the 1970s was created under William Wilson, one of the twentieth century's greatest English glassmakers.

'Wilson started in Whitefriars' Wigmore Street establishment at the age of 14 as an errand boy,' says William Clegg, co-owner of The Country Seat, a dealer, now closed, which sold the glass. 'But his boss, James Hogan, spotted his talent for drawing and writing and sent him to study calligraphy in the evenings. He did lettering on stained-glass windows, learnt diamond-point engraving and, when the firm moved to Harrow, he began to design glass.'

After the death of James Hogan in 1948, Wilson became chief designer and then managing director of Whitefriars, a post he held until 1972. He introduced many innovations – richly coloured Art Deco designs of the war years, aimed at the southern hemisphere because the domestic market had

dried up, and what was known as a Scandinavian aesthetic, incorporating colours such as arctic blue.

Some of his greatest designs came after the war, collaborating with Bernard Fitch in cut-glass design and with Harry Dyer in a range of heavy blown glass that 'cased' one colour within another.

Despite the company's fame, Mr Clegg says that the work was the 'Cinderella of glass collecting'. That is until two exhibitions a couple of decades ago at Manchester City Art Gallery and the Museum of London, which also produced a book about the glass. At the same time *Whitefriars Glass* was published by Lesley Jackson. Since then prices have risen fourfold, and in some cases tenfold.

Canes

Canes were, for a period of at least three centuries, as crucial a part of the male wardrobe as a pair of trousers is now. Indeed, men were likely to have several canes, to be used on different occasions – whether at the office, going out in the evening and at the weekends. They were carried, not as a walking stick or 'perambulatory aid', as the dealer Geoffrey Breeze puts it, but as an ornament and an indication of the owner's wealth and status.

'Canes originated out of the male psyche, which associates carrying a stick with power,' says Mr Breeze, who specialises in antique canes. 'Kings carry sceptres, Black Rod carries a rod, Merlin carried a wand and Moses used a staff to part the waves. And in the seventeenth century, when men had just put down their swords, they started carrying canes,' Mr Breeze says.

They continued to do so until the 1940s, when, sadly, they seemed to lay down their canes. But until then, some spectacular and unusual canes were produced, which now cost between £500 and £5,000. They could be classified into categories, for example: defence canes that contained hidden swords or blades; automaton canes that had heads that moved at the touch of a secret button; marine canes, made by sailors, frequently using whalebone; and folk art canes, carved and used by shepherds and farmers.

'When canes first appeared, in about 1650, the most common was the ivory-handled Malacca cane, the wood of which came from the Strait of Malacca in Malaysia,' he says. 'The wood would have been brought back to Britain as an exotic item, the equivalent now of buying something from the moon. The early canes had long brass fennels to protect the wood against being dunked in the mud, while the handles were ivory with silver-piqué work. These cost in the low thousands now.'

By 1700, men and their canes were being dandified. The wood was the same, but the handles were often gold and decorated with tassels. Men would pose with them, rather than swing them around. Such canes can be found in Gainsborough portraits. Then came the Victorian age and the Industrial Revolution, in which the newly rich middle class would display their wealth through an extensive collection of highly decorative canes.

Cane factories opened all over Europe: in London, Paris and Vienna. The handles, meanwhile, became increasingly idiosyncratic. Many had animal heads, including mice, eagles and a variety of dog breeds. Increasingly exotic materials were used as decoration, such as jade or amber, and this continued

until the Art Deco period, which produced some of the most spectacular canes of all.

'A gentleman would have a number of canes,' Mr Breeze says. 'There would be a rustic cane, perhaps made of a stout wood such as ash, for walking the dogs on Hampstead Heath, and a more sober cane for the office. Then, for going to dinner and to the opera, a man would carry a lighter cane with a shaft made of an exotic wood, perhaps rosewood, with a gorgeous handle made out of something such as tortoise shell. Whoever you were, there was a cane for you. If you were a duke, there were canes that reflected your status in the richness of the wood. Peasants would carve their own canes and illustrate them with country pursuits, such as shooting, fishing and hunting. Sailors would use whalebone with whale teeth for the handles. Ebony and ivory, transported to Britain from the colonies, also ended up on canes.' Some of these canes had additional functions. For example, defence canes could turn into a sword or a mace at the click of a button.

There were also canes that could turn into umbrellas or could entertain. For example, automaton canes in the form of a duck's head or a bulldog, cunningly designed so that the mouth could open to hold gloves while the owner was at the opera. Canes could turn into candles, cigarette cases and lighters and pipes. There were canes for all occasions. It is a great pity that they are no longer seen on the street.

Norwegian enamels

Glittering like jewels and a stunning example of Scandinavian design, Norwegian enamels are highly collectable and

desirable at every level, ranging in price from a few thousand pounds to eye watering amounts. Their heyday was just over a century ago, when the Viking revival craze swept Norway, which resulted in the creation of some of the finest enamel work ever made. Traditional Nordic subject matter such as Viking boats, horse heads and dragon motifs all featured in the designs, alongside flowers and other more universal themes. Norway has long had a reputation as one of the best enamel manufacturers in the world and as the Viking revival coincided with the advent of Art Nouveau, Norwegian manufacturers fused these two traditions to produce stunning work.

'Norwegian enamel from that period is unique and exceptional,' says John Atzbach, an expert and dealer in both Norwegian and Russian enamel, based in Redmond, Washington. 'The two most proficient manufacturers were Marius Hammer in Bergen and David Andersen in Christiania [now Oslo] and both produced the largest number of objects of very high quality. The very best work stems from 1885–1915 and they were exporting across Europe, catering to the elite.'

Enamel is essentially the process of fusing glass to metal via heat and a kiln and Norwegian expertise is in part due to its next door neighbour Russia. 'Culturally the two countries are very connected,' says Michael James of The Silver Fund. 'A lot of Norwegian enamellers trained in Russia and many worked for Fabergé. The colours they employed were vibrant blues, reds and yellows and the work they made was unusual in that previously no one thought to make candlesticks or coffee sets out of enamel as it can chip. It was very refined to make beautiful household objects out of enamel.'

Dr Widar Halén is Director of decorative arts and design at The National Museum of Art, Architecture and Design in Oslo. 'Norway has a strong filigree tradition that goes back to the Vikings,' and which is the basis of the renewal of enamelling in Norway, he says. 'The very finest work is termed plique-a-jour, literally 'letting in daylight,' which was a tour de force. When it was exhibited in Paris in the 1900s it was compared to Fabergé. There was a large international market and in those days people went to northern Europe on holiday – the British liked to go salmon fishing – and they would bring the pieces back as souvenirs.'

Collectable items can date from a slightly later period. One technique is known as Guilloche work. 'The manufacturers would create a stippled effect on the silver underneath the enamel,' says Michael James. 'The silver becomes oxidised under the enamel, which is itself translucent, so you can see the pattern.' (This section first published in the *Financial Times How To Spend It* magazine in 2016.)

Chocolate

No, not the actual edible substance, but the paraphernalia connected with drinking chocolate, which was hugely popular at one point. At the beginning of the sixteenth century drinking chocolate was introduced to Britain along with the culture of the coffee houses, where people discussed the issues of the day over a cup of cocoa. A selection of special chocolate pots and cups were used for the drink, which are now highly collectible.

Chocolate, or xocolatl, was discovered by the ancient Aztec and Mayan cultures, which thought, understandably, that the

cocoa plant was brought to earth from paradise. Chocolate was not introduced to Europe until a few thousand years later, but its arrival spawned the related paraphernalia that is now highly prized by collectors. 'Chocolate originally came from Mexico to Spain in the sixteenth century,' says Catherine Hunt, of Catherine Hunt Antiques in Cheltenham, a ceramics specialist. 'Monks had held the secret of how to process the cocoa bean for nearly 100 years, but then the secret got out and spread across Europe, reaching Britain by about 1660 to 1670.'

The drink, which quickly became popular, demanded a new type of crockery. Chocolate, like tea and coffee – introduced into Europe at about the same time – was a hot drink, something hitherto unknown. And so it required a pot for keeping it warm and serving it and a cup that would also keep it warm without scalding the drinker. The porcelain manufacturers of China, where tea had been drunk for centuries, saw a commercial opportunity and began making pots and cups for the newly popular drinks. Chocolate cups tended to be taller and straighter than those for tea and coffee and some had lids.

This coincided with the beginning of the manufacture of European porcelain, which based many early designs on the Chinese until, eventually, chocolate pots and cups became a European enterprise, with the Chinese input dwindling. Although the chocolate houses closed down hundreds of years ago, chocolate pots and cups were still being produced by the great European porcelain manufacturers into the early decades of the last century.

Chocolate-related collectibles are not only to be found in porcelain: silver spoons and wooden boxes are also popular. But

the china is particularly pleasing. As Chinese and European manufacturers became increasingly skilful, the porcelain was of such quality that it was almost translucent. The decoration is beautiful, too – fitting for what is, after all, the drink of Mexican gods.

Suffragette jewellery

As its name suggests, suffragette jewellery first appeared in the 1890s when it was worn by campaigners for women's right to vote. It was produced until 1918, when the first women were enfranchised. Suffragette jewellery is primarily made with green, white and violet stones, signifying 'give women votes'. But the stones have further meanings: green stood for hope, white for purity and violet for dignity. They might have looked like pretty pieces of jewellery, but the pieces were the expression of a desire to overturn the established mores of a society.

Lynn Lindsay, of Wimpole Antiques, says that women began wearing jewellery in these colours when the suffragette movement was banned. 'They wanted to be able to identify others who had similar political aspirations.' She says that cheaper pink tourmalines were sometimes used instead of violet amethysts, but the usual combination was amethyst, peridot (green) and pearl.

The jewellery was not cheap, so it tended to be worn by the upper-middle classes. Nor is it clear whether the jewellers of the time understood the true nature of their commissions: many might have believed that they were simply making fashion pieces. The women's maids wanted to achieve a similar look to their mistresses so wore jewellery in the same colour

combination. These pieces, made with paste stones, are also collectible, but at a fraction of the price.

Suffragette jewellery was relatively ignored until around the turn of the last century, when collectors began to realise the true meaning of the pieces. Interest intensified in the early years of the twenty-first century, when Judy Rosenbloom did a series of lectures in the US about the jewellery, based on *The Purple, White and Green*, a book by Diane Atkinson about suffragettes in London. A 2004 television film about American suffragettes, *Iron Jawed Angels*, also boosted awareness. Prices have since soared.

As ever, there is no guarantee that prices will rise, so buy only if you like what you see. But even today there is a certain enjoyment to be had from a piece of suffragette jewellery: these lovely feminine items are relics of an era in which women finally took charge of their own destiny.

Dry bars

The second half of the twentieth century saw a seismic change in the way people lived: gone were many of the large estates and grand mansions and in their place came living on a smaller scale in houses and flats. This had a direct effect on the furniture that was produced, no more so than when it came to cocktail cabinets, or dry bars, some of the best of which were produced in mid-century Italy and have recently seen a huge revival in demand.

'It was a time when people were living in smaller apartments and wanted to hold cocktail parties, but no longer had servants to help,' says Holly Johnson, of the eponymous Macclesfield-based dealer. 'The Italian designers led the way, taking over

from the French Art Deco period, creating mid-century Italian design. The biggest names were Aldo Tura, Piero Fornasetti, Geo Ponti, Osvaldo Borsani and Paulo Buffa.'

There were also some very noteworthy American designers as cocktails took off in a big way in the United States. 'Norman Bel Geddes designed the Manhattan cocktail set, which was inspired by the skyline of Manhattan and was part of a bigger interest in cocktail tables and cabinets,' says Dominic Bradbury, author of *Mid-Century Modern Complete*. 'It was an evolving lifestyle connected to changes in design. In the mid-century, there was a playful, more informal element to the cabinets but they are good fun enduring pieces which were incredibly well designed.'

Gary Rubinstein, a Florida-based antiques dealer, agrees. 'Around the mid-century, cocktail cabinets were the star of the show,' he says. 'People wanted to buy spotlight furniture pieces. Designers paid attention to the bells and whistles element and made them special. They also tended to make them higher than a normal cabinet so the line of the eye would settle on it. Buffa, for example, was a master architect, which informed his work, and he also did pieces of furniture that were super high quality.' Possibly the most notable US designer of these type of pieces is Paul Evans, whose heyday was actually in the 1970s and who is famous for his Cityscape range of furniture, among much else.

And the cabinets have seen a surge in recent popularity, with some dealers citing a 100 per cent price rise in recent years. 'Part of their appeal is that they bring glamour to an interior and they are a little risqué,' says Ken Bolan who ran

the London-based design emporium Talisman. 'We recently had an event at Talisman in which we invited eight designers to create an interior and every single one of them used a bar cabinet or bar cart. It brings a little fun into a room, they're out of the ordinary. And bars are coming back these days as people are spending more time entertaining at home, rather than going out to restaurants.'

Prices for pieces by Paul Evans have rocketed in recent years, but the entry level does not need to be so high. Aldo Tura is very sought after: 'His work is based on goatskin and lacquer,' says Holly Johnson. 'No one else had the quality of the work he did. His niche was bars and he used the lacquer to create the most beautiful colour.' The main colours in his work are reds, greens and browns.

Themes & Variations, based in London's Westbourne Grove, is one of Britain's leading dealers in Fornasetti and owner Liliane Fawcett agrees that cocktail bars are an elegant way of encouraging pleasure and conviviality. 'Bar tenders have now become mixologists and it is so sophisticated and advanced it is almost a science. It's almost a professional form of entertainment,' she says.

'These are all really examples of the rise of multi-functional pieces of furniture in more restricted living spaces,' says Dominic Bradbury. 'Increasingly we're seeing living and dining areas being combined. And these pieces stem from an optimistic era: it is a different period from the 1940s and the people who made these pieces were looking ahead. A lot of them are just so ingenious, combining all sorts of different ideas into just one piece of furniture. They are aspirational.'

William Morris said, 'Have nothing in your houses that you do not know to be useful or believe to be beautiful.' These cabinets are both. (This section first published in the *Financial Times How To Spend It* magazine in 2018.)

Treen

Have you ever wondered what Robin Hood and his Merry Men would have eaten their venison off? It would almost certainly have been treen – domestic objects turned and hewn from wood, such as trenches (plates), tankards and numerous other household pieces. Utterly charming, treen literally means, 'made of tree'.

'Treen was made from medieval times until the beginning of the nineteenth century and the Industrial Revolution,' says Nic McElhatton, of Christie's. 'There are two types of treen: the relatively simple objects that a woodsman would have whittled for himself and sophisticated items made for the households of the aristocracy and mounted on silver. These would have included wassail bowls and dipping cups: the bowl, made from lignum vitae, a wood that had recently been discovered in South America, would contain a punch and the cups would be dipped in.'

In some cases decoration was etched on the wood with a hot pipe; a technique known as pyrography. And treen was not confined to practical use: particularly charming are Welsh love spoons, which were created or commissioned by a man for his betrothed. They would often have symbolic elements, such as entwined hearts, or a birdcage with marks inside to symbolise the number of children the couple hoped for.

The woods used also differed according to the type of treen. The sophisticated pieces tend to be fruitwood, naive objects were more likely to be sycamore or beech. The fruit-woods produce a beautiful patina – one of the elements a collector should look for, according to Mr McElhatton. 'You should consider patina, rarity, quality, condition, which means not too much restoration, and the type of wood it is made from,' he says.

Treen stopped being made in the early nineteenth century when the Industrial Revolution took place. Pewter, which had been in use for two centuries but had been prohibitively expensive, now became cheap and the porcelain factories were flooding the market with china plates. Wooden trenches no longer seemed desirable. And so, despite the charm of the pieces, treen all but ceased to be made.

Good examples of treen are increasingly rare, but it is not an expensive area in which to collect, starting in the low hundreds. Just looking at them evokes the smell of the ale they once contained.

Nutcrackers

Although they are now often associated with the toy soldier figure made popular by the eponymous ballet and the story on which it is based, nutcrackers have actually been around for thousands of years, exist in many and diverse shapes and forms and are extremely collectable. And perhaps the most elegant and attractive were made in the nineteenth and twentieth century, often using silver, brass or other metals and, more latterly, employing modernist designs. Companies such as

Tiffany produced them, while pieces by designers such as the Austrian Carl Auböck II have become extremely sought after.

But the history of the nutcracker goes back a long way. 'The oldest known nutcracker can be seen in a museum in Taranto, Italy,' says Arlene Wagner, author of *The Art and Character of Nutcrackers* and founder of the Leavenworth Nutcracker Museum in Washington, thought to be one of two museums worldwide solely devoted to nutcrackers (the other is in Germany). 'It is a bronze pair of hands with wide gold bracelets, and dates to the third or fourth century BC. Other metal nutcrackers were made in Italy and other parts of Europe. England was known for its brass nutcracker production. Beautifully carved wooden nutcrackers were created in France and England that are shown today in many museums.'

And modern designs are sought after now. Patrick Parrish is a New York-based dealer who has contributed to the book *Carl Auböck: The Workshop* and in 2016 set up the first ever auction dedicated solely to the designer in conjunction with online auctioneer Wright. 'They are functional, and these days nostalgic objects as most people associate them with their parents or grandparents, or at least I do,' he says. 'Carl's are by far the best when you are limiting yourself to Modern, Modernist or even Post-Modernist examples. The nutcrackers that [father and son] Carl Auböck II and III made were generally polished brass or nickel with stitched leather handles. There are a few which are all wood and some that are attached or complemented by a bowl. Those use the 'hammer method' of cracking the nut rather than the more usual tightening until they crush method.'

And why are they associated with Christmas? How did the nutcracker come to be associated with this time of the year? Back to Arlene Wagner. 'Nuts ripen and fall in the last few months of the year, so naturally the winter months were busy with the shelling,' she says. 'Families sat around the fire and enjoyed cracking and eating these delicious morsels. Nuts were used in the Christmas baking, therefore usable nutcrackers were a necessity, and a popular gift for the housewife.' Collectable too, at any time of the year. (This section first published in the *Financial Times How To Spend It* magazine in 2018.)

Native American ware

Native American society was sophisticated, nowhere more so than on the northwest coast, in what is now British Columbia. That area was peopled with the Haida, Tsimshian, Kwakiutl and Nootka tribes – responsible for the totem pole, probably the best-known example of Native American art. But they created a great deal more, both for themselves and to sell to European traders.

Siobhan Quin, head of Tribal Art at Bonhams, says: 'The Native Americans lived in a land of plenty, which left time to be artistic. This is particularly seen through their argillite [soft carboniferous shale] carvings, which combine their myths with quirky likenesses of Europeans. Through their art they responded to changing times.' Indeed, they also realised that their art could be a source of income. There are pipes, some purely decorative, sold to visiting sailors as objects of curiosity. The finer pieces were collected by John Madden, of the Irish

gentry, who became a blood brother of the Blackfoot people before bringing his collection home.

There are also pieces made for the tribes' own use, such as implements used at potlachs, huge ceremonial feasts, for example, a decorated Tlingit sheep-horn feast ladle, bowls, sometimes in the form of a seal.

Sporting silver

If you are a collector as well as a football aficionado, there is a way to feed your obsession: by investing in a piece of sporting silver. This is a type of sporting memorabilia consisting of medals, trophies, plates and other silver objects with a sporting theme. Steven Linden, a silver dealer and chairman of the London Silver Vaults Association, says: 'Sporting memorabilia has existed for hundreds of years but came into its own in the nineteenth century, when many of today's popular sports began. It has always been collectible, because people interested in sport will want to buy pieces relating to their hobby, whether it be a famous trophy or a piece of silver, such as horseshoe cufflinks, that mirrors their interests.'

Some of the pieces are so attractive that they appeal to general collectors. You could look for a Victorian cruet set in the shape of a cricket ball and stumps, a Victorian desk bell that looks like a jockey's cap, and a manicure set that looks like a set of golf clubs. Mr Linden cites one particularly splendid sailing trophy made from solid silver which sold a decade or so ago. Created in London in 1847 by John Edward Terry, it has a sailing scene embossed on the silver, and handles in the shape of dolphins. He says: 'There's no inscription on it, which

means that it is likely to have been made for someone who was interested in sailing rather than for a specific occasion.'

Or there are pieces that have a more specific association, such as a plate made by Robert Garrard, of the eponymous firm, in 1862. The winner's trophy for the first ladies' singles championship at Wimbledon, held in 1884, was not a new commission but about 20 years old – the club effectively bought it off the shelf. There are also replicas (still collectable) of trophies, such as the Jules Rimet Trophy.

Armour

Knights are the stuff of legend and, these days, the stuff of collecting, too. Suits of armour and their individual components, such as helmets and gauntlets, are so popular among a certain type of collector that when really good armour comes on the market, it tends to be snapped up quickly. 'The very earliest armour dates from about the thirteenth or fourteenth centuries, when knights began to wear it in preference to chain mail,' says Dominic Strickland, of Michael German Antiques in London, an armour specialist. 'People think that it is unwieldy, but a good suit of armour would fit you like a glove. It originated in continental Europe before catching on in Britain.'

Armour was made out of iron, which was heated or hammered until it had almost the consistency of steel. When it comes to how it was made, a suit of armour has a great deal in common with suits made out of cloth today. Robin Dale, of Peter Dale, another London dealer, explains: 'A wealthy man would have armour made for him, while someone with less money would buy off the peg.'

The most desirable and expensive armour dates from before the fifteenth century, although very little of excellent quality comes on the market. Armour was made until about the seventeenth century, when the introduction of guns meant that armour had to be so heavy to protect the wearer that it was almost impossible to manage.

But armour has been manufactured since then. In the late nineteenth century, with the Gothic revival and the popularity of writers such as Sir Walter Scott, the Victorians started to make replicas. The good ones are also collectible and Mr Strickland says that a full suit can fetch well into the high five figures.

This area does require expert advice. Only specialists would be able to differentiate between original armour and Victorian imitation, and tell whether a suit is a composite of bits of different suits. Of course, most collectors have neither the money nor the room to house suits of armour, and this is where individual items come in. Helmets are probably the most popular pieces on the market. Prices start in the hundreds, although they can climb dramatically, depending on age, condition and style.

Swords have been around much longer than suits of armour, which means that there is more on the market. Viking swords are extremely popular but originals, not modern versions.

Romanesque stone carving

One little-known and relatively unexplored area is Romanesque stone carving. These carvings, which date from the tenth century to the late twelfth century, are not statues in their own right, but come from buildings, such as churches and

monasteries, that have been destroyed or left to ruin. In many cases the carvings simply lay where they fell until rescued by collectors. They are a fraction of the price of manuscripts from the same period. In addition, unlike medieval manuscripts – most of which have already been bought and which can now only be acquired by the very rich – these pieces, although not common, can still be found on the open market.

Many believe they are hugely undervalued. Arcadia Fletcher, of Sam Fogg gallery says: 'Romanesque stone carving went through a period of popularity at the beginning of the last century.' But since then it has remained something of a Cinderella in the world of collecting: largely forgotten and unnoticed. There are signs, however, that the fairy godmother may now be on her way, as there is increasing interest in what is on offer.

There is a huge variety of styles. Italian pieces trace a cultural heritage back to Ancient Rome. That influence also extends to the South of France, while other French carving features myriad styles from the Byzantine to forms more commonly found in Eastern Europe. Despite their provenance, these pieces do not depict only religious motifs. 'Animals, such as a ram in foliage among vines, were popular,' Ms Fletcher says. 'Another typical image is a bird attacking a hare. But many figures, including religious ones, would be decorated with all sorts of patterns: one that frequently appears is the acanthus leaf.'

The pieces were created by stonecutters who were often also the architects of the buildings. Although individual names have not been handed down, it is known that the same groups of people worked on different buildings: for example,

the cathedrals in Rheims and Strasbourg are the work of the same hands.

Mobile art

The interest in, and prices commanded by, mobile art in recent years has gone through the ceiling – appropriate, many would say, as that is where most mobile artworks are hung. There has been a big focus on mobiles recently, and particularly on their progenitor, the American artist Alexander Calder: in 2017, New York's Whitney Museum of American Art ran an exhibition entitled *Calder: Hypermobility*. This follows on from an exhibition a couple of years ago at Tate Modern, *Alexander Calder: Performing Sculpture*. Pace Gallery and Acquavella Galleries have just shown an exhibition entitled *Calder/Miró: Constellations in New York* and have published a book of the same name. And in 2017 Sotheby's sold a rare and unusual black monochrome Calder for over £5.2 million, while other Calder lots offered by the auction house have achieved prices ranging from just over $200,000 to more than $800,000 – and look set to continuing rising.

Mobiles are among the more unusual art forms, in that they appeal to the viewer's sense of whimsy as much as anything else. Melinda Lang of the Whitney Museum says, 'Their great appeal is their whimsicality. There is an irreverence in many of the works and the vocabulary is unique and unusual. There is a joyful element to them and some mobiles have a surprise element to them, such as for example a sound. That unpredictability creates a hidden anticipation when viewing the work.'

Calder is one of the great figures of American twentieth century art, an innovator who created a brand new form. 'Known mostly for his mobiles, Calder has reached great depths as an artist,' says Ted Vassilev of DTR Modern Galleries, which has four outlets across the United States. 'First and foremost as a sculptor, Calder is in the ranks of Alberto Giacometti and Constantin Brancusi.' But while Calder was the innovator, many other major names followed in his wake. Other makers of highly collectible mobiles, according to Vassilev, are the American Ruth Asawa and the Argentinian Julio Le Parc. A work by Asawa sold at Sotheby's in New York for just under $1 million in 2017, nearly twice its estimate; Julio Le Parc has a lower entry level, but is still sought after. Such is his name and growing reputation that the 2017 Brussels-based Brafa art fair paid homage to him in the form of four works at strategic parts of the building, while one major work, *Quantitative Sequences* dating from 1991 was on sale via dealers La Patinoire Royale for €450,000.

Mobiles were actually given their name by Marcel Duchamp in 1931. They are either often suspended entirely from the ceiling, or from a solid structure which is set on the ground, or sometimes a table top. (These are not to be confused with stabiles, which are set on the ground; there are also slightly different types of grounded mobiles using, for example, pulleys.) Calder was heavily influenced by Mondrian, among others, which manifests in the bright palette of many of his mobiles. A slightly different type of mobile, by the Swiss artist Jean Tinguely, was sold for £356,750; *Blanc – Blanc + Ombre*, which dates from 1955, consists of painted metal elements on

a painted wooden box with wooden pulleys, rubber belt, metal fixtures and electric motor.

As for what collectors look for, 'We have found that the primary assessment is quite simple: does the mobile fit into the interior/space?' says Colin Brim of Heritage Fine Art. 'Questions as to authenticity, provenance or the artist are secondary and helpful, but not decisive in the buyer's thought process. We find that buyers lean towards primary colours – almost certainly part of the Calder effect.'

Mobiles are by their very nature playful structures; so it should be no surprise that other artists took up the concept and gave it their own twist. Roy Lichtenstein was one: 'His mobiles don't actually move,' says Stefan Ratibor of Gagosian, who advises would-be collectors to base their choices on whether they actually love the piece as much as provenance (about which they should be diligent). 'Lichtenstein's pieces are like the frieze of a mobile, and the humour derives from that.' Playful and intriguing. Who could possibly ask for more from art? (This section first published in the *Financial Times How To Spend It* magazine in 2017.)

Posy rings

It is often said that every generation believes it is the first to discover romance. Of course, the real difference between generations is the way that romantic feelings are conveyed. One way, which remained in favour for the best part of 400 years, was to give posy, or 'poesy', rings. These are rings with a line of poetry written inside.

'They originated in about 1430, probably originally as wedding rings,' says Ted Donohoe, a dealer and expert on

the subject. 'They went on to become tokens given between lovers. They were extremely popular until the beginning of the nineteenth century and are very popular among collectors now.'

Posy rings can be rare. Sandra Lipton, a London dealer who has sold them, says that she has gone for as long as three years without spotting one. 'The trouble is that so many were lost,' she says. 'People wore rings outside their gloves so it was easy, when a glove was taken off, for the ring to go flying. We rely on people who go metal detecting to find more.'

The rings tended to be plain hoops of gold or silver, with the poetry inscribed outside the hoop, which was flat in the Middle Ages, and inside when the hoop became rounded. The rings from the Middle Ages are very hard to find. There is a big collection of posy rings in the British Museum, and private collectors are also partial to them. Popular inscriptions include 'A loving wife – a happy life', 'As God decreed, so we agreed' and 'I do rejoice in you my choice'.

More unusual messages include 'A kiss for peeping' on a Tudor ring and the rather darker 'Despair inflames desire'. Some rings were made for children to be given by a parent or godparent and say, 'Remember the giver'.

The standard work on the subject, *English Posies and Posy Rings*, was published by Joan Evans in 1931. Posy rings fell out of fashion in the nineteenth century. A wedding ring became a plain band and an engagement ring featured a gem. There was also a fear that posy rings could be used to bring breach-of-promise cases. For the romantic collector they make for a longer-lasting posy than flowers.

Chapter 11

Collecting Collectables: Part Three

Bookbinding

Books are there to be read, right? Wrong. Collecting books is a completely different area in itself and outside the remit of this book, but there is a certain type of volume that exists as much for decorative purposes as literary ones and that we shall tackle here. Bookbinders work on the premise that it is not only necessary but desirable to judge a book by its cover, with the result that contemporary bookbinding has become highly collectable. Such books double in value roughly every seven years, one dealer says, while works by some of the great bookbinders of the day, such as Ivor Robinson, Trevor Jones, Philip Smith and Lester Capon, can fetch large sums at auction.

Designer Bookbinders is a society devoted to the craft, and prices start fairly low. 'People interested in contemporary bookbinding tend to be lovers of both books and modern art, for this is a medium where the two come together,' Capon says. 'Most bookbinders work on books printed by a private press: the print run tends to be between 50 and 200, and one will be bound and signed by the author and the illustrator. Commissioning starts at about £1,000 to £1,500, although it can be much higher.'

Contemporary bookbinders do not confine themselves to new and limited works. For example, a first edition of *Brighton Rock* has been up for sale that has a contemporary binding. Derek Hood, the bookbinder, came across a first edition that was missing its dust jacket and had covers in poor condition. The pages, however, were beautiful and intact, and so he bound them afresh.

Bookbinding by hand was commonplace until the early nineteenth century, when the Industrial Revolution made mass production possible. Samuel Pepys was an early collector. The collection of a more recent aficionado – J. R. Abbey – was sold by Sotheby's in 1968: it is estimated that were the sale to take place 40 years later, the books would have fetched 100 times as much.

But a great deal depends on what is in fashion. Probably the greatest modern bookbinder is Philip Smith. His prices start at about £15,000. Another well-known master was Edgar Mansfield. Designer Bookbinders cites a case where a Mansfield book went for £70 in 1972 and is now worth £10,000.

Snuff

Charles Darwin, Alexander Pope and Admiral Lord Nelson all loved the stuff: snuff. Queen Charlotte was so partial that she was known as Snuffy Charlotte. It was Native Americans who first sniffed snuff, a pastime brought to Europe by Christopher Columbus. It gained great popularity in Spain and France, but did not really catch on in Britain until the reign of Charles II, who took up the habit during his exile in France. Once the

King started to take snuff, the aristocracy followed suit. By the nineteenth century it was practically a national pastime among a certain class. And with it came all the paraphernalia: shops opened selling mills to grind it and snuff mulls to hold a great quantity to share with guests. The personal snuffbox also made an appearance, in increasingly opulent forms, as those of the *beau monde* vied with one another to be the most fashionable.

Lucy Grazier, a silver specialist at Woolley & Wallis, the auction house in Salisbury, says: 'The more beautiful the box, the grander it made you look. There were Masonic snuffboxes, which might be given as gifts, and snuffboxes given to mark long service. There were snuffboxes that would be given as prizes and we even had a snuffbox in the shape of a coffin. It may have been a present to an undertaker or given to a family member of someone who had died because they took too much snuff. The Victorians were a funny lot.'

Snuffboxes are extremely collectible today. 'The market has changed,' Ms Grazier says. 'People can't be bothered to polish large silver items these days, so small pieces that are pretty and easy to care for are snapped up. Snuffboxes, like nutmeg graters, now fetch high. They represent a slice of history because sniffing snuff faded when cigarettes came in.'

Snuff boxes can be very unusual, such as one dating from 1816 and sold via the auction house that had two compartments, one hidden beneath the other. This might have meant that the owner kept a hidden stash for himself, or he may have used it for something stronger – the sort of substance a supermodel might favour now. The house also sold a Scottish snuffbox that

may have been owned by a Mason. It was round, with an agate on the top and a handshake engraved on the side. 'The date April 17, 1757, is engraved on it, so it may have been used to commemorate an event,' Ms Grazier says.

A type of snuffbox popular in the 1830s was a 'castle top'. These boxes are so called because they have images of grand buildings on top, such as Dryburgh Abbey, the Houses of Parliament and Westminster Abbey.

Chinese bond certificates

History is said to repeat itself, and that is currently true of the mighty dragon stretching its claws in the Far East. China is viewed as a land of great investment potential, but it is worth bearing in mind that the same tale was being spun about 100 years ago. Then, as now, China was growing and looking to the West, especially Britain, for the wherewithal to finance its expansion. For some investors it was a venture that ended in tears, but bond certificates, the remnants of those heady days, have now become collectible in themselves. Sales have been held of medals, bonds, banknotes and coins, sometimes including an auction of scripophily (share certificates).

Chinese railway bonds were issued to raise money at the beginning of the last century. Bruce Castlo, a scripophily expert, says: 'In 1913 the Chinese Government wanted to expand the railway system to bring people and agricultural goods into the cities. It issued bonds via the Hong Kong and Shanghai Bank in sterling to be listed on the London Stock Exchange. The interest rate was an attractive 6 per cent and the bonds were also often sold at a discount.'

However, China was as unstable then as many people believe it to be now and when the Communist Government took over several decades later, it refused to recognise the debts of the previous government. As a result, many of these bonds stopped paying interest and they were not redeemed. That said, most paid out until the 1930s. Many had finite lives and if they ended before the Communist takeover, the capital was paid back. Rather bizarrely, the bonds continued to be listed on the London Stock Exchange until the early 1980s. Their price had collapsed, of course, and they finally fell out of the market.

By that time, the pieces of paper were collectible. About twenty years earlier, Grover C. Criswell had published a book in the US entitled *Confederate and Southern States Bonds* and interest in scripophily took off. Not that it was called that back then: bond collecting had no official designation until *The Times* ran a competition in the early 1970s to give the pastime a name. Waterlows was one of the great security printers of the day. They made the Shanghai–Nanking Railway 6 per cent Government Guaranteed Sterling Land Bond of 1913. It was originally an issue of 150 £1,000 bonds to raise £150,000. And there were Chinese Imperial Railway Gold Loan £2,300,000 Sterling 5 per cent bonds from 1899. Each of the 23,000 bonds was for £100.

You can learn more about scripophily from the International Bonds and Shares Society's website at www.scripophily.org

Telescopes

Man may have reached the moon, but space remains the final frontier. Down here on earth there's only us but out there,

there is – what? That question lies at the basis of both the invention of and fascination with telescopes: 'The history of the telescope is extraordinary: it is the history of space and time,' says Allan Hatchwell of Hatchwell Antiques. 'It is a window on to the universe, a way of looking into the stars.'

Peter Louwman, a Dutch industrialist who works within his family's automotive group, was drawn to antique telescopes, 'Because I was interested in astronomy. Before I collected telescopes, I collected books about astronomy. I started gradually and bought my first telescope in Vienna in 1966 and I now have a very broad collection from many countries and different optical design. I used to buy in street markets and at auctions but now the dealers know me and I get offers from all kinds of dealers in Paris and London.'

Indeed Louwman, who says he is especially drawn to aesthetically beautiful telescopes, became so passionately interested in the subject that he established the Louwman Collection of Historic Telescopes, based in the Hague, in the Netherlands, which now houses his collection of 300 pieces. 'I am interested in both the technical side of old telescopes, as well as the history of their development,' he says and has written a book about the collection.

The first telescopes appeared in the Netherlands in the early seventeenth century and they have been collectable from that day to this. Bart Fried is the New York-based proprietor of an import/export company whose interest in telescopes was sparked 30 years ago when he bought a signed John A. Brashear telescope dating from 1905 in an estate auction 'for a lark'; his interest grew to the extent that he is now the founder and

past president of the International Antique Telescope Society and has done work for the British Astronomical Association. 'I am interested in astronomy and I like antiques,' he says. 'I appreciate the fine optics and the craftsmanship.'

Of course the telescopes produced today are extremely powerful, but many collectors delight in seeing space as it was viewed several centuries ago. Debbie James is the curator of The Herschel Museum of Astronomy, housed in the building in Bath in which Sir William Herschel, an amateur astronomer, discovered the planet Uranus on 13 March 1781. 'People find it fascinating that someone set up a telescope in his garden and discovered a planet,' she says. 'It is one of the most important astronomic instruments in use and if you look at eighteenth century paintings, you see many of gentlemen in their studies with telescopes and celestial globes. They give the impression of a man knowing about science and letters.'

For the best telescopes the sky's the limit (pun intended): the most expensive to date is an Italian binocular telescope by Pietro Patroni dating from 1719 which sold at Christie's in October 2013 for £338,500. 'Of the sought after characteristics, the telescope must be in working order unless it's spectacularly early,' says James Hislop, head of science and natural history at Christie's.

Telescopes are not simply celestial: they are also terrestrial, and their development is linked to breakthroughs in navigation. 'An understanding of astronomy with navigation made an important leap,' says John Hansord of Hansord Antiques. 'They are collected by two types: people interested in rare makers who are interested in the scientific instrument and

decorative collectors who want something to look good in a bay window.' He also emphasises the importance of working condition, although there are many criteria collectors will look for: the earliest telescopes were refracting telescopes, followed by reflecting telescopes, of which in 1688, Isaac Newton built the first practical example, known as the Newtonian reflector.

As with so much else, knowledge of an object's history adds to the appeal. 'People look for completeness and originality,' says Richard Dunn, author of *The Telescope* and Senior Curator and Head of Science and Technology at the National Maritime Museum, Greenwich. 'If they are signed with the maker's name that makes them more desirable, as does a personal association – for example if they are engraved with the owner's name. They like the association with a famous person or era.'

Collectors will look for specific makers such as Dollond, who made great leaps in the manufacture of lenses (now better known as part of Dollond and Aitchison) or George Adams, who made telescopes for George III and other nobility and scholars of the time. The condition of the lens is crucial and the telescope may have other desirable features such as the original case it was kept in.

John Bly of the eponymous antiques dealers says his collectors are interested in, 'mechanism, originality, good working order. People like to use them,' he says. 'They like to see the world as people would have done in the past.' Makers he cites as popular include James Gregory, who designed the Gregorian telescope, and Johannes Kepler, a German astronomer who designed some of the very earliest telescopes, and now, in Bly's words, fetch an 'astronomical price.' (This section first

published in the *Financial Times How To Spend It* magazine in 2016.)

Tea

Has there ever been a habit so quintessentially British as drinking tea? The inhabitants of these islands are famous for their love of it, which makes it rather ironic that it was not originally a British habit at all. Tea, like so much else, originated in China about 5,000 years ago when, legend has it, the emperor Shen Nung decreed that all drinking water should be boiled for reasons of hygiene. One day some leaves fell into the boiling water, colouring and infusing it with scent. Out of curiosity, Shen Nung decided to drink it. And so the world's best-loved drink was born.

Tania Buckrell Pos, author of *Tea and Taste: The Visual Language of Tea* says that it was the arrival of the Portuguese in Asia in 1498 that introduced tea to the Western world. It took another two centuries before it arrived here. 'It is believed that Catherine of Braganza, the future wife of King Charles II, introduced tea upon her arrival in 1662,' she says. Tea drinking spread from the court through the aristocracy to the rich, and the industry that grew to accommodate it has produced many highly collectible items.

Teapots began to appear, for it was also about this time that Chinese porcelain-making spread to the West, along with tea caddies, teaspoons, tea-caddy spoons and sugar tongs. Collectors tend to go for either porcelain (teapots), silver (tea-caddy spoons) or brown furniture (tea caddies). Perhaps the most collectible of these areas is the tea caddy. Susan Shaw,

of Period Pieces, says: 'A society lady would have her friends round and tea would be made in front of the fire. The kettle would be boiling over the flames and the butler would bring in the tea caddy for her to prepare the drink. 'Some of the greatest furniture makers of the day, such as Sheraton and Hepplewhite, began to manufacture tea caddies. Most tea caddies had locks well into the Victorian era because tea was such an expensive drink.'

The heyday of tea-caddy making was between 1750 and 1830 before mass production took over and tea became the preserve of hoi polloi. This is reflected in the prices. A late-Victorian tea caddy costs about £50, but a handmade one from 100 years earlier can run into the thousands. Originality of design is all. For example, some early tea caddies were made to resemble fruit and cost more than £10,000. But there are items for shallower pockets. A Chippendale design in oak or mahogany with a cavetto top costs between £400 and £500.

Clocks

Whoever said a clock exists just to tell the time? Some clocks are works of art and sell as such. Remarkably, buying a clock can be tax-efficient too. There is no capital gains tax payable because when clocks were first made, they were never expected to last, and have thus never been subjected to the charge.

'Clocks as we know them first began to be manufactured in about 1300,' says John Jillings, who runs Jillings Antique Clocks in Newent, Gloucestershire, with his wife, Doro. 'The earliest clock in England is in Salisbury Cathedral and dates from 1386. Then, after Christian Huygens invented the

pendulum in 1656, domestic clocks in the form of long cases, brackets and mantel clocks took off.'

The first clocks were made by locksmiths, but as the trade became increasingly prestigious, specialised clockmakers began to emerge. In Britain, the seventeenth century proved a high point in clock manufacturing: Thomas Tompion, Knibb, Fromanteel (originally a Dutch family) and Quare produced some of the most spectacular clocks in the world. The prices of these clocks reflect this: a Tompion clock will cost at least £100,000.

Across the Channel, French clockmaking really came into its own a century later. There are a great many names to choose from, but three of the most notable are Janvier, Berthoud and Leroy. They are not quite as expensive, costing in the tens of thousands. By this time, clockmaking was becoming quite an industry. A range of specialists was needed for each clock. There would be the manufacturer himself, who designed the clock, and then the dial enameller, the springmaker and the gilder, among others.

Clockmaking could be dangerous in the eighteenth century. 'Clocks were gilded by a method known as fire gilding,' Doro Jillings says. 'The clockmaker would mix gold and mercury, plaster it on to the bronze and then burn off the mercury. In some cases it proved fatal and mercurial gilding is now illegal.' The result was a particularly fine gild which, combined with quite superb craftsmanship, produced spectacular clocks that work to this day and that are pieces of sculpture in themselves.

They were not, however, for any old Frenchman; the best examples were owned only by the very rich. By the

nineteenth century, standards had begun to slip. The advent of electroplating made possible the mass production of clocks, which meant that although far more people were able to own them, they weren't quite as stunning as they had been.

Travelling games

While it may be better to travel than to arrive, time can lie weary on the hands while doing so and so travelling board games have become a voyager's must. First making a mainstream appearance in the nineteenth century (although some earlier examples can be found), portable chess and chequers sets, portable cribbage boards and portable BCDs – backgammon, chess and draughts sets – were all used to pass the time as their owners made the Grand Tour or waged military campaigns, and these beautiful objects have now become highly collectable.

'Portable games are essentially games that have been reduced in size and modified to use tiny pieces with apparata to keep them in place on the board,' says Bruce Whitehill, author of *American Board Games and Their Makers 1822–1992* and himself an avid collector. 'Some people collect for the artwork on the covers, some for what's inside and some for what they tell us about contemporary history.'

Gloucestershire-based Christopher Clarke Antiques specialises in items relating to military history and travel and as such sees quite a few travelling games sets. 'From the very earliest days, soldiers would take a pack of cards with them but travelling chess sets came into their own in the nineteenth century when trains took over and transport changed,' says Sean Clarke, son of the original owner. 'They were manufactured so

that the pieces had pins in the bottom that could slot into holes in the board, so they don't get knocked off during travel or you can keep the pieces in place if the journey has come to an end. And the journey could be a long one. If you were travelling to India, it could take six months.'

Chess is by far the most popular travelling game, according to Clarke, particularly among collectors who are also interested in the military side of life, as chess is a game of war and strategy. But collectors will also look for specific manufacturers, the foremost one being Jaques London (which still exists). 'A lot of the high-end retailers on Bond Street made them,' says Clarke. 'Thornhills and Asprey are also two popular names.'

Edward Copisarow, a trustee for various charities based in Shardeloes in Buckinghamshire, has been collecting games since he was a teenager in the 1980s. 'I needed a cribbage board at the weekend, the only shop that was open was an antique shop, so I bought a board from 1880 for £4.50, then two more and suddenly I was a collector,' he explains. For him games appeal on a huge variety of levels, from the ingenuity of the construction, such as the locking mechanisms that will keep some pieces on a board, to what they say about social history.

'When the game Patience became popular people wanted to play it on the train,' he says. 'They had to play it on their lap and so they would need a Patience board. Lady Adelaide Cadogan, who wrote *Lady Cadogan's Illustrated Games of Solitaire*, designed several for Queen Victoria. Mary Whitmore Jones, who wrote *Games of Patience*, lived in Chastleton House in Oxfordshire, also designed some of these boards, now known as Chastleton boards. I have a few and they are all exactly the

length of a First Class train seat because it wouldn't have occurred to her that anyone travelled in any other way.' They were manufactured by Jaques.

Chess may be the most popular game, but cribbage is also sought after. Northamptonshire-based Hampton Antiques specialises in, amongst other things, antique boxes such as games compendiums, which are essentially boxes that contain a variety of games and are easily transportable – the same theory as a BCD, but the boxes are bigger, more ornate and certainly wouldn't fit a pocket. 'George Betjemann & Sons are particularly good for compendiums,' he says. 'They made top quality boxes with ivory pieces.' (This section first published in the *Financial Times How To Spend It* magazine in 2015.)

Modern glass

Modern glass, specifically that made in the 1950s, is very collectable. And of the glass from that era, there are two distinct styles: Scandinavian glass and Murano glass, which comes from the famous glassworks on the island of the same name near Venice. The two types of glass are what you would expect from their places of origin: the Scandinavian designs are clear and flowing, the Italian ones warm and colourful. 'The best Scandinavian glass comes from Finland and is made by two designers in particular,' says Mark Colliton, owner of Good-Eye Design, a gallery in London that specialises in 1950s glass. 'The first is Tapio Wirkkala, who designed for a company called Iittala. He is famous for the organic movement of his pieces, which are clear glass cut decoratively, typically

in the shape of a mushroom or a leaf.' The smaller works start at about £100, while larger ones cost thousands. One piece by Wirkkala is in the V&A.

The second great Scandinavian glassmaker of the day was Timo Sarpaneva, who is most famous for a style called orkidea, which means orchid vase. Mr Colliton says: 'Sarpaneva introduced a new style of minimalism.' Again, his work will not break the bank. Small vases start at about £300 and larger ones at £1,000.

One of the catalysts for these new styles was the end of the Second World War, when a new generation of invigorated craftsmen were keen to break away from the ties of the past. That is certainly the case with the glassworks on Murano, which has been the home to glass manufacturing for hundreds of years. 'When the glassworks reopened after the war, there was a new sensitivity,' Mr Colliton says. 'One of the most striking of these pieces is the handkerchief vase, made by Venini. The glass is modelled to look like a handkerchief suspended in motion.'

The style was manufactured until the early 1960s and has been widely copied since. Another famous designer was Dino Martens. Originally a painter, he began to work for a company called Aureliano Toso, making colourful and unique vases and dishes. One example is Orient glass, which is a riot of different colours and designs. Expect to pay from £2,500.

Another Murano designer is Flavio Poli, who introduced a method called sommerso. It comprises various layers of perfectly symmetrical coloured glass and is very difficult to achieve. Prices start at £1,500.

Metalwork

Why did the pot call the kettle cheap? Because it is. Many forms of metalwork have been out of fashion of late, so there are bargains to be found, whether your taste is for the simple or the ornate. The vogue for minimalism in interiors is a significant factor behind metalwork's unfashionable status, especially when it comes to the kettles and warming pans beloved of households 35 years ago.

'Copper kettles cost £150 to £200 at the peak of the market in the 1980s,' says Keith Pinn, of Pinn and Lennard Antiques in Essex. 'Now they cost £40 to £80, and they look to stay there. I wouldn't recommend them as an investment, but other forms of metalwork are also currently too cheap, including seventeenth-century Dutch brass candlesticks. These were utilitarian objects and usually didn't survive because if domestic objects were broken they were simply thrown away. Those that have survived are pretty amazing objects and are now currently valued in the same way as other objects that are 300 to 400 years old.'

In the seventeenth century, Holland was the home of the best metalwork craftsmen. Collectors who favour the sixteenth century should look for German work, while by the nineteenth century, the focus had shifted to Birmingham.

Jane Walton, of Jane Walton Antiques in Sussex, sells garden furniture. The three main types of garden furniture are statues, urns and benches. In most cases, Mrs Walton says, it is a good idea to look for pairs. 'They are nearly always created as a pair as a way of establishing balance in a garden. Statues are

always a good investment. The nationality of the furniture you choose is entirely according to taste: a lot of English garden furniture is moving abroad.'

And then there is indoor metal furniture. Christopher Jones, of Christopher Jones Antiques in London says that the likes of a pewter pepper pot will probably cost about the same as 30 years ago and is unlikely to cause a great deal of interest. The more decorative the object, he believes, the more popular it is likely to be. Mr Jones says: 'Traditional collectibles are not making the prices they did previously. But fashion goes in 30 to 50-year cycles and they will rise again. However, people are interested in objects such as chandeliers and lanterns.'

Sailors' Valentines

Bringing home souvenirs from faraway lands is nothing new, but a particular kind of memento, Sailors' Valentines, the beautiful little nineteenth century arrangements of shells that sailors would bring home from Barbados to their sweethearts, has become a valuable and sought after collectable among some of the world's most stylish sophisticates, Annette de la Renta, for one. Together with her husband, fashion designer husband Oscar, she has created some stunning interiors in their various homes around the world, including a spectacular feature in one of the bathrooms: a collection of Sailors' Valentines.

These tokens of affection, the best of which can sell for up to £20,000 and beyond, are also collected by Dame Vivien Duffield, Lady Bamford, who keeps them in her home in Heron Bay, Florida; and were said to have been a favourite of Queen Victoria. 'They create a magical picture of a vanished world,'

says John Fondas, author of one of the two most authoritative books on the subject, *Sailors' Valentine.* 'They are charm personified. Delicate things – and not many have survived.'

Sailors' Valentines are still made today, but the collectable examples stem from what was essentially a cottage industry in Barbados between 1820 and 1880, with the finest made until c.1850. They almost certainly originated in a shop in Bridgetown owned by two English brothers, B. H. and George Belgrave. Local tradesmen would make complicated patterns of shells, later also incorporating motifs such as 'Forget Me Not' and 'Forever Thine,' which sailors would buy for a pittance on their way home to Britain and the US. Many will have a rose at their centre or a heart and many will have motifs. The Valentines are hexagonal, glass fronted, usually ranging from 8 to 15 inches in width when closed (the bigger they are, the more expensive they are) and the best ones are double fronted hinged boxes made with local wood.

Walpole says that collectors should not look at just the shells themselves but the construction of the case and the clasp, which can range from a simple hook to very ornate, for example in the shape of a heart, and the secondary materials including cotton wadding and glue. 'The cases were made out of cedar, bay mahogany, which is an inferior wood similar to cigar box wood or mahogany,' he says. 'Always look for cabinet-quality timber when buying – the better the materials, the more complex the design and the finer the shells.' The larger pieces tend to be more expensive; entry level for a small Valentine will be about £2,500.

Another high-profile collector is the actress turned hotelier and interior designer Anouska Hempel, Lady Weinberg. In May 2013, she sold 11 in the Christie's auction East & West: A Private Collection from Eaton Square and Anouska Hempel, which made between £625 to £4,000 for the pieces, thought to have been bought by Dame Vivien Duffield. 'They are very collectable, with large examples being particularly sought after,' says Amelia Walker, Christie's Associate Director, Specialist Head of Collection Sales. 'There has been a resurgence in shell-work as an art form and later/more recently-made examples can also be found on the market.'

'They were made using shells and seeds which are indigenous to Barbados,' says Stephan Boyer, owner of specialist dealers Finish Line Collectables in Pennsylvania, 'Which is one way of ensuring that you are looking at the real thing. If you are so inclined you can take them apart and find newspapers from the era at the back, which can specifically date them.' He currently has one Sailors' Valentine for sale, nine inches across when closed and twice that when opened, bearing the motifs 'With Love' ($4,800).

In total, according to John Fondas, only about 35 types of shell were ever used. And the more intricate the work, the better the piece. 'Some use gold foil to make the little pattern dividers and some are housed in a mahogany veneered case that opens from the front. This means that if a shell comes loose you can open it and fix it,' says Diana Bittel of Diana Bittel Antiques, another Pennsylvania-based expert (and personal collector) in Sailors' Valentines. Of course the better

the maintenance of the Valentine, the more this will increase the price.

Pippa Vlasov, a garden designer who lives in the Bahamas with her husband Peter, who works in shipping, has amassed an enormous collection (possibly the largest in the world), not least through her friendship with the author John Fondas. 'I had started collecting Victorian seaside souvenirs including shell work and seaweed, and when I saw John's collection I fell in love,' she says. Initial purchases were made on eBay about 18 years ago for a couple of hundred dollars – eBay is still a collectors' source although most buying is done through specialist dealers these days – and after assembling 12, she bought Fondas's own 50-something collection of pieces. She buys less now simply because she has most of the patterns that exist. 'The shell work must be in good condition or it must have an unusual saying for me to buy,' she says. She has one piece that says Happy Christmas, which is quite rare, another displaying a pornographic image (very rare – most of the images are charming and naive) and another that has a bouquet of flowers at its centre, a very sought after design.

Amy Tompkins, a former foreign exchange trader who now lives in South Carolina, is another enthusiast. 'I love seashells – I live on an island,' she says. 'My mother and I have been picking them up all our lives and my daughter and I vacation on islands. I also grew up with antiques, and these combine nature and art. I bought my first one when I was straight out of college in 1978 in a flea market in Connecticut – it was love at first sight.' The piece was double sided and had a heart on one side and the motif 'Home Again' on the other. Tompkins

now has six double Valentines and three single ones and she too insists the shell work should be in good shape.

'They are chic, clean and fresh,' says John Fondas, summing up their appeal. 'And plain folk art looks wonderful in a modern space.' (This section first published in the *Financial Times How To Spend It* magazine in 2014.)

Children's books

First editions of children's books are fetching very adult prices these days. But do they represent a good investment? The answer is yes, if you choose carefully. Just as in other markets, there are the blue chip first editions that have already achieved a handsome market price and will almost certainly maintain their value and rise along with the market. These comprise first editions of established children's classics, such as *The Wind in the Willows*, *Alice in Wonderland* and *Peter Pan*. Then there are the newcomers that may well achieve significant prices in the future.

'The really good titles always rise to the top,' says Mike Emeny, of Books Illustrated, based in Salisbury. 'About 25 years ago a first edition of *The Lion, the Witch and the Wardrobe* cost about £1,000, which was a lot of money then. Now it costs between £5,000 and £8,000 depending on its condition. *Wind in the Willows*, which was published in 1908, would cost £3,000 to £4,000 for a good first edition but could command up to £30,000 for a really excellent example with a dust jacket. *Peter Pan*, with illustrations by Arthur Rackham, would be £600 to £1,500 for a standard first edition, but about £7,000 for a signed limited edition.' Prices can go higher still:

at the time of writing a first edition of *Wind in the Willows* is up for sale at £75,000.

Full editions of the Narnia books can be very differently priced. Although the first of the set, *The Lion, the Witch and the Wardrobe*, commands extremely high prices, other first editions in the set become progressively cheaper. This is because the Narnia books came out in a similar way to the Harry Potter series. The classic C. S. Lewis books appeared once a year from 1950 to 1956 and were given much bigger print runs as they gained in popularity. As a result, the earlier editions have a much greater rarity value.

The first in J. K. Rowling's Harry Potter series, *Harry Potter and the Philosopher's Stone*, had an initial print run of only 500, which means that you could probably sell a copy today for many thousands. At the time of writing one first edition is up for sale at over £250,000. In contrast, the print run for the most recent book in the series was into the millions.

There are two main factors that affect the value of children's books. The first, of course, is that they are produced for children, which means they will be subjected to considerably more wear and tear from their readers than, say, an Agatha Christie novel. A first edition of a children's classic with an immaculate dust jacket can be hard to find – hence the high prices. The other factor is that children's books tend to be illustrated. While illustrations provide additional appeal, there is also the problem of children, or parents, removing much-loved pictures to adorn a bedroom wall, meaning that perfect first editions can be hard to find.

Of the children's books appearing recently that might become collectibles of tomorrow, Mr Emeny cites Madonna's books – *The English Roses* and *Lotsa De Casha* – as ones to watch. 'They are beautifully illustrated,' he says. He also recommends books from The Edge Chronicles series, illustrated by Chris Riddell, and Kevin Crossley-Holland's King Arthur books, illustrated by Peter Malone. Alternatively, you could buy the original paintings used for the illustrations, which could prove to be a very good buy should the books attain classic status. Prices start at about £1,000.

Pineapple-shaped ice buckets

Pineapple-shaped ice buckets were a very popular mid-century shape and reached their height of production and style in the 1960s, due to a combination of an explosion in holiday travel, strange and exotic new fruits in the shops and the pineapple's longstanding reputation as a symbol of hospitality. Pineapples really came to signify the blessings of the hearth during the Georgian era of the eighteenth century: discovered in South America a couple of centuries earlier, their sweet taste and exotic appearance meant they grew into a symbol of hospitality, wealth (they were hard to get hold of and expensive) and fashion, appearing not only in architecture but even in the weave of clothing. If you couldn't own a real pineapple, at least you could possess something resembling it. They were associated with monarchy: in the eighteenth century, when European gardeners were managing to grow pineapples in hothouses, Charles II posed with one and that popularity was mirrored right across Europe.

And recently there has been another surge of interest in these pieces, with everyone from interior designers to mid-century style collectors expressing an interest. There are essentially three big names to look out for, although there are plenty of unsigned treasures as well: Michel Dartois from France, the Swiss firm Freddo Therm and the acknowledged master of the lot, the Italian Mauro Manetti, who is very sought after. 'Manetti is the top designer,' says Monique Relander, an antiques dealer based in Schoten, Belgium, who displays in fairs all over Europe. 'The pineapple shape has always been popular, but the 1960s was a time when people were beginning to travel more and see exotic fruit in its country of origin and pineapples were beginning to appear in shops.'

Barometers

Collectors buy barometers as much for their aesthetic appeal as their functionality. The more traditional type of nineteenth-century gilt-edged barometer is, like much brown furniture, not so popular these days, but striking and innovative pieces are very sought after. The late Sir Nicholas Goodison, former chairman of the London Stock Exchange and President of the Furniture History Society, published a book on them about 40 years ago, which is still considered to be the definitive history of the English barometer. Fellow devotee Philip Collins went on to build up a huge collection which is now known as Barometer World, sometimes described as the world's only barometer museum (it also buys, sells and repairs; if you are interested in seeing the exhibition, ring to make an appointment.) He points

out that as barometers are classed as scientific instruments, there is no IHT on them.

Sometimes the great designers of the twentieth century such as Tiffany and Cartier made barometers from the Art Deco period and 30 to 40 years onwards, and these have become extremely desirable items to purchase. Sometimes there are clocks attached and there are also desk top compendiums, or 'weather stations' comprising clock, barometer, calendar, compass and thermometer, probably the most famous being designed for Hermes by Paul Dupré-Lafon who worked with the company from the late 1920s for about 30 years.

Chapter 12

How to Buy: Auctions, Galleries and Fairs

Going, going, gone: Auctions

God help us, if we ever take the theatre out of the auction business or anything else. It would be an awfully boring world.

A. Alfred Taubman, erstwhile owner of Sotheby's

Buying at auction is an excellent way to build up an art collection, but it can be daunting when you start. The best way to get going is to visit a few auctions to watch the process: they are free to enter, although in the case of the extremely high-profile sales of, say, contemporary art, access is limited, sometimes by invitation only. Contrary to popular myth, it is impossible to make an accidental bid for something by coughing or rubbing your eye: if you want to buy something you will almost always have to register in advance and if you are there in person you will have a numbered paddle or card. Relax.

The auction is presided over by the auctioneer who introduces each lot and conducts the bidding; he or she is often a larger-than-life figure and it can be entertaining to watch the showmanship even if you don't want to buy. In the highest echelons of the art world, the evening sales are where the real

drama takes place: these are the very high-profile auctions selling world famous lots. The atmosphere is like that of a party; it is not uncommon to see champagne being served. But that does tend to apply to the global names. There are many smaller auction houses that do not stage such extravaganzas.

Buying at auction is a very ancient process: the earliest auctions were held around 500BC. They fell out of favour, though, and it was not until the sixteenth century that they made a tentative return, while buying art at auction began in the late seventeenth century. The oldest auction house in the world was the Stockholm Auction House in Sweden (Stockholms Auktionsverk), founded in 1674 by Baron Claes Rålamb, while Sotheby's, the world's second largest auction house, came along in 1744. The world's largest auction house, Christie's, was founded by James Christie in 1766. Christie's also published the first auction catalogue that year. Other early auction houses that are still selling works include Göteborgs Auktionsverk (1681), Dorotheum (1707), Uppsala auktionskammare (1731), Mallams (1788), Bonhams (1793), Phillips de Pury & Company (1796), Freeman's (1805) and Lyon & Turnbull (1826). There are many, many more auction houses, both small and large, which we will look at below.

When buying at auction, you start by studying the catalogue, which these days is also usually online. Every lot will have a pre-sale estimate, set by the auction house's experts; this can, however, have little relevance to the final price of the piece. Some will massively overshoot their estimate; others will fail to sell at all, but it does allow you to have a good idea of what is within your budget. You can also ask for a condition report,

which will tell you if the piece is damaged, and you can further request to speak to the relevant expert.

However, do be aware that the auction house will probably not take responsibility for statements in the catalogue and will expect the buyer to have done their own homework. You will also get used to the kind of language used. Common terms include, 'attributed to', 'studio/workshop of', 'circle of', 'style of', 'follower of', 'manner of', and 'after.' In each of these cases it means that you are probably not buying a genuine Rubens (or whatever), but a work created by other artists in his studio, or by his followers and so on. This may not matter if you are buying a picture entirely on aesthetic grounds, but it is more important if you are going after an Old Master. Also, be aware that experts can and do change their opinion as to the authorship of a painting, although again this only makes a real difference at the very highest echelons of the market.

One great advantage of buying at auction is that you not only know what you will probably have to pay, but you can compare your piece with similar items in past auctions and how much they sold for, which are frequently public knowledge. This is not the case with galleries, where the process can be a little opaque. (This also allows you to chart the fate of a particular artist. If someone has done well but starts to fall out of favour, then auction prices will fall.) You can find out past prices through the auction house's website and there are also a number of online services that will help you find achieved prices: these include mutualart.com, invaluable. com, artprice.com, askart.com, auctionhouse.co.uk and more.

Sometimes you will have to subscribe to see the achieved price and sometimes this will involve a fee.

When an item goes up for auction, it usually, but not always, has a reserve price (you sometimes see lots advertised as having no reserve.) This is an amount agreed between the seller and the auction house as the minimum sum the seller will accept and if bidding doesn't reach the reserve price then the lot will be withdrawn for the sale. However, you are free to make an individual offer for it to the auction house afterwards.

The final price is known as the 'hammer price'; this is the highest bid on which the auctioneer brings down his gavel. However, there are costs on top of that. For a start the auction house will charge a premium on the purchase and this can be very high: up to 25 per cent in the major auction houses and you will also pay VAT, another 20 per cent at the time of writing, on that. Local auction house premiums can be much cheaper, sometimes as low as 7.5 per cent. All auction houses will make their terms clear beforehand so you will know what your additional costs are but do bear them in mind when working out your budget. Incidentally, the auction houses will also take a seller's commission from the consigner – the person selling the work – which means they profit on both the buying and selling. In some cases they will waive the seller's commission, usually when they are keen to land a high-profile and prestigious work.

There are various ways to buy at auction. You can be there in person and actively bid when the lot you are interested in comes up for sale. If you can't attend in person, you can give

your details to the auction house, including your highest bid, and you may achieve your purchase that way. You can also bid on the phone – if you watch the major auction houses during one of their important and high-profile sales, you will see a bank of the house's employees sitting in a row at the side of the room on the telephone. They are taking bids from clients.

The world of auction houses, as with much of the art world, is split between the big, powerful and expensive, and the smaller regional houses, although these have also done very well in recent years (Covid notwithstanding.) The two biggest beasts are Christie's and Sotheby's, followed by Bonhams and Phillips. But some of the regional houses are also very successful in their own right and in some cases have existed for centuries: they include Dreweatts, Sworders, Mallams, Cheffins, Lyon & Turnbull and Woolley and Wallis. There are specialist auction houses for particular fields: for example Kerry Taylor specialises in vintage and contemporary fashion and antique costume jewellery, and Tennants is one of the only UK auctioneers to hold dedicated sales of costume, accessories and textile.

Tales from the Salesroom

The most expensive painting in the world to sell at auction is Leonardo da Vinci's *Salvator Mundi*, which sold for $450.3 million on 15 November 2017 at Christie's in New York. That was quite an investment – in 1958 it sold at Sotheby's for £45. However, the sale was controversial: many people said it had been so extensively repaired and conserved that it might no longer be an original Leonardo. It is thought to be owned by

the Saudi Arabian crown prince Mohammed bin Salman and its current whereabouts are unknown.

In 2013 Christie's in London held an Out of the Ordinary sale. A 'rare north Italian taxidermy ostrich' dating from 1785 sold for £21,250.

The Hollywood star Debbie Reynolds built up a huge collection of costumes from the film industry, including the white dress worn by Marilyn Monroe in *The Seven Year Itch* when she cavorted over a subway grate. In 2011 it was sold for $4.6 million at a sale in Los Angeles through the auction house Profiles in History. It had been expected to sell for around $2 million. In the same sale Charlie Chaplin's bowler hat fetched $135,300 and a dress and ruby slippers worn by Judy Garland while filming *The Wizard Of Oz* went for $1.75 million. This was despite the fact that they had not actually appeared in the film.

Sworders Fine Art Auctioneers once sold a tray of Victorian glass eyes for £400.

In October 2018, the street artist Banksy staged a moment of high drama at that most august of institutions, Sotheby's, when one of his most famous images, a girl reaching out for a bright red balloon sold for £1,042,000. Shortly after the final hammer went down, a shredder within the frame of *Girl With Balloon* was activated and the picture was partially destroyed. 'It appears we just got Banksy-ed,' said Alex Branczik, Senior Director and Head of Contemporary Art, Europe London, with remarkable *sang froid*, but there was speculation that someone, somewhere must have been in on this. The concealed shredder would have made the frame unusually heavy and the

lot was the last one to be sold on the night, ensuring maximum publicity. Either way, the buyer was offered his money back but bought the picture anyway, re-naming it *Love Is In The Bin*. It is now thought to be more valuable than it would have been in pristine condition.

Celebrity hair can be very collectable. In 2017 a lock of hair belonging to Elvis sold for €1,300 (it had been collected by his barber). The same year locks of hair belonging to each of The Beatles sold for €8,000 each, Napoleon's tresses went for £2,000 and in 2016 a lock of Marilyn Monroe's hair went for nearly $40,000.

First edition comic books are extremely collectable, and if they have something that really stands out they can fetch a fortune. One famous example is *Action Comics No. 1*, the first comic to ever feature Superman. Originally released in June, 1938, the comic took a staggering $3.2million (or £2.3mmillion) on eBay in 2011. Pass the Krypton.

When the *Titanic* sank in 1912, the eight-piece band on board played as the ship went down. It was led by the English musician Wallace Hartley and, according to CNN, 'Hartley's body was reportedly pulled from the water days after the April 1912 sinking with his violin case still strapped to his back.' In 2013, Hartley's damaged violin was sold at an auction for $1.7 million, the most expensive memento linked to the tragic vessel.

In AD193, the Roman Empire was sold for 6,250 drachmas when the Praetorian Guard, who were the empire's secret police, put it up for sale. They killed the emperor, Pertinax,

and then offered it to the highest bidder, Didius Julianus. After a civil war Julianus was beheaded.

Buying from galleries

Buying from galleries is typically more expensive than buying from auction, not least as this is one of the ways gallerists replenish their stock. It's impossible to quantify the exact difference in price, but as a very broad rule, a gallery may be about a third to half more expensive than buying at auction, although it can be a lot more than that. But there are great advantages to buying through a gallery, not least that you can get to know the gallerist well and they will help you build up your collection.

The great advantage of buying from a gallery is that they are putting their money where their mouth is,' says Alexandra Toscano, former director and now consultant at Trinity Fine Art and former vice chairman of London Art Week. 'They will also be hugely knowledgeable about their area as so many come from an auction or family gallery background. A gallery owner is buying in stock with their own money, which means they really know about their stock.' This does not apply quite across the board: some galleries represent contemporary artists, whose work might be new to the market: in cases like these it is possible that the gallerist might not have paid upfront for the work and will only pay the artist when the work has been sold. But the knowledge and commitment is still there.

Chapter 14 has more suggestions about how to pay for your art, but Alex says that you can always ask for a discount, and up

to 10 per cent is quite normal. There is also particular kudos for a gallery if it sells to a museum (and galleries have been known to put their prices up if a known museum operative appears – some, like the Getty, prefer to buy if something is reassuringly expensive).

It can and does happen that galleries sell works that are attributed to one person and then turn out to be created by someone else. A reputable gallery will probably offer to buy the piece back, within a set timeframe at least. Reputable galleries are those that belong to trade associations, such as The Society of London Art Dealers, The British Antique Dealers' Association, The Association of Art and Antiques Dealers (Lapada) and so on. Check to see if your gallery is a member because their rules and regulations will afford you some degree of protection, but do remember that if an attribution turns out to be incorrect, this is very unlikely to be deliberate on the part of the gallery. It's just that new facts can come to light.

To get some idea of the breadth of galleries and the goods they offer, go to an event such as London Art Week. 'Some galleries will have a very small turnover as they will specifically want to sell to museums, so even if you can't afford the work, this is an opportunity to see a museum-quality work up close and personal.'

There will also be galleries that house one-off special shows, such as Mall Galleries in London. These showcase a society, such as, for example, The Royal Society of Marine Artists Annual Exhibition or The Society of Wildlife Artists Annual Exhibition or The Pastel Society Annual Exhibition and so on.

Buying from art fairs

There are art fairs everywhere these days, from little local events held in village halls to gigantic, international fairs, which attract a clientele at the very highest level of collecting and who will typically follow the art fair calendar around the world, typically in a private jet. The biggest ones include Art Basel, Art Basel Miami, The Armory Show, TEFAF, which shows in Maastricht and New York, Art Toronto, Frieze (London and New York), Masterpiece London, FIAC International Contemporary Art Fair, La Biennale, Paris, BRAFA in Brussels, PAD (London and Paris), Melbourne Art Fair, India Art Fair, Art Stage, Hong Kong Art Fair, Contemporary Istanbul, Contemporary African Art Fair and Art Dubai. Then there are all manner of smaller ones, which have opened in the wake of the big fairs – for example, the success of Frieze prompted other, smaller contemporary fairs to open around the same time.

As above, the great advantage of these fairs is that you will see an awful lot all at once and it could be wildly different, for although some fairs confine themselves to one type of subject matter, such as tribal art, others, such as BRAFA, encourage everything under the sun.

Apart from the variety, there are other advantages in art fairs, too. The very high-end ones provide their own vetting service for the work involved. 'Objects are vetted by a separate panel of experts,' says Alex. 'This is to establish a level of safety and security and to eliminate fraud. The gallerist is asked to leave his or her stall while the vetting is done and sometimes

he or she declines to change the description requested by the panel. In those cases they take the item off their stand. It can be a nerve-wracking time for the galleries involved.' Of course during the pandemic, a lot of these fairs – like the galleries – had to move online, but at the time of writing, at least, normal service is being resumed.

Chapter 13

Buying from Art Schools and Virtual Collecting

Once you have developed confidence and your own eye – or indeed, as a bit of fun when you are starting out – one very good way to build up a collection is to buy from student art shows, or final degree shows, as they are more correctly known. As the name suggests, this is the show held at the end of art students' final year in art schools and universities across the land, and it is the students' chance to showcase their work.

It is a very important moment for them, because along with individual collectors, galleries also send talent scouts along and to catch the eye of one of them could be the start of a big career. Charles Saatchi was an habitué at these types of shows, sometimes buying up the entire inventory of a student artist who had caught his eye.

There are pros and cons in buying this way, as there always are, but the major two are these. On the one hand the artist concerned has no track record and even if he or she benefits from one brief moment of glory, may well sink without trace. On the other hand, it gives you the opportunity to get in right at the start of someone's career, with prices to match, and so if you do spot the new Tracy Emin, you will not be paying Tracy

Emin-style prices. It should be said that you shouldn't expect the work on display to be actually cheap, but nor will you be paying what you would have to in a gallery.

These shows were put on hold during the Covid-19 crisis, of course, causing a great deal of dismay among students as this is their chance to shine, but at the time of writing some normality seems to be returning. Most universities have art departments these days, so get in touch with your local one to see what they are planning to do. In London, there are the famous art schools: these include The Royal College of Art, Slade School of Fine Art, Camberwell College, Central Saint Martins, the Royal Academy Schools and Goldsmiths. Other very well thought of institutions include University College, London, University of the Arts, London, the Glasgow School of Art, Loughborough University, Oxford University, University of Brighton, the Edinburgh College of Arts and Lancaster University. But that is not a comprehensive list: do look for institutions near you.

People tend to associate final degree shows with painting, but given the huge number of courses on offer, this is by no means the case. You may find graphic design, animation, fashion (the stylist Isabella Blow famously bought Alexander McQueen's entire graduate collection for £5,000; she paid it off in weekly instalments of £100 and although we haven't talked much about clothing in this book, those clothes would certainly be considered collectables now), photography, ceramics and much, much more. By buying this way you might find yourself the owner of a work of genius – and even if you don't, you will at least have given the career of a hopeful young artist a boost.

Buying online

One place you would have been able to find graduate art shows is online, as the entire art world migrated to the new virtual reality as the pandemic hit. And there are online galleries devoted to new graduate and emerging art, such as New Blood Art, run by Sarah Ryan, herself an art school alumni (newbloodart.com), Studentartworks (studentartworks.org), Degree Art (degreeart. com) and, appropriately enough, Saatchi Art (saatchiart.com), to name but a few. This last is an enormous gallery, the largest online gallery in the world, and not all the artists are students, although they are there. But virtual art galleries have been around for a long time, either as the online presence of an established gallery (just about every gallery will have a website now), or as an online entity in its own right.

Broadly speaking, the advice is similar to that in buying from a bricks and mortar gallery, although there are particular tips for a virtual purchase. As ever, do your research and find out about the artist and gallery first; you might also ask for a Certificate of Authenticity.

By their very nature, online galleries can hold far more works than bricks and mortar establishments, so you will want to narrow your search. You can look for art by specific artists, by the medium, by price, by region and so on. But bear in mind there will be other costs: shipping and insurance, which should be taken care of by the gallery, but which you will still have to pay for (if the work is valuable, you should make absolutely certain it is coming via a reputable art handler) and customs duties when it enters the country. Some galleries will

include this in your final bill, but some will not, so make sure you know what the final cost will be. And do be aware that pieces can go missing in transit, so make sure everything will be properly tracked.

One huge advantage in buying online is that the world really is your oyster (albeit one subject to customs duties.) If you find an artist you love and Google them you can buy from across the world, rather than confining yourself to one geographical area. And most of the major auction houses now run sales that are only online and as such, tend to last for days, rather than hours. Again, this is by no means confined to visual arts: handbags and watches are both areas that attract a lot of online sales.

Ultimately, trust your instinct. If you are dealing with a famous name, you are very unlikely to have any problems. But if you come across a gallery that you've never heard of, do try to establish something about them – it shouldn't be hard. Most will have a customer care section and you should not hesitate to get on the phone to them. But don't be too hesitant: this really is a whole new world of art.

Chapter 14

How to Pay for Your Art

Art for art's sake it may be but the reality is that hard cash is going to be involved along the way. As in every area of life, if it looks too good to be true, it probably is. If you are offered a Picasso for a few thousand pounds, it's not a Picasso. But if you are canny you can have a jolly good go at cutting back on your outlays.

In an auction house, of course, you are going to pay the hammer price, plus VAT and commission, and there's not a lot you can do about that. But if you are buy in a gallery, there is a very good chance that you will be able to negotiate a discount, at least five per cent and possibly more, especially if you are a repeat customer. The standard way to negotiate this is to ask, 'What's your best price?' You can then attempt to undercut this a little bit more, although don't be too silly about it. This applies to every area: paintings, furniture, jewellery, collectables, the lot. Never be afraid to ask, the worst that can happen is that the dealer will say no.

Bear in mind when negotiating this that the gallery concerned will also be earning a commission on the artwork; the amount varies enormously. It can be anywhere between 33 and 100 per cent, although in some cases it can be as high as 250 per cent. You could, of course, try to buy from an artist directly to avoid these costs, but many will refuse to sell to you,

perhaps out of loyalty to the gallery/dealer or perhaps because they will be contractually forbidden from doing so. But you can always approach an artist if he or she leaves a gallery and negotiate with them then. I have!

Incidentally, a word to the wise. Some dealers will name a price depending on your appearance, namely how much they think you can afford. That certainly doesn't apply across the board, and most art dealers are honest and upstanding people, but it can be the case, so best to leave the Rolex at home if you want to negotiate a bargain.

There are other ways of paying. Many galleries will allow you to pay in instalments, over, say, three or six months, and some will even allow you to have the work after the first instalments, although many will wait until you have paid in full. Some of these schemes will even go up to 10 months. These instalments will typically be interest free and do make sure they are: there's no point in negotiating a good price for a work if you're going to have to fork out interest payments. Some galleries are also not mad keen on instalments if you're paying by credit card.

You can also play the long game and hope that if an item doesn't sell it will come down in price. This once worked for me: I once saw a pair of lamps I wanted which cost a fortune; several years later, with the dealer clearly desperate to sell, I got them for a couple of thousand pounds. But this approach is also full of pitfalls, the first being that if the artist's reputation grows, the prices will increase exponentially. The first time I saw the work of Paula Rego, back in the 1980s, she was selling for around £40,000. This was, alas, totally out of the question

for me at the time and her work is still out of the question for me as it now sells in many hundreds of thousands of pounds.

The other downside to this approach is that the dealer might also be playing the long game. The greatest art dealer who ever lived was Joseph Duveen, Lord Duveen in later life, who around the turn of the last century identified the fact that a lot of Europeans had great art but needed money, while a lot of Americans had money but no great art. The ensuing trade he established across the Atlantic made him an exceedingly rich man, but he was a very canny one, too. In 1906 he bought the Rodolfe Kann collection, the Maurice Kann collection, and the Hainauer collection, all large collections costing astronomical sums. Over 20 years later, in 1927 he bought the Robert H. Benson collection of 114 Italian paintings in England and then three years later he purchased the Dreyfus collection of Italian paintings and sculpture in Paris. Items from this latter went to Andrew Mellon and Samuel H. Kress and are now the core of the National Gallery collections in Washington, D.C. In 1939, the year of his death, Joseph was still selling paintings and sculpture from these purchases, which had, of course, rocketed in value, as well as taking into account the substantial difference in price a dealer will have when buying a picture and selling it on. They formed a substantial part of his fortune. This was called taking a long view.

And if you leave it for too long, of course, there is always the danger that someone else will snaffle it up.

Various galleries run art investment funds, which will help you buy, but these can sometimes be a form of borrowing. There are also specialist loans you can take to buy art. There's

nothing wrong with it and they like to cite instances of the rocketing value of painting, which can be resold, netting you a fortune, but I would advocate caution. If I'd bought my Paula Rego that way I'd be in the black, but if I'd bought one of her contemporaries, who hasn't been heard of for the last 40 years, perhaps the future wouldn't look so bright.

Above all, display a little common sense. You cannot expect really huge discounts (after all, those dealers have to make a living), but if you treat them fairly, you will become a known and trusted client and they may well hold work back for you. This is especially useful if you want to collect from someone whose art often sells out. And you can get discounts from everywhere, even market stalls and chaotic art fairs. In these latter you are also more likely to find a bargain. Just remember: it never, ever hurts to ask.

Chapter 15

Displaying and Looking After Your Art

So you have amassed your collection: now, how to display and take care of it? Because never forget that the ultimate aim in collecting is that art is there to enjoy. You don't want to hide it from view or stash it in a bonded warehouse in Switzerland: you want to display it, contemplate it and make it a part of your life. So what's the best thing to do?

It depends on what it is, of course: some objects merit special display cabinets, either made for the purpose or you can look for old shop display cabinets, which after all were made to display wares. These can also be cheaper than anything bespoke. Cabinets that were made for items such as gloves or ties can be especially good: they will have shallow drawers that you can pull out and glass fronts so you can see what you're looking for. Statues may need perhaps a plinth or a position in a room or corridor from which they can be viewed from all sides, objets d'art can also go on coffee tables and shelves. Don't forget windowsills: they can be a lovely backdrop for a particular collection of objects, as long as you don't have a pet who will push them off again. I have some Parkinson pottery on one of mine.

Very specialist areas may need specific solutions: for example, if you collect coins you want to guard against sunlight, heat, water and oils. You might want to invest in coin folders,

in which coins are inserted into punched holes. Banknotes should also be kept away from direct sunlight and there are specialist folders with pages or sheets that will keep them safe and allow you to view them from both sides.

China and glass present their own issues. A good display cabinet is an obvious way forward: if you find one (or make one) with a mirrored back and a light at the top, it will display your china beautifully, enabling people to see it from all sides without taking it out and touching it. Look for glass shelves, which will also help you to see the china more clearly, and could have a groove etched in the back of the shelf to allow plates to stand up, with their backs resting on the glass. If you have a lot of pieces in the same pattern, building up the display can be so effective it becomes an artwork in its own right. The same applies if you have a big collection of, say, blue and white china: even if the patterns are different, keeping it all together can look magnificent.

You can get special wall hangers to show plates on the wall or little (or big) display stands, either to put within cabinets or to dot about your home. Be imaginative. If you have lots of books and bookshelves, it can look wonderful to put items of china and glass on the shelf in between the books, although do make sure the books are secure on either side and won't damage or break the piece. If you have a big dinner service, you might also want to take the odd piece out and use it as a little ornament or trinket to display in its own right. The French started this custom and the UK followed suit.

Another way to display your bibelots is on the coffee table. Divide the space into, say, six squares and pile sumptuous books

into three of them, not all together – on one side the books should be at either end of the table, with a space in the middle, on the other the books should only be in the middle space. Place objects in the three non-book spaces and a grouping on a mirrored tray of a range of pieces can be very striking. If you have shelves above your radiators, that is another place to display art, again perhaps in a grouping of similar pieces, such as little architectural models all in one place.

But it is really visuals: prints, paintings, photographs and so on that sometimes make people nervous. Do you spend hours marking out the exact position of paintings with a pencil and then use a spirit level to get it straight? Or do you employ a professional picture hanger? Personally, I like an organic approach: start with either one large picture and build others around it or take a group of smaller pictures and, say, hang them above a fireplace, where conventionally there would have only been one large portrait or a mirror. (Books on a mantelpiece, instead of objects, can be very effective too. But here are a few hints to get you started:

- It may seem obvious but start with the frame. Your picture might already have a frame, in which case all well and good, but if it doesn't, or you don't like the frame it has, you will need to buy one. I strongly recommend not skimping on expense here. If you go to a good picture framer, not only will they be able to recommend the right frame for your picture (the dealer might also be able to do this), perhaps picking out a gold flecked with colour within the picture, or a sharply contrasting one, but if

necessary they may also be able to advise on glass to protect it from the sun. Incidentally, you can buy empty frames from galleries and at auction; if you have an Old Master style painting, you might want to consider that option.

- However you are going to hang it, of which more below, you will need picture wire. These days, D-rings – so-called because of their shape – are usually used: they come in pairs and should be screwed into the frame about a third of the way down. You can use picture wire or picture cord.

- Pick your space and think about how it will look together with any other pictures. Is this a group of pictures or one on its own? Think about how the light will change in the course of the day, affecting its appearance, and don't hang it in direct sunlight. If it is a particularly good piece, you might want to light it. There are bracket lights that you can hang directly above the picture, or you might want to go for the more subtle and increasing popular approach of using spotlights.

- When you position your painting, you can use a pencil to mark where you want it to be, a process that is much easier if there are two of you. One somewhat intriguing suggestion from Gray Malin is to put dabs of toothpaste a third of the way down the frame, and press it against the wall in your chosen permission. When you pull it back the toothpaste mark will be on the wall: you can nail the hook in and then wipe the toothpaste off everything. But I have never tried this myself!

- What is the wall you are hanging on made of? If it's plaster, then hooks should go in quite easily, although be aware that in older houses, at least, plaster crumbles and if the picture is very heavy, you should look for a stud (vertical wooden beam) and a noggin (horizontal wooden beam) behind the plaster. If you hang the picture there it will be much more secure. If it's brick, you will need a pre-drilled hole and a wall anchor, a drywall anchor or a brass anchor. Hang the picture on the mortar, not the brick.

- Be aware of factors that might damage your painting. Beware of harsh sunlight, as above, and also heat and perhaps smoke, generated by radiators and fireplaces. Be very careful of damp: this means not only bathrooms but any other areas of the house that are prone to it. Damp can destroy a painting. I had a very nice poster of a Harry Soviak exhibition for years until I foolishly put it above the bath. Ultimately it had to go.

- Don't hang it too high, which will have you craning your neck to see it, and will cause the picture to lose its impact, or too low, which will make the room seem smaller. Try to get it at eye level. Standard advice is to hang pictures 57 inches above the floor or eight inches above a shelf, mantlepiece and so on. Another tip is to divide your wall into four levels and hang the picture in the third. However, this does not take account of gallery walls, of which more below. Nor does it work with very high ceilings.

- There are several ways to hang the picture. The most obvious one is a picture hook hammered into a wall. If it is a very heavy picture, you might need a drill, rawlplug

and screw to get the hook into the wall – the gallery you bought from might be able to advise. Make sure you do not choose a wall location with cables or pipes behind it.

- On the other hand, you might have a dado rail. These were out of fashion for a while, but are coming back and are a good option if you don't want to hammer hooks into a wall, or if the painting is especially heavy and you want to balance the weight. If you have an eight foot ceiling, the dado rail should be placed either 300mm or 500mm below the ceiling, although this can vary widely depending on the height of the ceiling. Hang hooks on the dado rail, thread your picture wire through the D-rings and hang it from the hook.

You might also consider displaying your artwork on easels. These can come in every size, from the tiny, to prop on a bookshelf, to an enormous one of the type an artist would use to put in the corner of the room. If you have a number of unframed works, you can keep them in special flat drawers in chests of drawers which are designed exclusively for this type of art, and which can be pulled out for display purposes. You can also keep them in print storage racks, in which people can flick through them, but bear in mind they should be properly mounted or supported by think cardboard, or you risk them crumpling and losing their shape. I wouldn't employ this one over the longer term.

Building a gallery wall

If you have one particularly spectacular or important painting, you might want to give it a wall of its own, or at least a large

amount of wall space, spotlight it and have done with it. But the opposite approach can also be very attractive: covering a wall with as many paintings as possible. This is known as a gallery wall.

Gallery walls, sometimes called salon walls, originated in seventeenth century Paris, when paintings by the graduates of the Royal Academy were hung floor to ceiling, in order to get as many up on the wall to be viewed as possible. This caught on immediately, and is the way many museums display their treasures to this day; it is also the way that many collectors, from the richest to those who buy mainly from flea markets, like to display their art. You do not require a great deal of space to do this: this is a very good way of adding depth to a small flat, as well as maximising the number of works of art you display. Think of it as a sort of collage. You can make them anywhere, but popular areas are up a staircase and above sofas in the sitting room.

Do not be afraid to mix and match. You can hang Victorian oils cheek by jowl with modern photographs, watercolours next to decorated skateboards – anything you like. Don't forget plates and tapestries. Nor do the paintings need to be framed – again, a mix is interesting. Sometimes people adopt a theme, such as a wall full of botanical paintings, or frames all in the same colour, but it tends to work best when you have variety and that also applies to mixing different shapes and sizes. People take very different attitudes to how they build their wall: some assemble everything on the floor beforehand to see how it all fits together. Others ensure exactly the same amount of space is between each painting. Personally, I prefer the 'bung it on

the wall' approach: just start with a few pictures and add to them, as and when you get your next acquisition, but however you do it, start from the middle and work outwards. You can also apply this approach to patches of wall rather than the whole wall: it can be very effective.

But whatever you do, the advice remains the same: buy the best you can and wait to build up your gallery wall rather than rushing to do it all at once. Some galleries will sell a gallery wall 'kit', namely what they call a curated selection that's ready to hang, but it's far better and more satisfying to make your own individual choices and watch your wall grow alongside your collection. And you can constantly rearrange it as you go along: nothing is set in stone.

Cabinet of Curiosities

Another way of displaying your art, although not, in this case, your paintings (unless they are very small) is to build a Cabinet of Curiosities. Also known as Kunstkabinett, Kustkammer or Wunderkammer, Cabinets of Wonder and wonder-rooms, these were first recorded in Italy at the end of the sixteenth century and were originally whole rooms, although they have now boiled down to become cabinets. Traditionally they contain a variety of objects from different categories, including natural history, antiquities, relics, both religious and historical, geological objects, tribal objects and sometimes books and small paintings. There is no fixed way of building the cabinet: it is entirely personal.

Some Cabinets of Curiosities evolved into major collections: they are the basis for the Ashmolean in Oxford, the British

Museum and the Grünes Gewölbe in Dresden, but anyone can build them as long as they have a few interesting objects. Start with the cabinet itself. There are cabinets that are actually built to be Cabinets of Curiosities or you can use another type of cabinet and customise it, but the key is to make sure you have lots of different sized and shaped compartments. Look for them in auction houses, antique and junk shops, online – the usual places.

There is no limit on what you can put in your cabinet, but here is a list of what would fit the bill: small busts of Roman emperors, silvered shells, coral, ammonite slices, skulls, antique (or modern) paperweights, lobster claws, megalodon teeth, anything in resin, semi-precious bowls, rock crystal, obelisks, malachite, small pieces of tribal art, desert roses (found in Tunisia and Algeria and made out of sand), ethnic headdresses (for example, a Chinese opera theatre headdress), miniature apothecary bottles, scientific instruments – the sky and your imagination is the limit. One hint, though: don't cram everything in all together willy-nilly. It will look much more effective if you curate it properly, think about what will work well together and give everything a little space.

African masks

Today these most intriguing of tribal artefacts are often used as a stylistic counterpoint to contemporary interiors, adding a rustic, artisanal element to other ultra-sleek designs: for example the designer Hernán Arriaga grouped a collection of masks against a white backdrop in a bedroom in Rita Noroña Schrager's home in Southampton, New York.

White backgrounds are a common way to display the masks in interiors as they tend to be dark coloured but people often also put them on plinths: 'It is an individual choice but we like to place them on a custom made bases to show the angularity of the mask and its three dimensional quality so people can move around it,' says Christian Elwes, of London's Entwistle gallery. Different ways of displaying the masks include grouping them together on walls for maximum impact or alternately featuring exceptional pieces on standalone bases. (This section first published in the *Financial Times How To Spend It* magazine in 2016.)

Looking after your art

To a certain extent, looking after your art properly simply involves common sense. As I have said above, keep pictures and anything that might fade out of direct sunlight, especially south facing light. Dust everything regularly. Do not put good pictures into bathrooms, where the air is damp (although one famous society lady kept her collection of Sailors' Valentines in her bathrooms, where they looked fabulous. Then again, her bathrooms were the size of most people's two-bedroomed flats.) Cellars and attics are also not ideal. When you are touching your artworks, try to stay away from the actual image and if you can, use gloves. Pastels and charcoal drawings are prone to smudging and contemporary prints are often on such high-quality paper that they show fingerprints and can be damaged through oil from the skin.

Now, to more specific advice. When you are having visuals framed, pay attention to the mount, because if this is badly

done it could ruin the picture or print. Never, ever glue a picture to a mount. This may well ruin it, although that said I once found a pretty little watercolour in Portobello Road that had been glued down. It cost £35. I took my little bargain to a specialist restorer, who unglued it and charged me £200 (this was around 2002.) 'It costs the same if it's an amateur or a Picasso,' he explained.

Keep the temperature under control. Both extreme heat and extreme cold can affect a picture and allow it to be attacked by insects and mould. Heat, and that includes heat generated by radiators or spotlights, dries the air and can also draw in dirt. Cold causes condensation and mould. Make sure your art is not kept anywhere humid. If you are buying old prints, drawings, maps and watercolours, chances are you will some across foxing, namely brown spots caused by factors such as high humidity. Cardboard containing unpurified woodpulp will cause paper to turn brittle and brown and glue or adhesive tape can cause yellow markings. If for some reason your paintings or art get soaked, lay them on blotting paper to dry out.

Most professional framers will know the pitfalls but it's worth checking to make sure they use UV protected glass. As a general rule, the front and back of the mount should be made of museum board (solid core 100 per cent cotton board) or conservation board (purified woodpulp board.) Anything else risks damaging the picture. Ask the framer if they are using acid-free paper hinges and a water-soluble adhesive. The Institute of Paper Conservation has issued a leaflet, *Guidelines for Conservation Framing*, which is very helpful. It has a great

deal of advice on this and other conservation issues: go to
https://www.icon.org.uk/

Photographs

Almost all of the above applies to photographs, such as avoiding
direct sunlight, wearing gloves while handling them, framing
them with glare-proof glass, keeping them away from extremes
of heat and cold and humidity and so on. Just be aware of a few
extra elements: never scratch a photograph with your nails,
nor use a rubber on it to remove marks. Don't blow on them
as you might accidentally deposit saliva on them. Don't pile
them directly on top of each other as they might get scratched.

Statues – outside

Totally different considerations apply when it comes to statues
and that starts with whether they are indoor or outdoor. If the
latter it is good to keep bronze statues in a sheltered area, but
of course that is not always possible – think of the *Angel of the
North* (actually, that is steel). Water, including that dripping
from trees, will stain your statue (or course, you may want that
as part of the effect) and mould, algae and lichen might also
develop. It may be advisable to put them on a plinth. Very cold
weather might cause stonework to crack and you should try
to keep mud and dirt out of urns and troughs and wipe them
free of falling leaves. And do be careful when spraying garden
chemicals.

 If your statue is stone, marble or plaster, be aware that some
stones get worn away, especially if you use the wrong cleaning
materials – always use soft brushes and a little water. You will

have the same issues with algae and lichen as you would with a bronze, but in this case they will add to the statue's allure. Clean, bright stone looks wrong. Alabaster and marble are both porous and stain easily, and if that happens it's better to have it cleaned professionally, as otherwise you risk forcing the stain deeper in.

Statues – inside

It is much easier to look after your indoor bronzes than their outdoor counterparts. For a start, don't place statues and small bronzes where they are likely to be knocked over, and they can be harmed by direct contact with wooden floorboards, so consider a plinth. As with most artworks, it's a good idea to wear gloves when handling it (sweat is acidic and corrodes metal). Dust it regularly and use a small toothbrush to get into hard-to-reach crevices.

If you spill something on it, wipe it off immediately with a damp cloth and dry it afterwards. This might seem extremely obvious advice, but sometimes people think that because it's not material, it will dry without staining. This is not the case: it will leave a mark. Don't ever use abrasive cleaning products: they will scratch it. Chemicals and tarnish removers will also cause damage.

Your statue will have a patina: this is the colour on the surface of the bronze. The sculptor will have made it by applying chemicals to the work with heat and it also describes the natural reaction of the bronze to the elements, including humidity. A thin layer of wax covers it and to maintain it in the same condition that it was in when it left the gallery, you will

have to maintain this layer of wax. However, you should not use normal waxes or polishes on it; there are some specialist products especially for statues and bronzes – you might ask the seller what they recommend. Wash and dry the bronze first before polishing. However, you might also want to let the wax thin out and watch the differing patinas as the statue ages. Over time it will acquire a greenish hue if you leave it to develop. The bronze itself should last for a very long time.

Fibreglass sculptures are to be treated in a similar way and you should try not to leave them outside, as the sun will dull the work and rain will cause mould. That said, plenty of people and organisations do. Again, wash them occasionally, and don't use chemicals or sharp objects on them.

Your art afloat

Should you be lucky enough to own a yacht and wish to keep some suitably snazzy art on the high seas, then you have different issues altogether. And this is a considerably more common problem than you would think. Leonardo da Vinci's *Salvator Mundi* was bought by Saudi Crown Prince Mohammed bin Salman for $450 million in 2017 and although its whereabouts have largely remained a mystery for much of the time since then, there are credible reports that it spent at least some of the time on his 439-foot yacht *Serene*. It might even have sailed to Paris.

Yacht owners tend also to be art collectors: just look at the Venice Biennale or Art Basil Miami Beach and see how many super-boats are on show. And some yachts are practically floating museums: the superyacht *Aviva* is thought to house Francis

Bacon's *Triptych 1974–1977* and a few other masterpieces. *MY Revelry* contains pieces by Alexander Calder, Ellsworth Kelly and Richard Diebenkorn, and *Topaz* has a huge collection put together by its owner Sheikh Mansour bin Zayed al-Nahyan. In some cases, the value of the art will actually be greater than the value of the yacht.

So, how to look after ocean-going art? For a start, be sensible in what you choose. While it is possible to protect paintings against the damp and salt in the air, it is not possible to guard against rough seas, and so an installation piece such as a Damien Hirst mammal in formaldehyde is probably not a good idea. You can help cope with damp and salty air by installing climate control using special climate boxes and if your works are really good (namely, expensive), your insurer might actually require this. You will need something with an alarm announcing atmospheric changes. This means keeping everything inside and avoiding vents, portholes and heating elements, but these climate control systems are now so sophisticated, they can actually rival what you can find in museums.

Some of the same issues apply as on land, most notably direct sunlight. And at sea you might have glare from the water. Make sure they are framed with anti-glare, anti-reflective glass. When you are actually hanging the pictures, remember that ceiling heights in yachts are usually lower than in houses, so monumental works are probably out, and nor will you just bang in a hook in a way that you might in your drawing room. Pictures should be screwed to the wall and objects and small sculptures should be held in place with museum glue, which will do the trick but is not permanent.

This is not just in case of rough weather: the boat's engine alone will provide constant vibration.

Issues crop up that can be very unexpected. Will you have to worry about customs? The Spanish banking billionaire Jaime Botin got a very nasty shock a few years back when was arrested in Corsica by French authorities on the grounds that he was trying to take a Picasso painting worth more than €25 million out of Spain. According to the Spanish authorities, the painting is part of the country's heritage and cannot be removed from the country. The case continues to this day (at the time of writing, at least). You might need to talk to an expert when planning your itinerary. CITES (Convention on International Trade in Endangered Species of Wild Fauna and Flora) regulations may apply if the artwork contains one of 36,000 species – including ivory, corals and crocodile skins. They all require a licence to transport across countries.

In view of all of the above, if you are in a position to own a yacht and fill it with expensive art, your best bet is to bring in the professionals, including an interior designer and an expert on climate controls. It is now also common for the crew to be trained in looking after good art. This is essential when it comes to avoiding some of the disasters of the past. A couple of years ago, Pandora Mather-Lees, who is an advisor on how to look after high art on the high seas, spoke at London's Superyacht Investor conference and recalled one very unfortunate incident.

'[The yacht owner's] kids had thrown their cornflakes at [the Basquiat] over breakfast on his yacht because they thought it was scary,' Mather-Lees said, according to the *Guardian*.

'And the crew had made the damage worse by wiping them off the painting.' This is considerably less likely to happen with properly trained staff. And do remember to beware flying champagne corks, which could damage a canvas. Yup, that really did happen in real life, too.

Insuring your art collection

If the art is on a boat, make sure it's included in your marine insurance policy. Security is an issue: in April 2019, a painting by Picasso was discovered in Antibes – it had been stolen from a superyacht 20 years previously. As before, yacht owners will have more to worry about security-wise than just their art: at the very minimum you should have CCTV and wireless protection systems and possibly a full Close Protection service.

Most of us will not have our art on a boat, although CCTV is a good idea if your collection contains valuable works. A normal home contents insurance policy might be all you need, but make sure you check with your insurer to make sure your valuables are covered. There are also insurance companies that specialise in art insurance: as usual it is a good idea to shop around. Various price comparison websites will get you started.

Here are some general tips that will help if your works are stolen or damaged in some way:

- Always keep your invoices. Keep them in a dedicated folder both online and in actual fact; make it part of your domestic admin. Supplemental documents such assessments and conservator notes should also be on file.

- Keep a list of your works, including the name of the artist and painting, when and where you bought them and the price. Include any incidental costs such as framing. Materials, dimensions and provenance should also be kept to hand and you should note supplementals such as gallery marks, labels, artists' signatures, edition numbers and so on.
- Keep photographs of every work; very easy these days with cameras on phones. It might also be an idea to photograph the interiors in which they are hung.
- If you sell any of your works, keep a record of that too. Not only might you need it for tax purposes, but if you have a work that will stand the test of time, you are now part of its history and provenance.

Here are also some supplemental thoughts to maintain your collection:

- Keep a record of how much it costs to maintain your collection. This can include security and annual maintenance, such as waxing statues.
- Keep a record of all the art professionals you deal with: galleries, conservators, contacts at auction houses and so on.
- Create reminders for yourself for when that maintenance work is due to be done, so that you do not neglect your collection. There are specialist websites that you can sign up for or you can simply run your own programme at home.

It is also an idea to keep track of other works by the artists that you have in your collection. If you bought from a student degree show, it is entirely possible that your artist's reputation has soared (although unfortunately, the opposite might also be true) and the same applies to art bought from an earlier period. Artists' reputations change over the decades.

And finally, don't forget to enjoy your art. If you buy work you really love, display it properly and maintain its upkeep, it should afford you a lifetime of pleasure and perhaps for your children's children after you. Art is there to be nurtured and cherished and it brings an immense amount to the lives of many people. You are now an art collector. With any luck, years of happiness lie ahead.

Index